So what's on the menu for you? This charming book will appeal to all ages! It is packed with favorite foods and gorgeous photos to assist you all year long. You can make it your goal to create and enjoy each recipe at least once. We chose our best and most 'down home eats' to help you spend less time in the kitchen, and more time for joy, quality of life, and the best menu choices for your family and friends.

A Farm Girl's Menu has only a brief sampling of previously published recipes, so for satisfaction of variety in cooking from an abundance of choices, my entire collection of books is available.

A Farm Girl's Menu
Timeless Recipes

By Frances A. Gillette

Photography and layout by Gabrielle Massie

Typing by Brooke Tormanen

Editing by Bethany Kadow

Written and published by Frances A. Gillette

Layout and file preparation by

Ward Homola at Infinite Color Inc.

Print Production by Mike Williamson

at West Coast Print Shop

SLEIGH BELLS & SUGARPLUMS

BOUNTEOUS BLESSINGS

TASTES OF COUNTRY

THE OLD FARMHOUSE KITCHEN

THE HEARTLAND

Recipes shared from some of
the best cooks in the U.S.A.
Beautiful colored pictures with fun
stories and history.

Guaranteed to please anyone!
Order these country cookbooks
by Fran Gillette

SLEIGH BELLS & SUGARPLUMS	$8.95
BOUNTEOUS BLESSINGS	$12.95
TASTES OF COUNTRY	$18.95
THE OLD FARMHOUSE KITCHEN	$19.95
THE HEARTLAND	$19.95
Shipping for 1 book	$5.95
Shipping for 2-6 books	$12.95

CAN BE ORDERED ONLINE AT:
www.frangillettecookbooks.com

ALSO ON FACEBOOK AT:
www.facebook.com/frangillettecookbooks

WASHINGTON RESIDENTS, please add sales tax.

FRAN GILLETTE
P.O. Box 351
Yacolt, WA 98675
360-686-3420

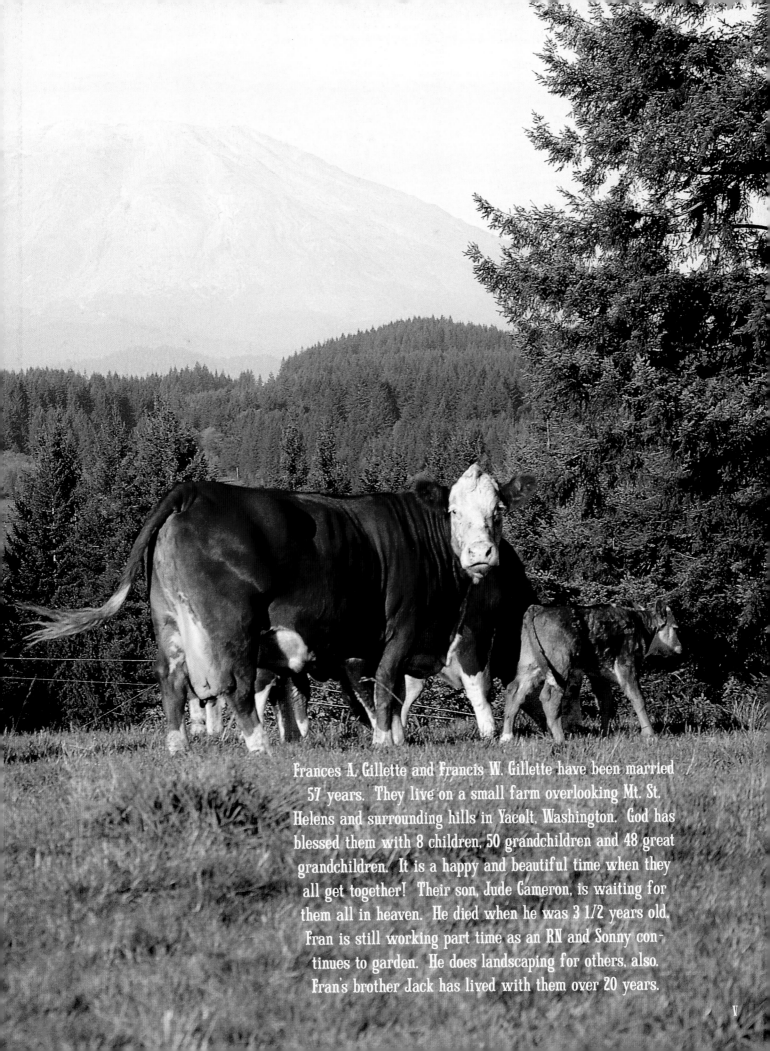

Frances A. Gillette and Francis W. Gillette have been married 57 years. They live on a small farm overlooking Mt. St. Helens and surrounding hills in Yacolt, Washington. God has blessed them with 8 children, 50 grandchildren and 48 great grandchildren. It is a happy and beautiful time when they all get together! Their son, Jude Cameron, is waiting for them all in heaven. He died when he was 3 1/2 years old. Fran is still working part time as an RN and Sonny continues to garden. He does landscaping for others, also. Fran's brother Jack has lived with them over 20 years.

Acknowledgements

Innumerable thanks to all who have contributed their recipes and memories. My granddaughters Gabrielle Massie, Brooke Tormanen and Bethany Kadow helped me put this book together. It's impossible to explain the amount of time necessary to create and publish an illustrated cookbook. Gabrielle kept me focused when I wanted to quit. Her suggestions and visions and, "You can do it, Grammy- sure, I'll be right over" were inspiring. She kept the ultimate goal achievable. The astronomical amounts of food I cooked were turned into literal pieces of artwork by Gabrielle's deft hand and gifted eye through her lens. We had so many amazing photos, we could not possibly use them all. Brooke dedicated hours to enormous pages of typing very willingly, giving the pages to her sister Bethany, who edited and organized the whole book, page after page; these 3 deserve medals for courage and skill! My daughters: Lori, Heidi, Cheri' and Heather made several recipes. Gabrielle and I went to their houses to take the pictures; very endearing to me and I thank them for their ability and willingness with their preparations. I appreciate all they've done to encourage and help me. Thanks to everyone who has purchased my other books, for your phone calls of gratitude and for encouraging me to write another book. Outstanding thanks from the bottom of my heart to Gabrielle Massie, Bev Amundson, Stan and Mary Sneeden, Sherry Deel, sister Linda Kysar, Rose Merne Gillette, my beautiful daughters and anyone I have not mentioned for all the times you've been sounding boards, making it easier to compile this book. You are all priceless and the best! Thanks to Leila Kysar, Linda Kysar, Merle Moore, Heidi Esteb, Lori Homola, Debbie Rinta, Elaine Sarkinen, and Janina Kerr-Bryant, for keeping me on target with proofing. Appreciation goes out to Char and Jim Lambert for taking us around their beautiful dwelling and to their daughter Megan and husband Jesse's farm in Trout Lake. They sell fresh milk and their home is truly an old, old farmhouse. Several pictures in this book were taken there. Once again, Ward Homola and Mike Williamson have patiently guided me through to completion of this book.

Last but not least: Without my dear husband Sonny doing so many errands to assist me there would not be a book. Every day I cooked, usually once a week, he gave the whole day to help me. He ran for groceries I'd forgotten and always gathered produce from his garden. And the dishes he's done would fill every inch of our kitchen. Thank you! Thank you, sweet love!

Timeless Recipes

Timeless...
Without beginning or end.
Never ending, enduring, everlasting

I married the love of my life-my boyfriend and my partner. I dedicate this last and final book to my Sweetheart. You, dear Sonny, have always been there for me. I thank God for you every day and realize how fortunate I am! Oh, the many sales and auctions... you are always with me carrying the treasures and boxes of junk we buy to the pickup. I appreciate your unending support with all of my books! Every year your gardens faithfully produce so many berries, popcorn and vegetables for us and our family. The best blessing is that you are the giving and loving Father to all of our children, grandchildren and great grandchildren. You have been such a wonderful example for them all. Sonny, you make me the happiest woman in the world; thank you Farm Boy with the cheeks of tan! Now, come sit by the fire with me and enjoy this book!

Forever yours, Fran

BREAKFAST AND BREADS

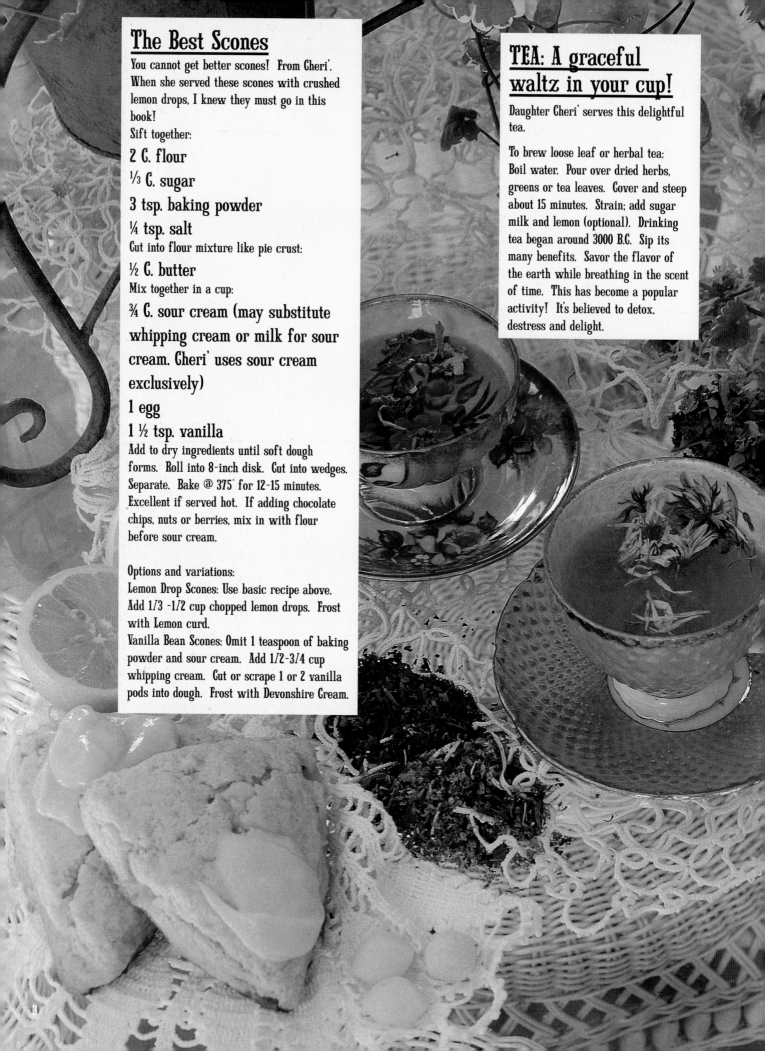

The Best Scones

You cannot get better scones! From Cheri'.
When she served these scones with crushed
lemon drops, I knew they must go in this
book!
Sift together:

2 C. flour

⅓ C. sugar

3 tsp. baking powder

¼ tsp. salt

Cut into flour mixture like pie crust:

½ C. butter

Mix together in a cup:

¾ C. sour cream (may substitute
whipping cream or milk for sour
cream. Cheri' uses sour cream
exclusively)

1 egg

1 ½ tsp. vanilla

Add to dry ingredients until soft dough
forms. Roll into 8-inch disk. Cut into wedges.
Separate. Bake @ 375° for 12-15 minutes.
Excellent if served hot. If adding chocolate
chips, nuts or berries, mix in with flour
before sour cream.

Options and variations:
Lemon Drop Scones: Use basic recipe above.
Add 1/3 -1/2 cup chopped lemon drops. Frost
with Lemon curd.
Vanilla Bean Scones: Omit 1 teaspoon of baking
powder and sour cream. Add 1/2-3/4 cup
whipping cream. Cut or scrape 1 or 2 vanilla
pods into dough. Frost with Devonshire Cream.

TEA: A graceful waltz in your cup!

Daughter Cheri' serves this delightful
tea.

To brew loose leaf or herbal tea:
Boil water. Pour over dried herbs,
greens or tea leaves. Cover and steep
about 15 minutes. Strain; add sugar
milk and lemon (optional). Drinking
tea began around 3000 B.C. Sip its
many benefits. Savor the flavor of
the earth while breathing in the scent
of time. This has become a popular
activity! It's believed to detox,
destress and delight.

Enchanting
Beautiful Springtime

Lemon Curd
This delicacy is for scones, pancakes or just to eat like pudding! Recipe from daughter Cheri'.

3 eggs, large
3 lemons, large (squeezed and seeded)
¾ C. sugar
¼ C. butter (cut into small chunks)
Lemon zest (optional)

Whisk together eggs, sugar and lemon juice in a stainless steel pot. Cook, stirring constantly until mixture becomes thick (approx. 10 minutes). Strain to remove the lumps. Whisk butter into the mixture, add zest and let it cool. Cover immediately and refrigerate. Lasts one week. Makes 1 ½ cups.

Devonshire Cream for Scones
Recipe from my daughter Cheri'.

1 8 oz. pkg. cream cheese, softened
3 Tbsp. powdered sugar
1 tsp. vanilla
⅔ to ¾ C. whipping cream

In a mixing bowl, beat cream cheese, powdered sugar and vanilla until fluffy. Gradually beat in cream, adding enough to achieve a spreading consistency; cover and chill.

4

Hallelujah!

Old trunks can be rugged and wonderful;
one wonders about their story!
A trunk is just what you've been looking for,
to put magazines, the newspaper and your morning cup of coffee on!

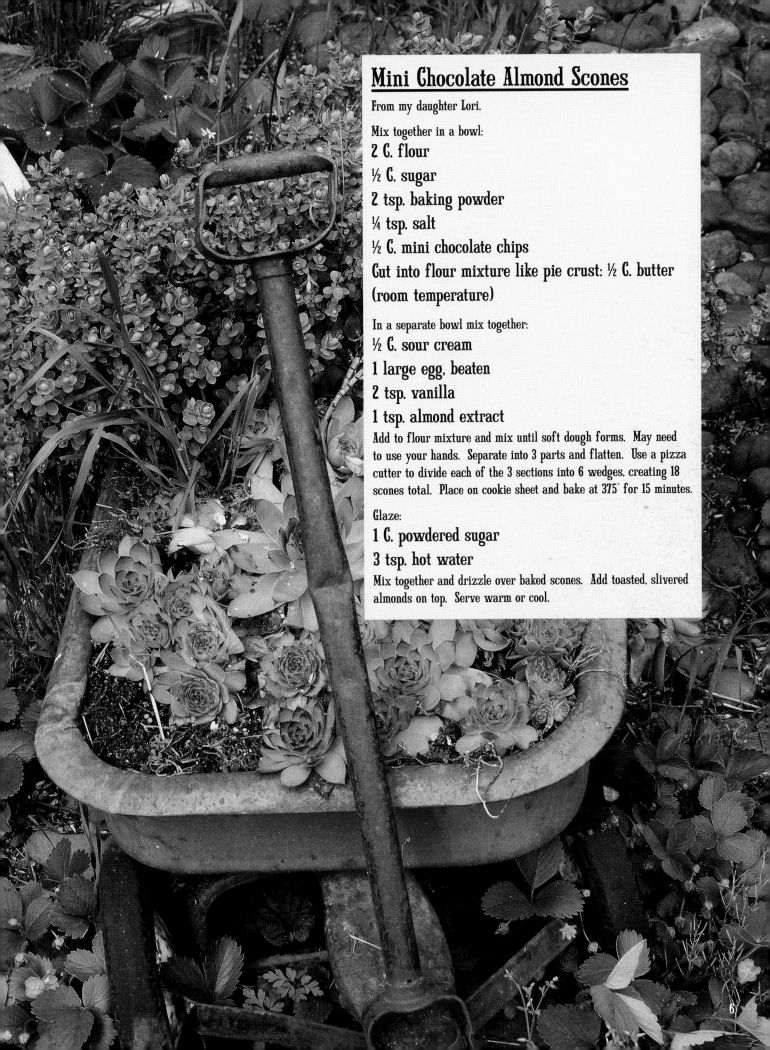

Mini Chocolate Almond Scones

From my daughter Lori.

Mix together in a bowl:

2 C. flour

½ C. sugar

2 tsp. baking powder

¼ tsp. salt

½ C. mini chocolate chips

Cut into flour mixture like pie crust: ½ C. butter (room temperature)

In a separate bowl mix together:

½ C. sour cream

1 large egg, beaten

2 tsp. vanilla

1 tsp. almond extract

Add to flour mixture and mix until soft dough forms. May need to use your hands. Separate into 3 parts and flatten. Use a pizza cutter to divide each of the 3 sections into 6 wedges, creating 18 scones total. Place on cookie sheet and bake at 375° for 15 minutes.

Glaze:

1 C. powdered sugar

3 tsp. hot water

Mix together and drizzle over baked scones. Add toasted, slivered almonds on top. Serve warm or cool.

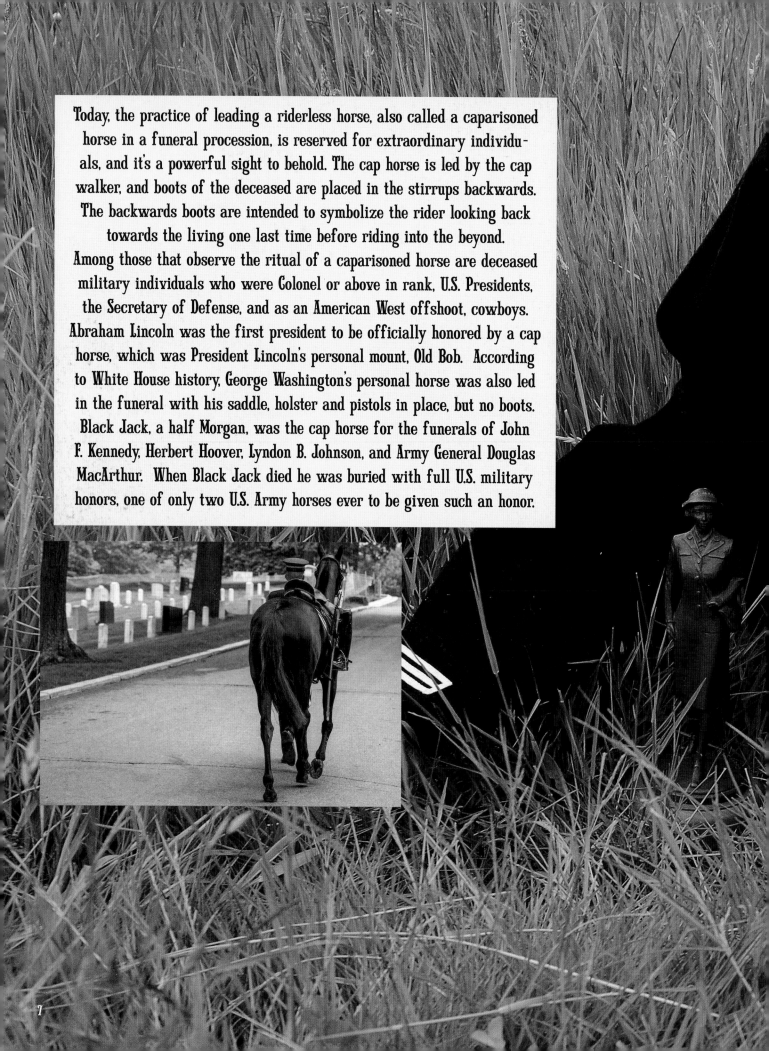

Today, the practice of leading a riderless horse, also called a caparisoned horse in a funeral procession, is reserved for extraordinary individuals, and it's a powerful sight to behold. The cap horse is led by the cap walker, and boots of the deceased are placed in the stirrups backwards. The backwards boots are intended to symbolize the rider looking back towards the living one last time before riding into the beyond.

Among those that observe the ritual of a caparisoned horse are deceased military individuals who were Colonel or above in rank, U.S. Presidents, the Secretary of Defense, and as an American West offshoot, cowboys. Abraham Lincoln was the first president to be officially honored by a cap horse, which was President Lincoln's personal mount, Old Bob. According to White House history, George Washington's personal horse was also led in the funeral with his saddle, holster and pistols in place, but no boots.

Black Jack, a half Morgan, was the cap horse for the funerals of John F. Kennedy, Herbert Hoover, Lyndon B. Johnson, and Army General Douglas MacArthur. When Black Jack died he was buried with full U.S. military honors, one of only two U.S. Army horses ever to be given such an honor.

In FLANDERS FIELDS

In Flanders fields the poppies blow
Between the crosses, row on row,
That mark our place; and in the sky
The larks, still bravely singing, fly
Scarce heard amid the guns below.

We are the Dead. Short days ago
We lived, felt dawn, saw sunset glow,
Loved and were loved, and now we lie
 In Flanders fields.

Take up our quarrel with the foe:
To you from failing hands we throw
The torch; be yours to hold it high.
If ye break faith with us who die
We shall not sleep, though poppies grow
 In Flanders fields.

Flax and Oat Bran Muffins

Recipe from my niece, Molly Kangas. Anything from her kitchen is TOPS.

½ C. gluten free flour

¾ C. flax meal

¾ C. oat bran or oatmeal

½ C. organic sugar or brown sugar

2 tsp. baking soda

½ tsp. salt

1 tsp. vanilla

2 tsp. baking powder

2 tsp. cinnamon

1 C. carrots, grated

1 large apple, chopped

½ C. raisins, Craisins or currants

¾ C. almond milk or other

2 eggs

Mix all ingredients in order given. (Do not overmix). Grease muffin tins. Bake @ 350° for 20-25 minutes.

Luscious Lemon Banana Muffins

Recipe compiled and made by our daughter Heidi. These muffins are divine!

Whisk together:

4 C. rice flour, white

5 tsp. baking powder

1 tsp. salt

2 C. butter, softened

2 C. sugar

5 bananas, large and ripe

1 C. flax seed, ground

8 eggs

Preheat oven to 350°. Beat the softened butter, sugar and bananas together until smooth. Briefly stir in eggs. Combine butter mixture with flour mixture until blended. Let batter rest in a bowl before spooning into greased muffin pans. Bake for 25-30 minutes.

Glaze

Mix:

2 C. powdered sugar

¼ C. lemon juice (more can be used)

Drizzle over hot muffin tops. You can adjust frosting to personal taste and thickness.

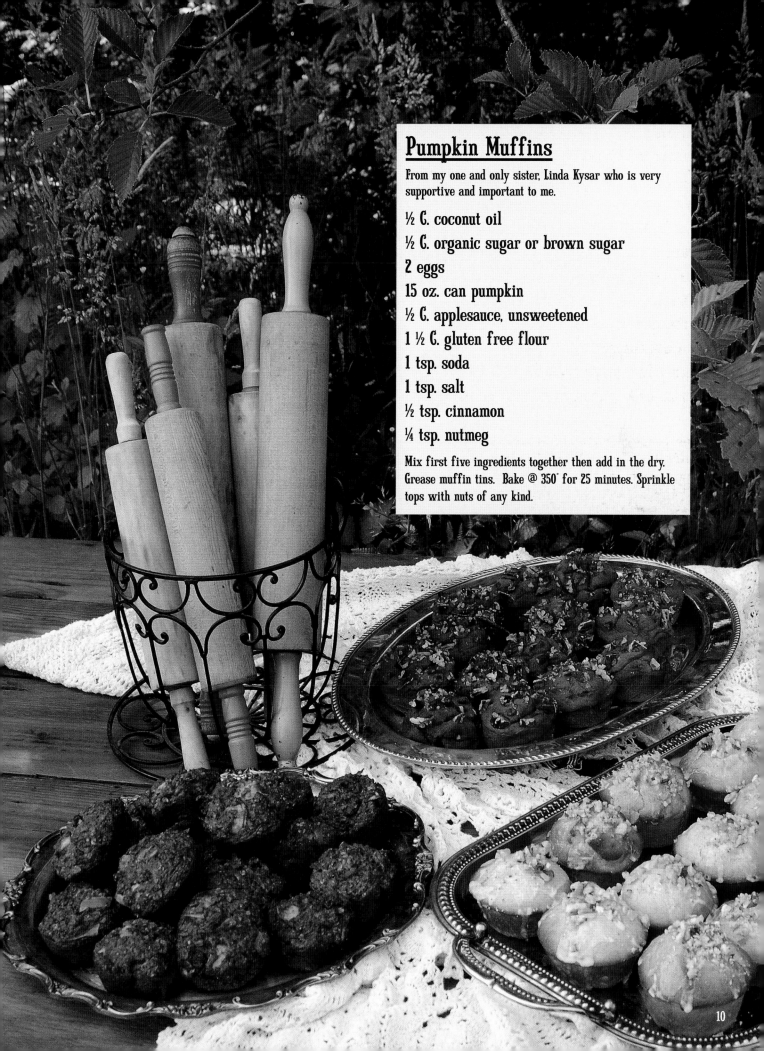

Pumpkin Muffins

From my one and only sister, Linda Kysar who is very supportive and important to me.

½ C. coconut oil

½ C. organic sugar or brown sugar

2 eggs

15 oz. can pumpkin

½ C. applesauce, unsweetened

1 ½ C. gluten free flour

1 tsp. soda

1 tsp. salt

½ tsp. cinnamon

¼ tsp. nutmeg

Mix first five ingredients together then add in the dry. Grease muffin tins. Bake @ 350° for 25 minutes. Sprinkle tops with nuts of any kind.

Breakfast Casserole Supreme

This hearty recipe gives you your potatoes, eggs and meat all in one easy dish. From the home of my daughter Lori.

2 cups tater tots, frozen

1 dozen eggs

1 C. peppers of choice, chopped

1 C. bacon bits or crumbled sausage

1 C. mushrooms, chopped

½ C. onions, chopped

1 ½ C. cheese, grated

1 C. cream

1 tsp. pepper, ground

½ tsp. salt

Spray a 9x13 casserole pan with cooking spray, line bottom with frozen tater tots and set aside. Beat eggs in a bowl and add cream and pepper. Set aside. Layer meat, chopped pepper, mushroom, onion, and one cup of cheese on top of tater tots. Pour egg mixture over top. Bake @ 350˚ for 50 minutes. Check last 10 minutes for doneness, and sprinkle the remaining ½ cup of cheese over top.

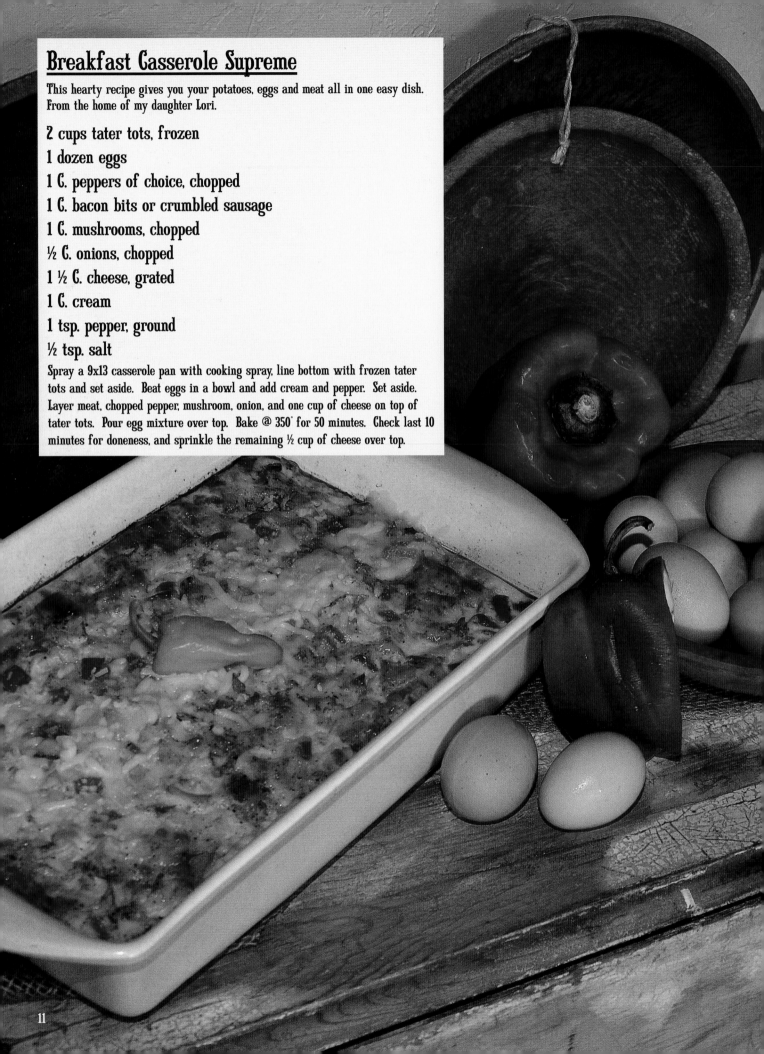

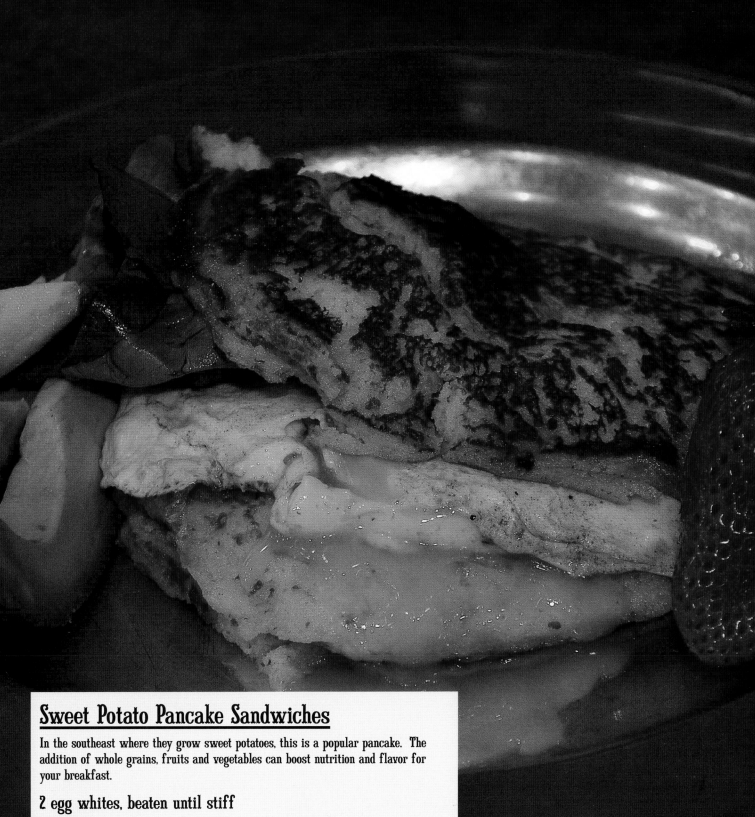

Sweet Potato Pancake Sandwiches

In the southeast where they grow sweet potatoes, this is a popular pancake. The addition of whole grains, fruits and vegetables can boost nutrition and flavor for your breakfast.

2 egg whites, beaten until stiff
1 C. white flour
½ C. whole wheat flour
1 tsp. baking powder
½ tsp. salt
1 C. sweet potatoes, mashed
¼ C. butter, melted
1½ C. milk

Beat egg whites, set aside. Combine flours, baking powder and salt. Add sweet potatoes, milk and butter. Fold in egg whites. Stir until smooth, but do not overmix. I use olive oil or butter to fry the pancakes.

For each pancake sandwich, fry one egg and layer on pancake. Put second pancake on top of egg. Break egg yolk so it runs. Garnish with avocado, lettuce and berries. It is tricky to keep several warm, but it can be done if you have pancakes warming in the oven while frying the eggs.

Bread Pudding

An all-time favorite. I make this treat with homemade bread.

1 lb loaf of bread, buttered

⅓ C. chopped pecans

5 eggs, beaten

¾ C. sugar

2 tsp. vanilla

½ tsp. salt

3 ½ C. milk, warmed

½ C. butter

Cut bread into slices and then cut into cubes. Place in a buttered baking pan. Sprinkle with nuts. Beat together eggs, sugar, vanilla and salt. Beat in warm milk. Pour mixture over cubed bread, making sure all bread is thoroughly saturated. Pour melted butter over the top of milk and bread mixture. Bake at 350 for approximately 45-50 minutes or until set like custard. Cool and serve with cream.

Memories On the Farm Are the Best

Growing up in the 1940s and 50s on a farm at the end of nowhere was a terrible life to a teen-ager. Milking the cow every night was my job. Washing clothes with the wringer washer on Saturday (without fail) was a shared job with my sister. And worst of all was clean-ing the chicken house every week (it's a wonder I ever eat eggs). Looking back I can see that I was the luckiest girl in the world. It makes me sad that teenagers today have no idea where milk or eggs come from. It was as they say "a wonderful life." I just didn't know it!

Written By Sharon Sorenson

Sharon and I were close buddies down in the valley. We had each other to play and get into trouble with. Together, we discovered the challenges of growing into the people we are today. Of all my cousins, she and I were continually looking for something beyond the fence, and we usually found it! Our farm had so many animals. There were always lots of pigs (I mean between 100 to 200), and their troughs ran for many yards down the field. Our job was to help feed them! Sharon, her two sisters and her mom and dad lived close to me, my six siblings and my mom and dad. In those days as a small child, trying to grow older, it felt like all we had was each other. When I was twelve, we finally got electricity and running water. My job, like Sharon's, was to hitch up the work horse, Prince, go to the spring and haul water to heat on the cook stove for the wringer washing machine. We were both young when we milked the cows and made lots and lots of butter on the farm. As Sharon stated, "It was a wonderful life."

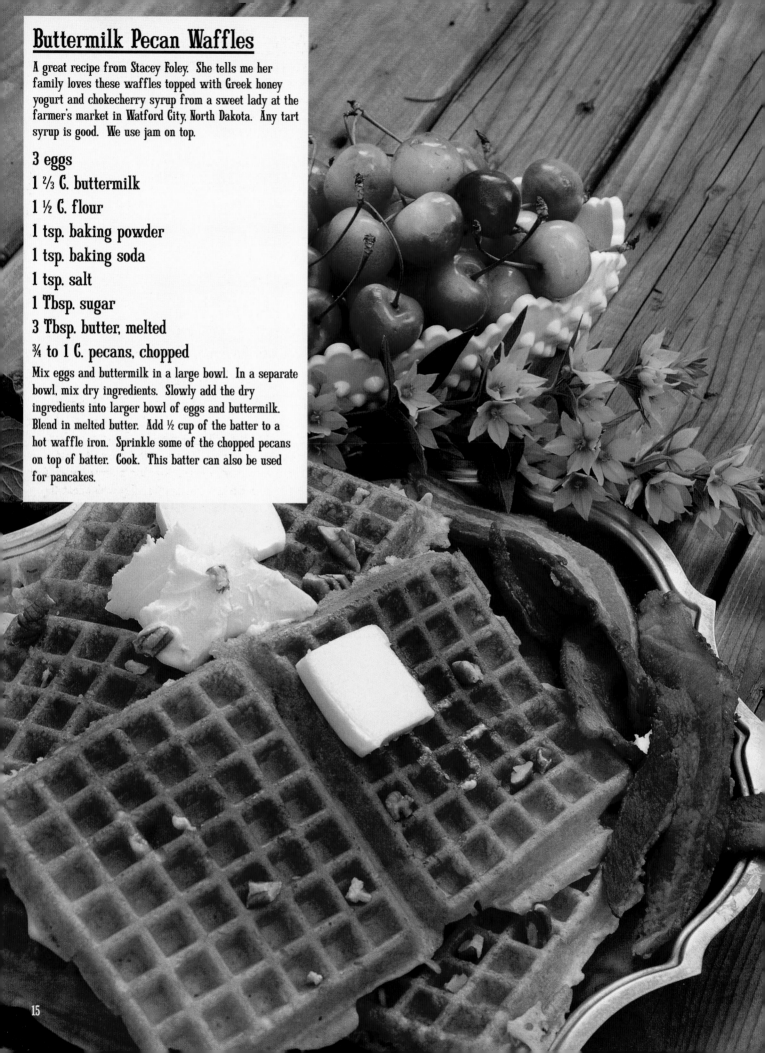

Buttermilk Pecan Waffles

A great recipe from Stacey Foley. She tells me her family loves these waffles topped with Greek honey yogurt and chokecherry syrup from a sweet lady at the farmer's market in Watford City, North Dakota. Any tart syrup is good. We use jam on top.

3 eggs
1 ⅔ C. buttermilk
1 ½ C. flour
1 tsp. baking powder
1 tsp. baking soda
1 tsp. salt
1 Tbsp. sugar
3 Tbsp. butter, melted
¾ to 1 C. pecans, chopped

Mix eggs and buttermilk in a large bowl. In a separate bowl, mix dry ingredients. Slowly add the dry ingredients into larger bowl of eggs and buttermilk. Blend in melted butter. Add ½ cup of the batter to a hot waffle iron. Sprinkle some of the chopped pecans on top of batter. Cook. This batter can also be used for pancakes.

15

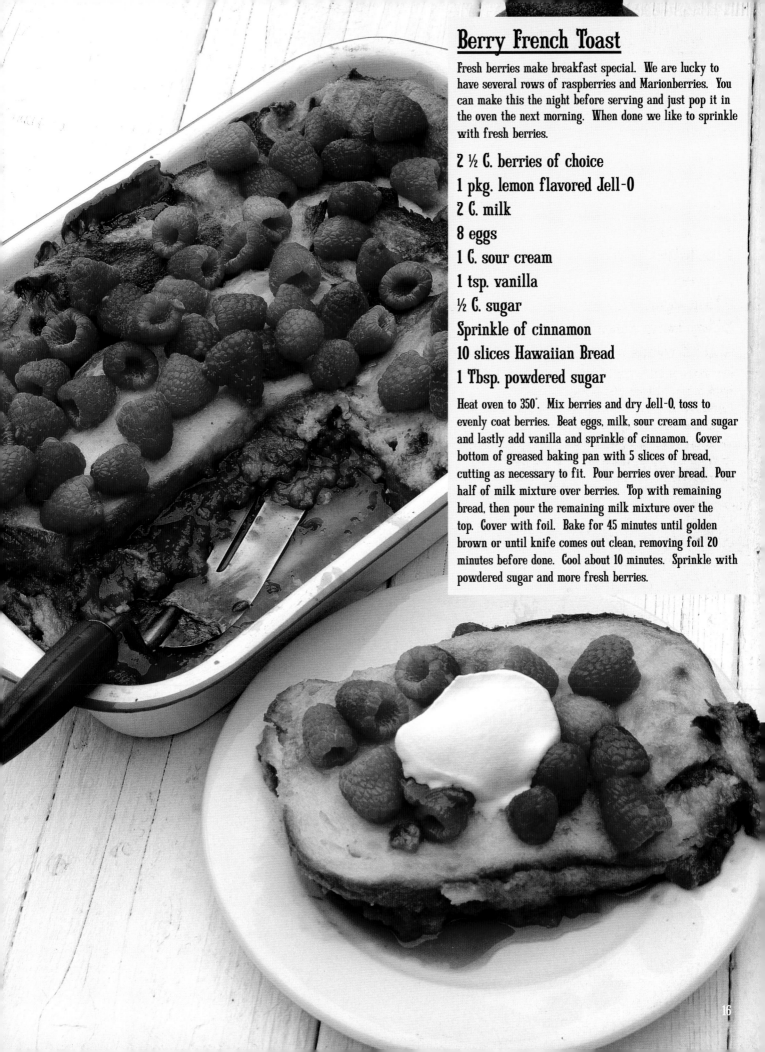

Berry French Toast

Fresh berries make breakfast special. We are lucky to have several rows of raspberries and Marionberries. You can make this the night before serving and just pop it in the oven the next morning. When done we like to sprinkle with fresh berries.

2 ½ C. berries of choice
1 pkg. lemon flavored Jell-O
2 C. milk
8 eggs
1 C. sour cream
1 tsp. vanilla
½ C. sugar
Sprinkle of cinnamon
10 slices Hawaiian Bread
1 Tbsp. powdered sugar

Heat oven to 350°. Mix berries and dry Jell-O, toss to evenly coat berries. Beat eggs, milk, sour cream and sugar and lastly add vanilla and sprinkle of cinnamon. Cover bottom of greased baking pan with 5 slices of bread, cutting as necessary to fit. Pour berries over bread. Pour half of milk mixture over berries. Top with remaining bread, then pour the remaining milk mixture over the top. Cover with foil. Bake for 45 minutes until golden brown or until knife comes out clean, removing foil 20 minutes before done. Cool about 10 minutes. Sprinkle with powdered sugar and more fresh berries.

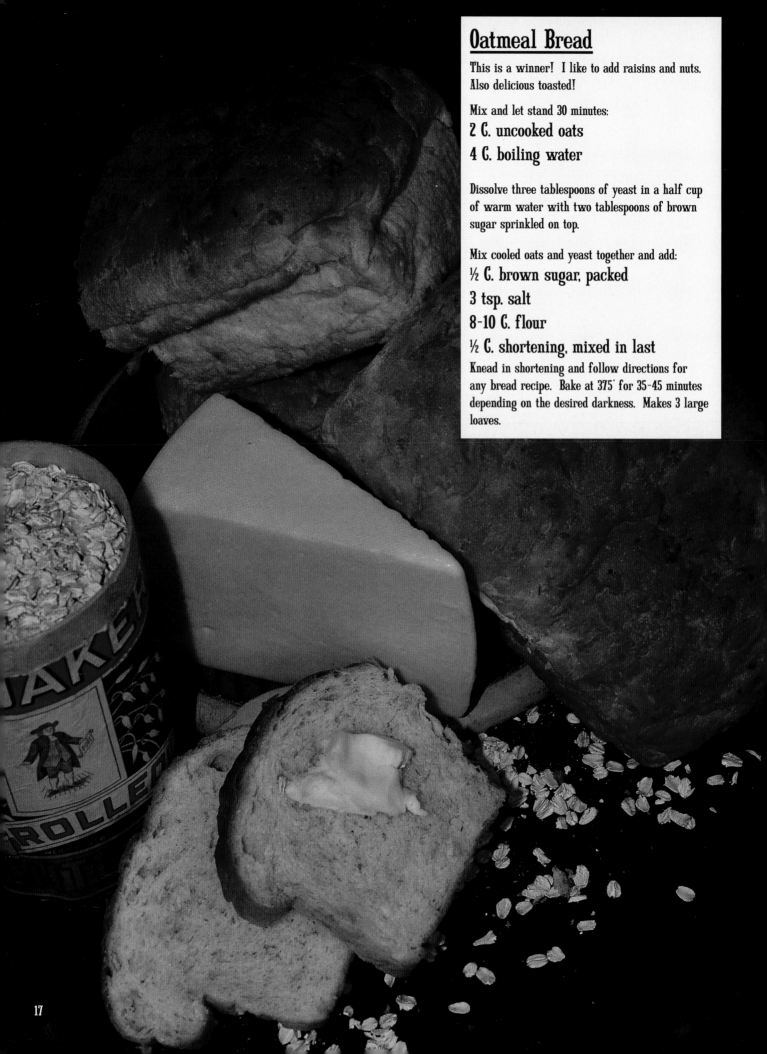

Oatmeal Bread

This is a winner! I like to add raisins and nuts.
Also delicious toasted!

Mix and let stand 30 minutes:

2 C. uncooked oats

4 C. boiling water

Dissolve three tablespoons of yeast in a half cup
of warm water with two tablespoons of brown
sugar sprinkled on top.

Mix cooled oats and yeast together and add:

½ C. brown sugar, packed

3 tsp. salt

8-10 C. flour

½ C. shortening, mixed in last

Knead in shortening and follow directions for
any bread recipe. Bake at 375° for 35-45 minutes
depending on the desired darkness. Makes 3 large
loaves.

Delicious Egg Bread

Do you have extra eggs? Use some in this beautiful bread. Makes the best toast!

Dissolve into large bowl:

1 C. water

3 Tbsp. yeast

¼ C. sugar

After yeast mixture is dissolved, add:

2 C. milk, warmed (not too hot, will kill yeast)

½ C. sugar

3 tsp. salt

6 eggs

6 C. flour

½ C. butter, softened

Mix well. When dough is still sticky, knead in a half cup of butter. Add enough flour until dough is smooth and easy to handle. Put mixture on floured board; knead at least five minutes. Shape into round lump and place in a greased bowl. Grease top of dough and let rise until double. Shape into 3-5 loaves, depending on size of pan. Let rise until almost double. Bake at 375° for 35-40 minutes. It should be golden brown. So good!

Apple Sauce Bread

Recipe from Cindy Sutton, handed down from her grandmother, Hazel Frasier.

2 C. flour

16 oz. applesauce

1 ¼ C. sugar

½ C. shortening

1 C. raisins

2 tsp. soda

1 tsp. cinnamon

½ tsp. salt

1 tsp. cloves

1 C. nuts, chopped

Heat apple sauce to boiling; add sugar, shortening, and spices. Then add soda mixed with a teaspoon of hot water and stir. Add flour, raisins and nuts. Pour into greased loaf pan. Bake @ 350° for 40 minutes.

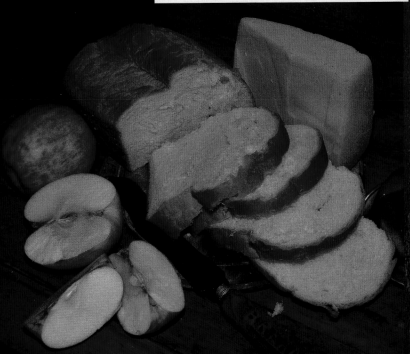

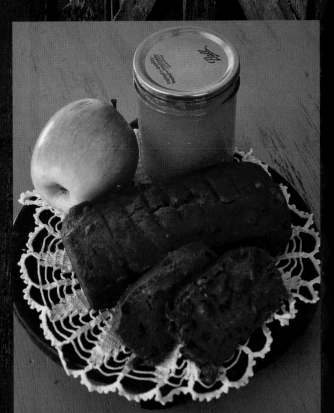

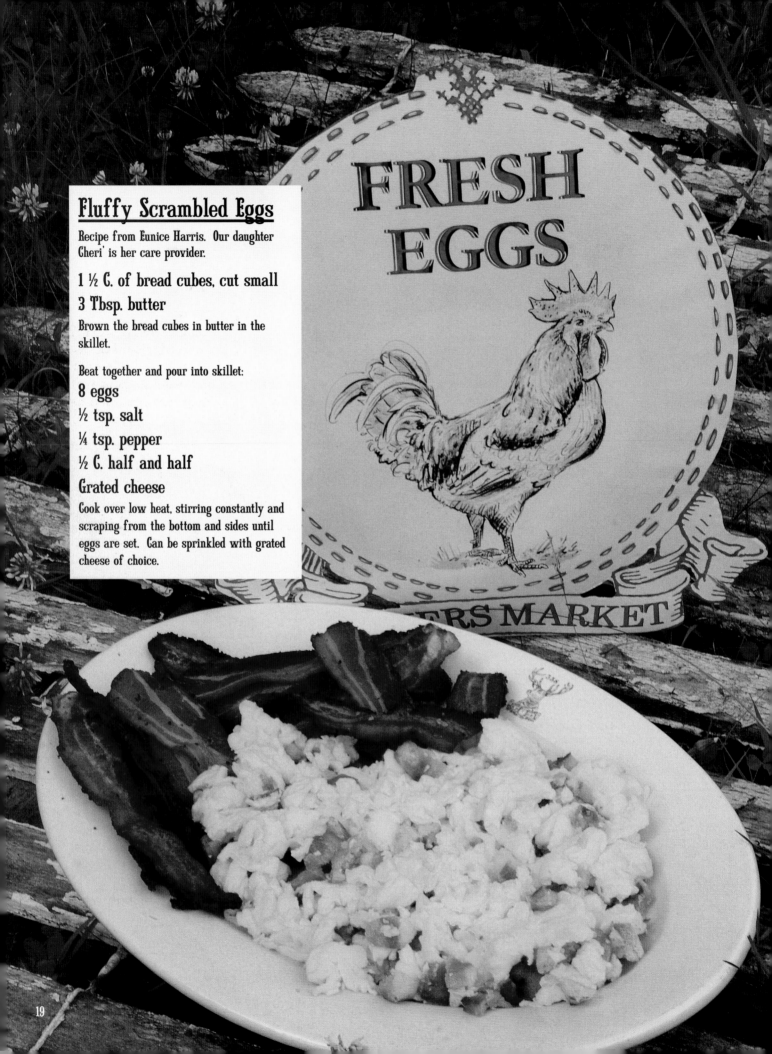

Fluffy Scrambled Eggs

Recipe from Eunice Harris. Our daughter Cheri' is her care provider.

1 ½ C. of bread cubes, cut small
3 Tbsp. butter

Brown the bread cubes in butter in the skillet.

Beat together and pour into skillet:

8 eggs
½ tsp. salt
¼ tsp. pepper
½ C. half and half
Grated cheese

Cook over low heat, stirring constantly and scraping from the bottom and sides until eggs are set. Can be sprinkled with grated cheese of choice.

FRESH EGGS

ERS MARKET

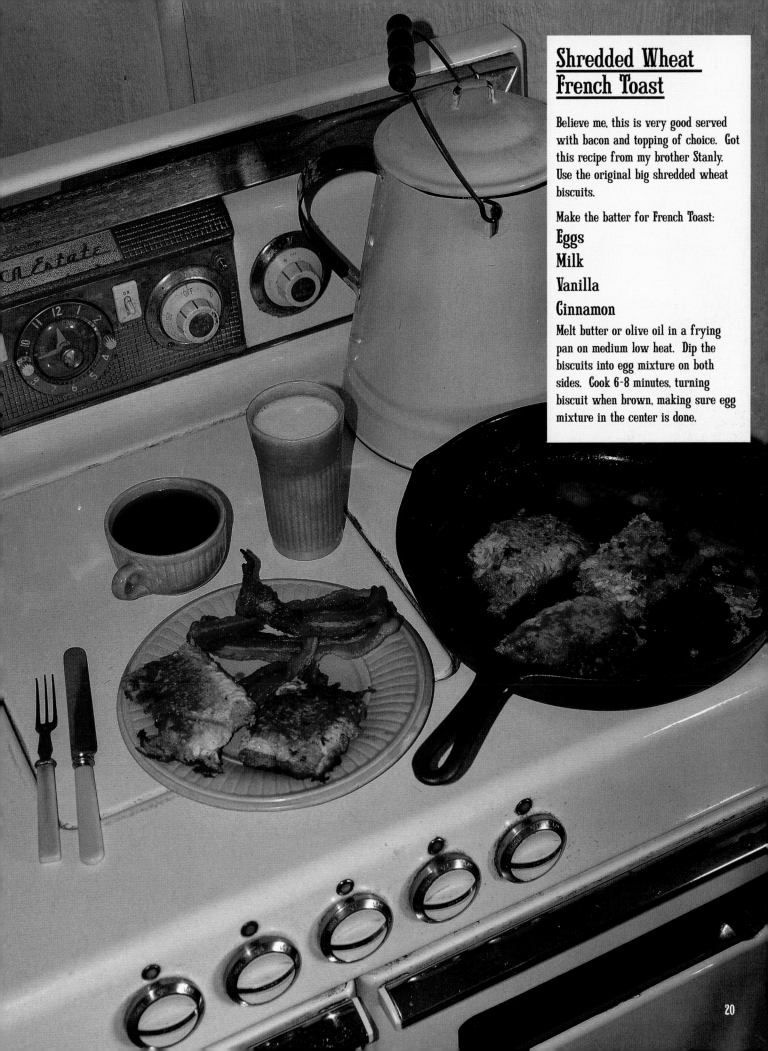

Shredded Wheat French Toast

Believe me, this is very good served with bacon and topping of choice. Got this recipe from my brother Stanly. Use the original big shredded wheat biscuits.

Make the batter for French Toast:

Eggs

Milk

Vanilla

Cinnamon

Melt butter or olive oil in a frying pan on medium low heat. Dip the biscuits into egg mixture on both sides. Cook 6-8 minutes, turning biscuit when brown, making sure egg mixture in the center is done.

Italian Bread

This recipe is from Rachel Koistinen. A very good recipe!

2 pkg. (4 oz. each) active dry yeast
3 Tbsp. sugar
3 Tbsp. shortening
3 C. water (warm, 110°-115°)
8-10 C. all-purpose flour
1 Tbsp. salt
1 egg, beaten

Dissolve yeast, sugar and shortening in water. Stir in 4 cups flour, salt, and eggs and beat until smooth. Stir in enough remaining flour to form a stiff dough. Turn onto floured surface; knead until smooth and elastic, about 6-8 minutes. Place in bowl coated with non-stick cooking spray (I used shortening), turning once to grease top. Cover and allow to rise in warm place. Punch dough down every 10 minutes for one hour. Then allow dough to rise for one additional hour or until doubled. Punch dough down. Let rest 10 minutes. Divide into 2 loaves, slash top and place on baking pans or two 9x5x3 loaf pans coated with non-stick cooking spray or shortening. Cover and let rise until doubled, about one hour. Bake @ 350° for 45 minutes or until golden brown. Cool. Makes 2 large loaves.

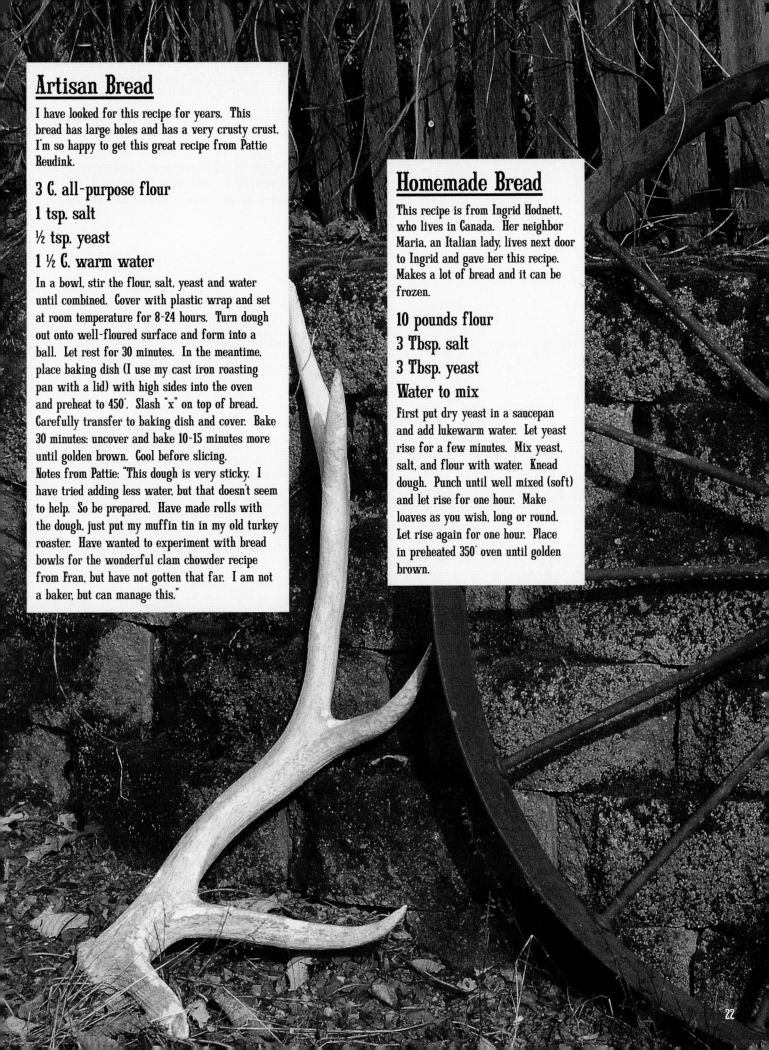

Artisan Bread

I have looked for this recipe for years. This bread has large holes and has a very crusty crust. I'm so happy to get this great recipe from Pattie Reudink.

3 C. all-purpose flour

1 tsp. salt

½ tsp. yeast

1 ½ C. warm water

In a bowl, stir the flour, salt, yeast and water until combined. Cover with plastic wrap and set at room temperature for 8-24 hours. Turn dough out onto well-floured surface and form into a ball. Let rest for 30 minutes. In the meantime, place baking dish (I use my cast iron roasting pan with a lid) with high sides into the oven and preheat to 450˙. Slash "x" on top of bread. Carefully transfer to baking dish and cover. Bake 30 minutes: uncover and bake 10-15 minutes more until golden brown. Cool before slicing.

Notes from Pattie: "This dough is very sticky. I have tried adding less water, but that doesn't seem to help. So be prepared. Have made rolls with the dough, just put my muffin tin in my old turkey roaster. Have wanted to experiment with bread bowls for the wonderful clam chowder recipe from Fran, but have not gotten that far. I am not a baker, but can manage this."

Homemade Bread

This recipe is from Ingrid Hodnett, who lives in Canada. Her neighbor Maria, an Italian lady, lives next door to Ingrid and gave her this recipe. Makes a lot of bread and it can be frozen.

10 pounds flour

3 Tbsp. salt

3 Tbsp. yeast

Water to mix

First put dry yeast in a saucepan and add lukewarm water. Let yeast rise for a few minutes. Mix yeast, salt, and flour with water. Knead dough. Punch until well mixed (soft) and let rise for one hour. Make loaves as you wish, long or round. Let rise again for one hour. Place in preheated 350˙ oven until golden brown.

Sausage and Grits

Mother never made grits until our family made a trip to North Carolina. We've all been eating and enjoying these great grits for years. Very nutritious!

2 lbs. sausage, seasoned

1 tsp. salt

1 ½ C. uncooked grits (quick cooking)

2 (8 oz.) pkgs. or 1 lb. shredded cheese (cheese of choice)

1 C. milk

½ tsp. black pepper

4 large eggs, beaten

4 ½ C. water

Brown and crumble sausage in a large skillet over medium heat, stirring occasionally. Drain on paper towels. Bring salt and water to a boil in a large kettle. Whisk in grits and bring to a boil. Reduce heat and simmer for five minutes, stirring occasionally. Remove from heat and add cheese, stirring until melted. Stir in milk and pepper. Lastly, stir in sausage. Pour mixture into a lightly greased 9x13 pan or casserole dish. Bake at 350° until golden brown or bubbling, about 45 minutes.

Basted Eggs

Recipe from Lily Frances's husband Jerome. A hit every morning you make these eggs. Try them!

Eggs

Butter

Water

Salt and Pepper

Heat frying pan on medium heat. Add a tablespoon of butter and let it melt. Crack a couple of eggs in melted butter. Sprinkle a few tablespoons of water around eggs as they cook. Cover pan and let the water simmer and steam until eggs are cooked to your liking. Enjoy on a slice of toast.

Egg Bake

A good way to start the day and very simple to make. A baked egg casserole with plenty of ham and cheese. Sonny says this dish of eggs is better than any omelet. This will satisfy everyone! Helen Hendrickson gave me this recipe.

12 eggs, beaten

1 ½ C. milk

1 C. ham or bacon, already cooked and chopped (browned sausage can be used as well)

4 Tbsp. onion, minced

½ tsp. seasoned salt

1 ½ C. cheese, grated

Grease a 9x13 pan. Mix all ingredients together and bake at 350˚ for 45-50 minutes, until golden brown.

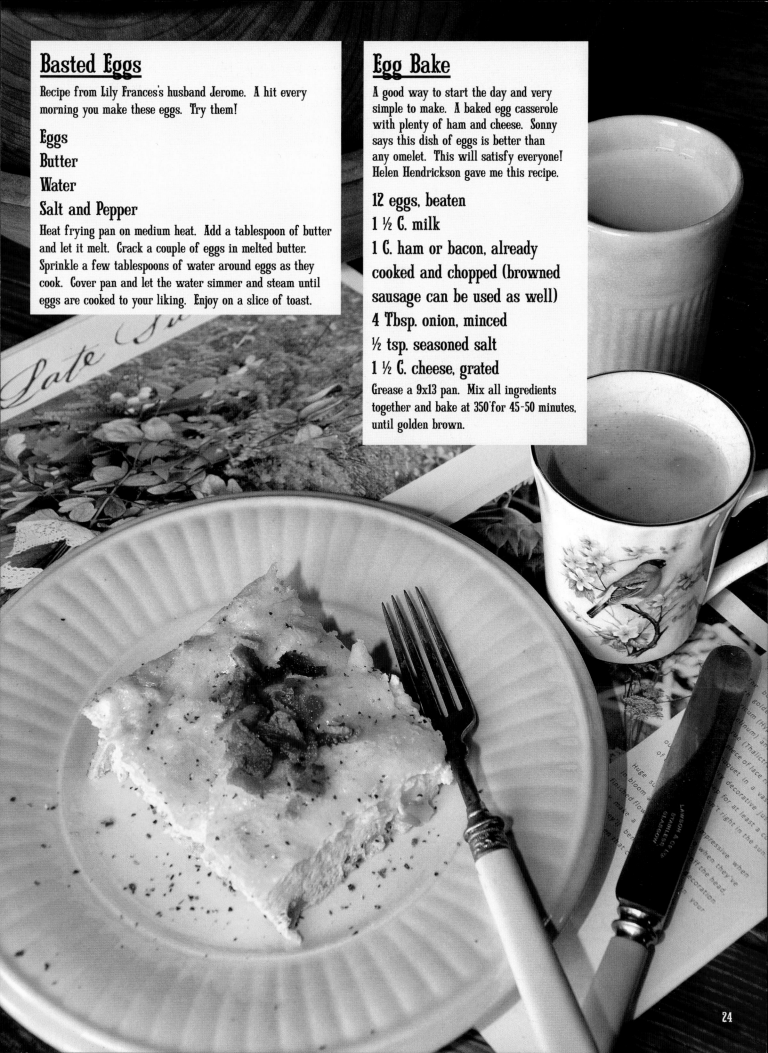

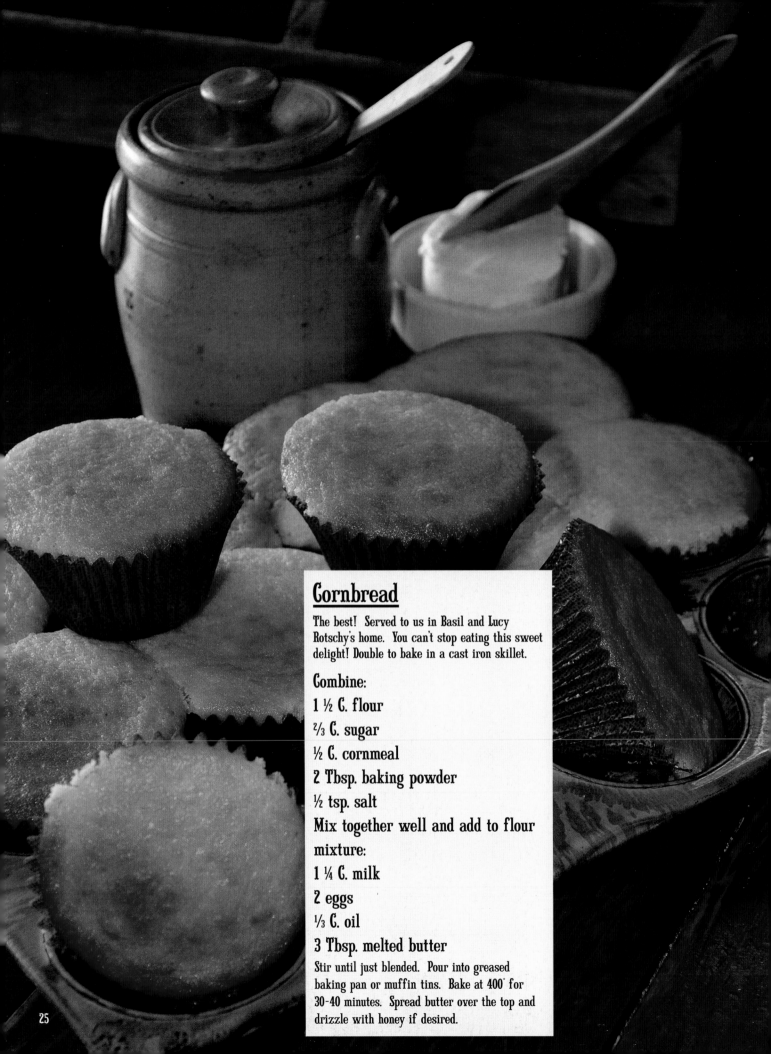

Cornbread

The best! Served to us in Basil and Lucy Rotschy's home. You can't stop eating this sweet delight! Double to bake in a cast iron skillet.

Combine:
1 ½ C. flour
⅔ C. sugar
½ C. cornmeal
2 Tbsp. baking powder
½ tsp. salt
Mix together well and add to flour mixture:
1 ¼ C. milk
2 eggs
⅓ C. oil
3 Tbsp. melted butter

Stir until just blended. Pour into greased baking pan or muffin tins. Bake at 400° for 30-40 minutes. Spread butter over the top and drizzle with honey if desired.

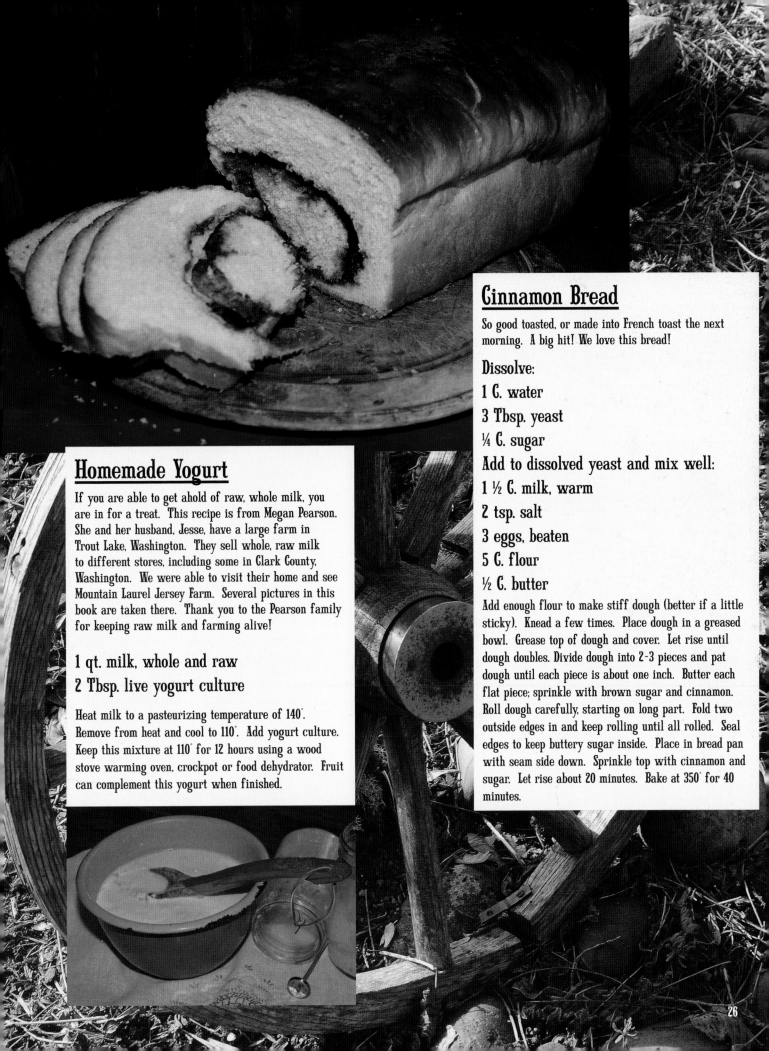

Cinnamon Bread

So good toasted, or made into French toast the next morning. A big hit! We love this bread!

Dissolve:

1 C. water

3 Tbsp. yeast

¼ C. sugar

Add to dissolved yeast and mix well:

1 ½ C. milk, warm

2 tsp. salt

3 eggs, beaten

5 C. flour

½ C. butter

Add enough flour to make stiff dough (better if a little sticky). Knead a few times. Place dough in a greased bowl. Grease top of dough and cover. Let rise until dough doubles. Divide dough into 2-3 pieces and pat dough until each piece is about one inch. Butter each flat piece; sprinkle with brown sugar and cinnamon. Roll dough carefully, starting on long part. Fold two outside edges in and keep rolling until all rolled. Seal edges to keep buttery sugar inside. Place in bread pan with seam side down. Sprinkle top with cinnamon and sugar. Let rise about 20 minutes. Bake at 350˚ for 40 minutes.

Homemade Yogurt

If you are able to get ahold of raw, whole milk, you are in for a treat. This recipe is from Megan Pearson. She and her husband, Jesse, have a large farm in Trout Lake, Washington. They sell whole, raw milk to different stores, including some in Clark County, Washington. We were able to visit their home and see Mountain Laurel Jersey Farm. Several pictures in this book are taken there. Thank you to the Pearson family for keeping raw milk and farming alive!

1 qt. milk, whole and raw
2 Tbsp. live yogurt culture

Heat milk to a pasteurizing temperature of 140˚. Remove from heat and cool to 110˚. Add yogurt culture. Keep this mixture at 110˚ for 12 hours using a wood stove warming oven, crockpot or food dehydrator. Fruit can complement this yogurt when finished.

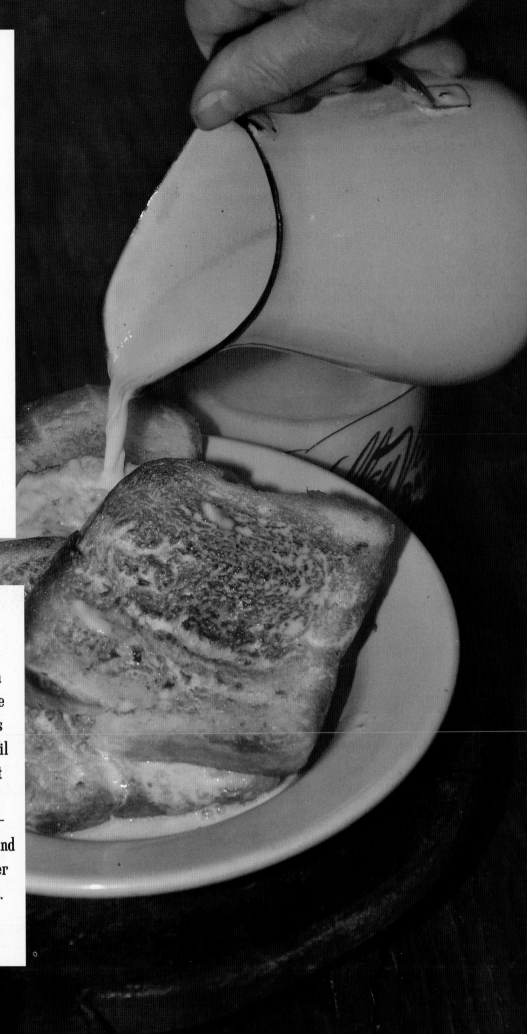

Basic Bread

So easy to make! Give it a try...
today!

6 C. warm water
3 Tbsp. yeast
1 C. sugar
3 tsp. salt
½ C. shortening
Flour

In a large mixing bowl, dissolve
yeast in warm water and sugar
until bubbly. Add salt and be-
gin adding flour. Mix in enough
flour until dough comes away
from bowl. I knead bread right
in the bowl. Last, knead in
shortening. Dough should be
smooth and elastic. Grease
bottom and top of dough and
allow to rise. Punch down and
make into loaves. Put dough
into greased pans. Let rise until
doubled. Bake at 375° for
40-45 minutes.

Milk Toast
Very, very old fashioned
and a wonderful break-
fast! We were raised on
this great food. Of course
homemade white bread is
the best! Toast bread until
it is well toasted, but not
burnt. Heat milk on the
stove with a couple table-
spoons of butter and salt and
pepper. Pour hot milk over
toast in individual bowls.
A very soothing calming
food for the stomach.

Corn Meal Rolls

I'm repeating this recipe from one of my other books! It is an all-time favorite of mine and everyone who makes them!

Recipe from Ima Massie.

Heat in a heavy pan:

4 C. milk

1 C. butter

⅔ C. cornmeal

1 C. sugar

2 tsp. salt

Mix ingredients together and boil for a few minutes, then cool.

Add:

4 eggs, beaten

3 Tbsp. yeast; dissolve first in

½ cup warm water

Add last:

8 C. flour

Mix all together. I usually make the dough the night before I want rolls and refrigerate all night. Cover with shortening and a dish towel. Remove from refrigerator. Punch dough down. Let rise for at least an hour, as the dough will be cold. I sprinkle corn meal on the greased baking pan before adding rolls. Shape dough into rolls; let rise until double. Bake the rolls at 375° for 20 minutes or until golden brown.

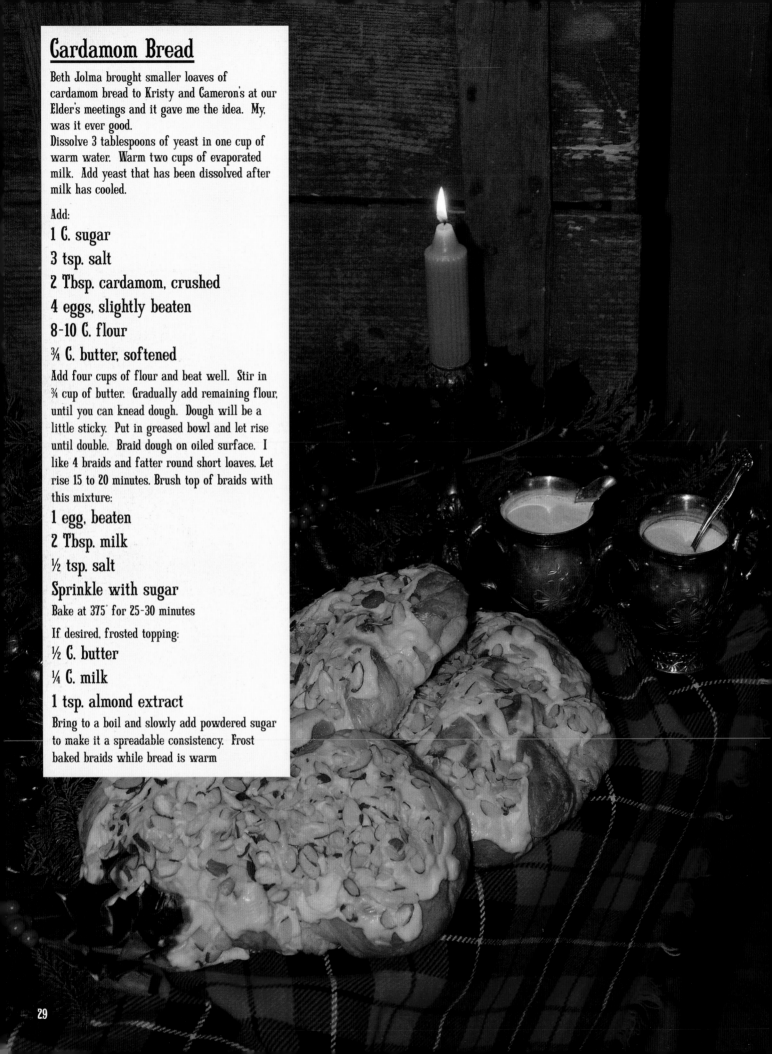

Cardamom Bread

Beth Jolma brought smaller loaves of cardamom bread to Kristy and Cameron's at our Elder's meetings and it gave me the idea. My, was it ever good.

Dissolve 3 tablespoons of yeast in one cup of warm water. Warm two cups of evaporated milk. Add yeast that has been dissolved after milk has cooled.

Add:

1 C. sugar

3 tsp. salt

2 Tbsp. cardamom, crushed

4 eggs, slightly beaten

8-10 C. flour

¾ C. butter, softened

Add four cups of flour and beat well. Stir in ¾ cup of butter. Gradually add remaining flour, until you can knead dough. Dough will be a little sticky. Put in greased bowl and let rise until double. Braid dough on oiled surface. I like 4 braids and fatter round short loaves. Let rise 15 to 20 minutes. Brush top of braids with this mixture:

1 egg, beaten

2 Tbsp. milk

½ tsp. salt

Sprinkle with sugar

Bake at 375° for 25-30 minutes

If desired, frosted topping:

½ C. butter

¼ C. milk

1 tsp. almond extract

Bring to a boil and slowly add powdered sugar to make it a spreadable consistency. Frost baked braids while bread is warm

MAIN DISHES

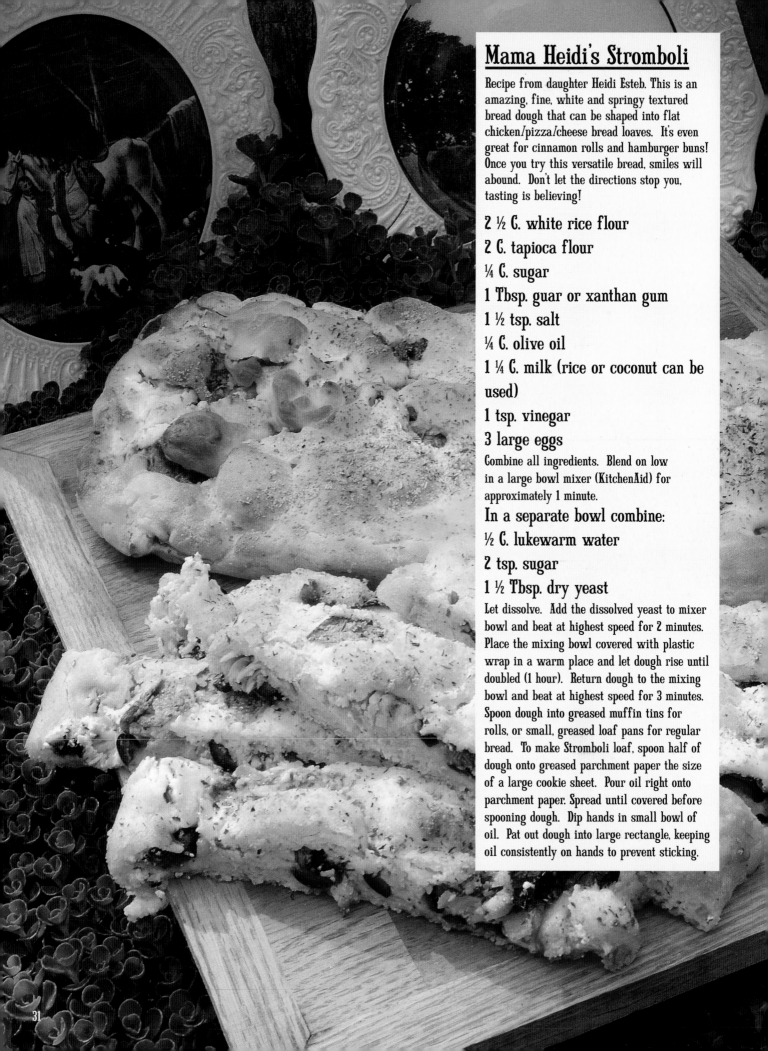

Mama Heidi's Stromboli

Recipe from daughter Heidi Esteb. This is an amazing, fine, white and springy textured bread dough that can be shaped into flat chicken/pizza/cheese bread loaves. It's even great for cinnamon rolls and hamburger buns! Once you try this versatile bread, smiles will abound. Don't let the directions stop you, tasting is believing!

2 ½ C. white rice flour

2 C. tapioca flour

¼ C. sugar

1 Tbsp. guar or xanthan gum

1 ½ tsp. salt

¼ C. olive oil

1 ¼ C. milk (rice or coconut can be used)

1 tsp. vinegar

3 large eggs

Combine all ingredients. Blend on low in a large bowl mixer (KitchenAid) for approximately 1 minute.

In a separate bowl combine:

½ C. lukewarm water

2 tsp. sugar

1 ½ Tbsp. dry yeast

Let dissolve. Add the dissolved yeast to mixer bowl and beat at highest speed for 2 minutes. Place the mixing bowl covered with plastic wrap in a warm place and let dough rise until doubled (1 hour). Return dough to the mixing bowl and beat at highest speed for 3 minutes. Spoon dough into greased muffin tins for rolls, or small, greased loaf pans for regular bread. To make Stromboli loaf, spoon half of dough onto greased parchment paper the size of a large cookie sheet. Pour oil right onto parchment paper. Spread until covered before spooning dough. Dip hands in small bowl of oil. Pat out dough into large rectangle, keeping oil consistently on hands to prevent sticking.

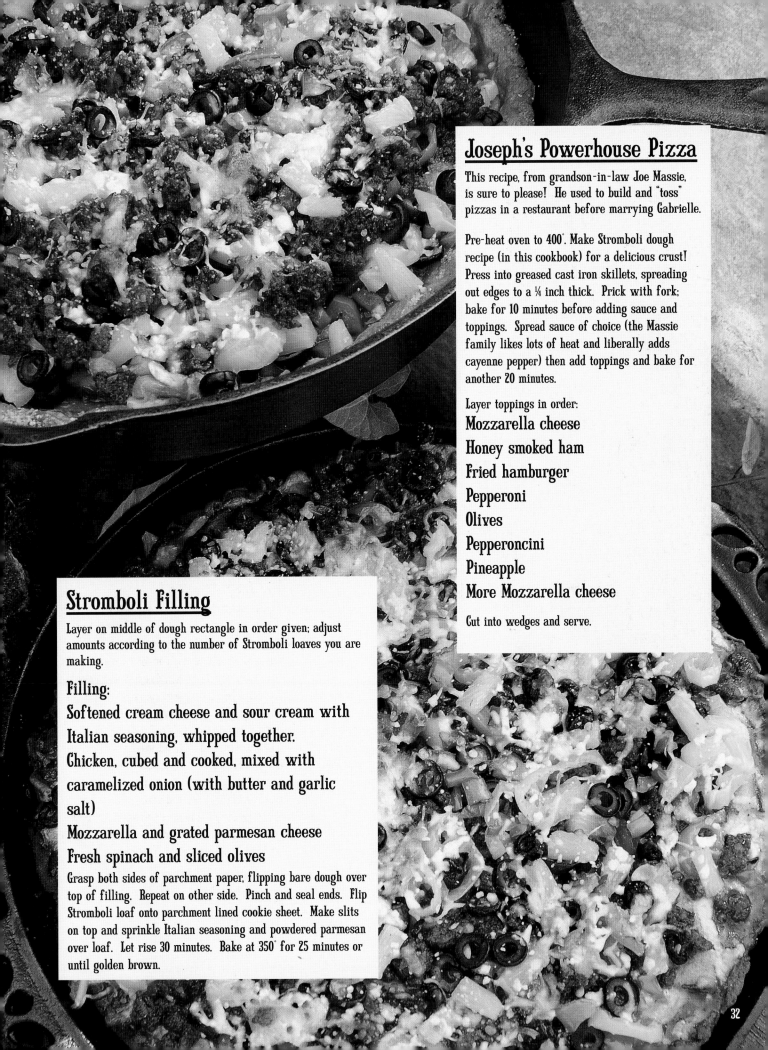

Joseph's Powerhouse Pizza

This recipe, from grandson-in-law Joe Massie, is sure to please! He used to build and "toss" pizzas in a restaurant before marrying Gabrielle.

Pre-heat oven to 400°. Make Stromboli dough recipe (in this cookbook) for a delicious crust! Press into greased cast iron skillets, spreading out edges to a ¼ inch thick. Prick with fork; bake for 10 minutes before adding sauce and toppings. Spread sauce of choice (the Massie family likes lots of heat and liberally adds cayenne pepper) then add toppings and bake for another 20 minutes.

Layer toppings in order:

Mozzarella cheese

Honey smoked ham

Fried hamburger

Pepperoni

Olives

Pepperoncini

Pineapple

More Mozzarella cheese

Cut into wedges and serve.

Stromboli Filling

Layer on middle of dough rectangle in order given; adjust amounts according to the number of Stromboli loaves you are making.

Filling:

Softened cream cheese and sour cream with Italian seasoning, whipped together.

Chicken, cubed and cooked, mixed with caramelized onion (with butter and garlic salt)

Mozzarella and grated parmesan cheese

Fresh spinach and sliced olives

Grasp both sides of parchment paper, flipping bare dough over top of filling. Repeat on other side. Pinch and seal ends. Flip Stromboli loaf onto parchment lined cookie sheet. Make slits on top and sprinkle Italian seasoning and powdered parmesan over loaf. Let rise 30 minutes. Bake at 350° for 25 minutes or until golden brown.

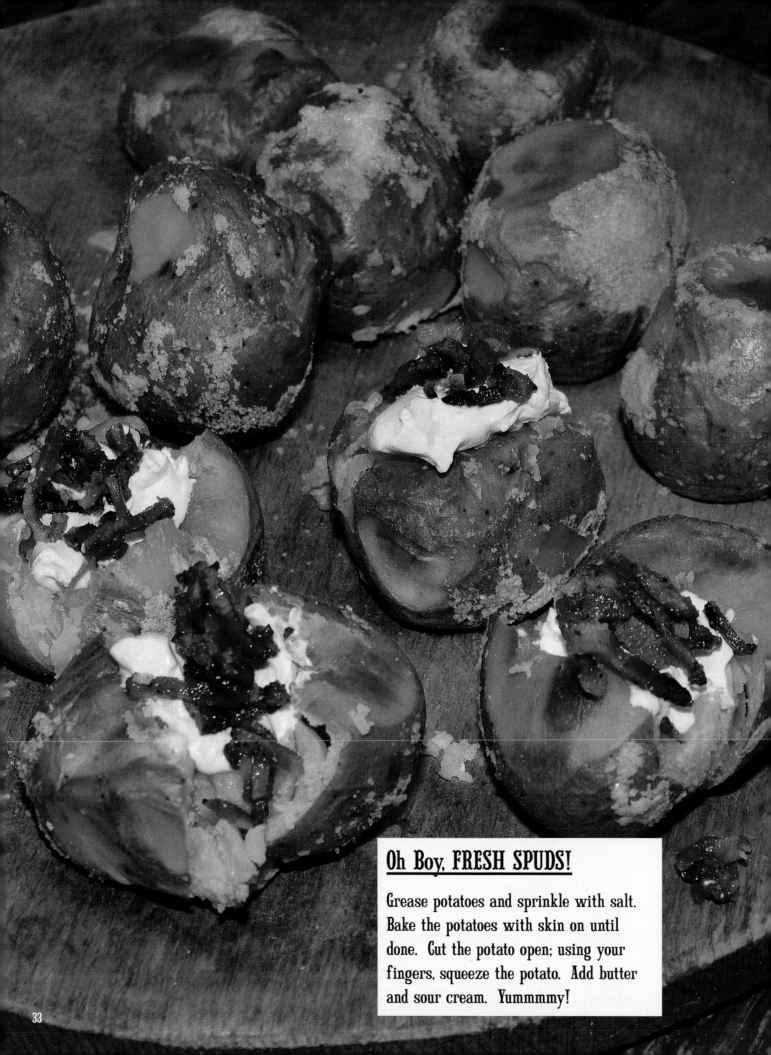

Oh Boy, FRESH SPUDS!

Grease potatoes and sprinkle with salt.
Bake the potatoes with skin on until
done. Cut the potato open; using your
fingers, squeeze the potato. Add butter
and sour cream. Yummmmy!

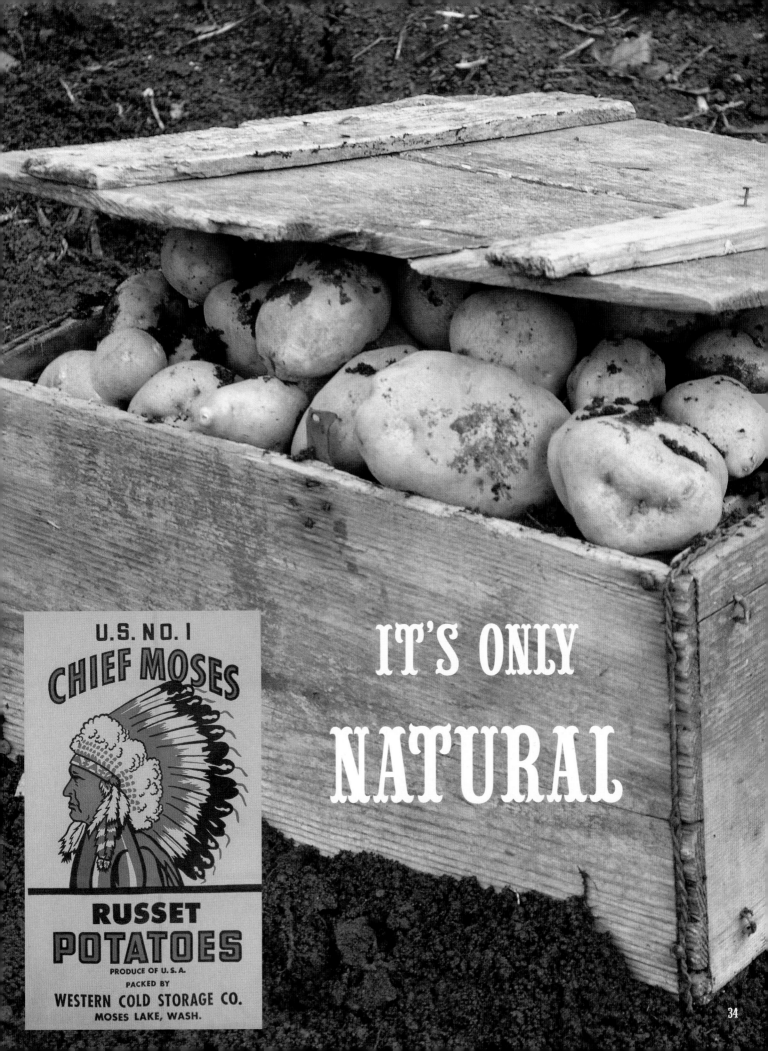

U.S. NO. I
CHIEF MOSES

RUSSET
POTATOES
PRODUCE OF U.S.A.
PACKED BY
WESTERN COLD STORAGE CO.
MOSES LAKE, WASH.

IT'S ONLY
NATURAL

HONEGGER

Layers

Sub Sandwich

Now, this is a winner! Everyone comments on this delicious bread AND what's inside. My sister Linda gave me this recipe; she got it from Sally Tapani. I roasted my meat and then sliced it when it was cool.

Dissolve:

2 Tbsp. yeast

2 C. warm water

2 Tbsp. sugar

Add to dissolved yeast and mix well:

2 Tbsp. oil

2 tsp. salt

6-6 ½ C. flour

Add enough flour to make a stiff dough. Knead about 3 minutes. Place dough in a greased bowl. Grease top of dough and cover. Let rise until double. Punch down and shape into a long loaf and place onto a large greased baking pan. I made a loaf about 16 inches long; next time I plan to make it a little bit longer. Let rise for about a half hour. Bake for 35-40 minutes at 375°; cool. Cut length ways all the way and fill with meat, cheese, tomatoes, lettuce and mayonnaise. You can add mustard or whatever you like!

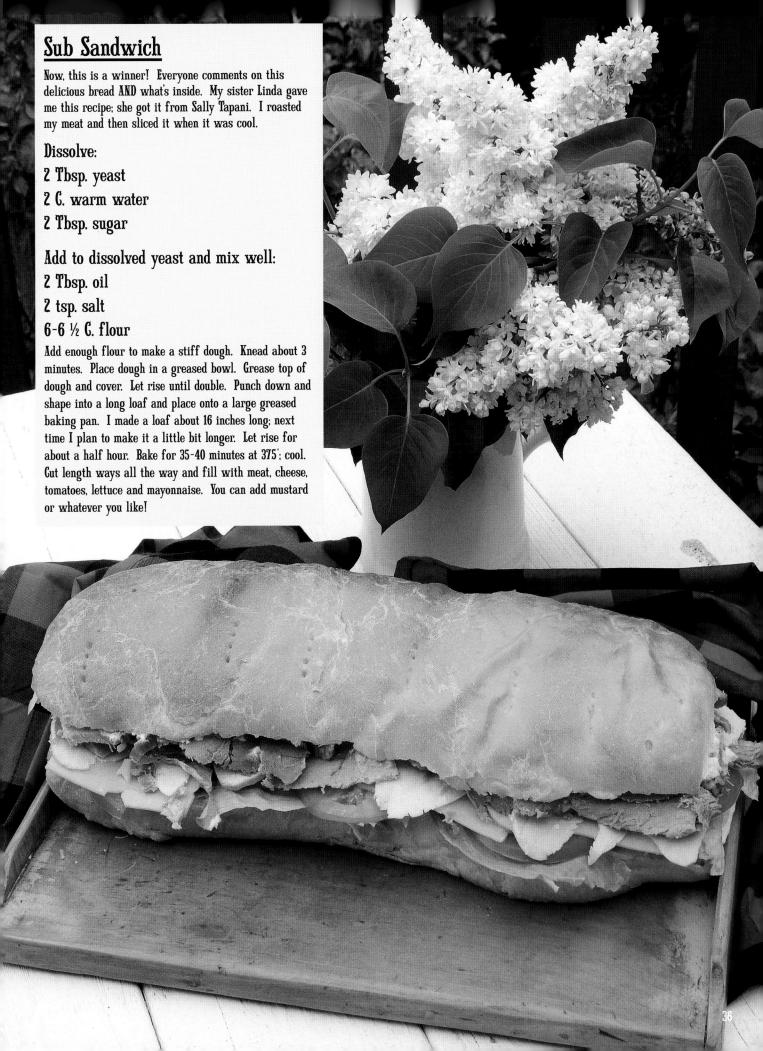

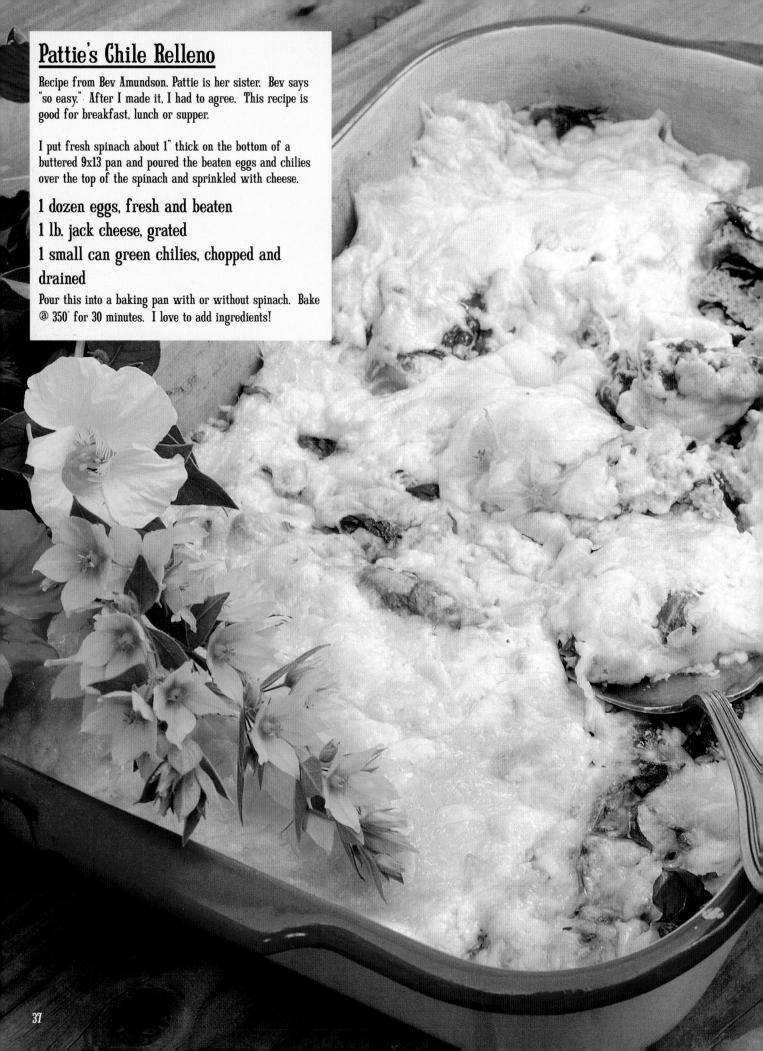

Pattie's Chile Relleno

Recipe from Bev Amundson. Pattie is her sister. Bev says "so easy." After I made it, I had to agree. This recipe is good for breakfast, lunch or supper.

I put fresh spinach about 1" thick on the bottom of a buttered 9x13 pan and poured the beaten eggs and chilies over the top of the spinach and sprinkled with cheese.

1 dozen eggs, fresh and beaten

1 lb. jack cheese, grated

1 small can green chilies, chopped and drained

Pour this into a baking pan with or without spinach. Bake @ 350° for 30 minutes. I love to add ingredients!

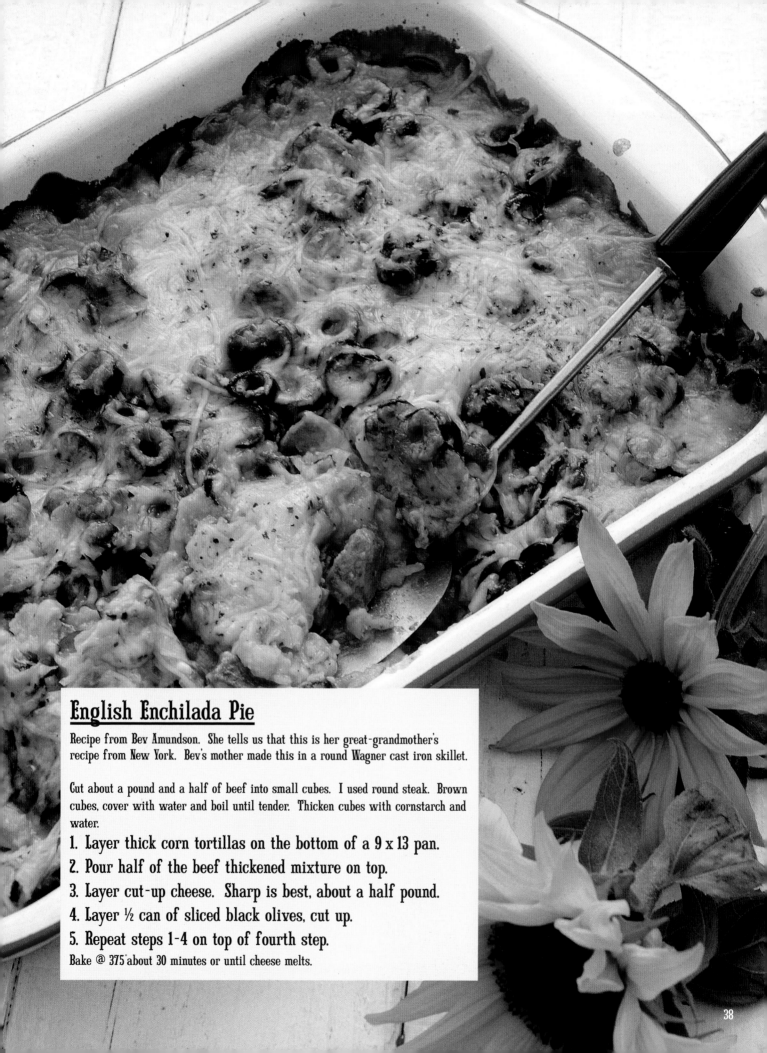

English Enchilada Pie

Recipe from Bev Amundson. She tells us that this is her great-grandmother's recipe from New York. Bev's mother made this in a round Wagner cast iron skillet.

Cut about a pound and a half of beef into small cubes. I used round steak. Brown cubes, cover with water and boil until tender. Thicken cubes with cornstarch and water.

1. Layer thick corn tortillas on the bottom of a 9 x 13 pan.
2. Pour half of the beef thickened mixture on top.
3. Layer cut-up cheese. Sharp is best, about a half pound.
4. Layer ½ can of sliced black olives, cut up.
5. Repeat steps 1-4 on top of fourth step.

Bake @ 375° about 30 minutes or until cheese melts.

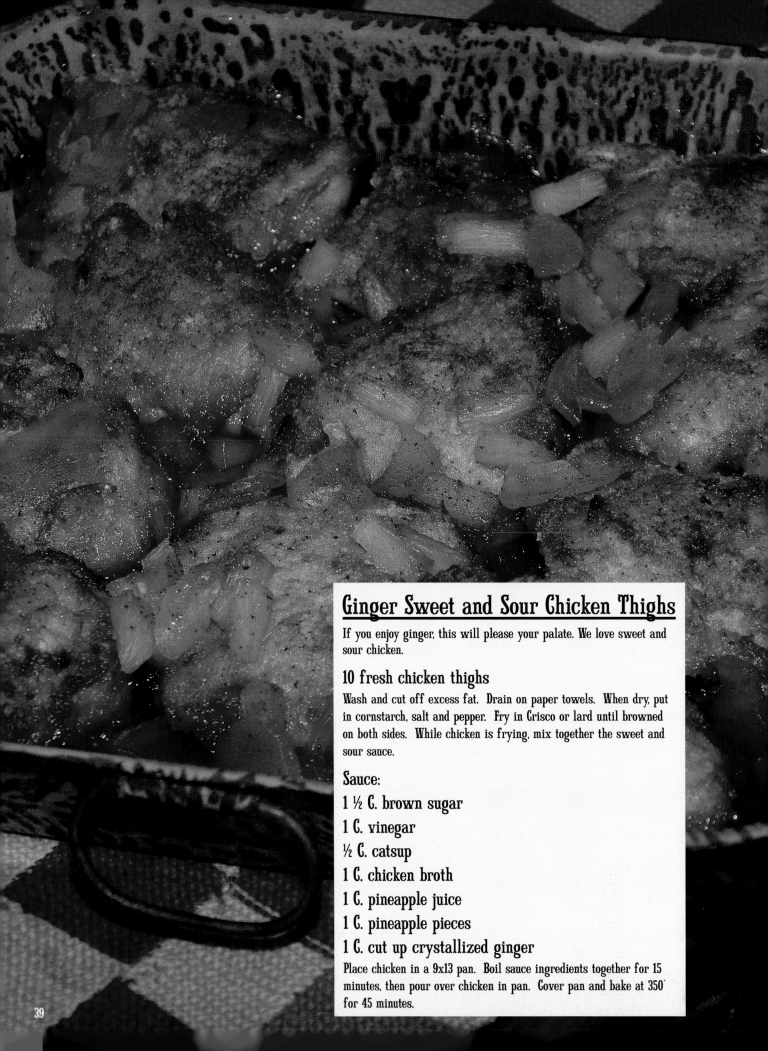

Ginger Sweet and Sour Chicken Thighs

If you enjoy ginger, this will please your palate. We love sweet and sour chicken.

10 fresh chicken thighs

Wash and cut off excess fat. Drain on paper towels. When dry, put in cornstarch, salt and pepper. Fry in Crisco or lard until browned on both sides. While chicken is frying, mix together the sweet and sour sauce.

Sauce:

1 ½ C. brown sugar

1 C. vinegar

½ C. catsup

1 C. chicken broth

1 C. pineapple juice

1 C. pineapple pieces

1 C. cut up crystallized ginger

Place chicken in a 9x13 pan. Boil sauce ingredients together for 15 minutes, then pour over chicken in pan. Cover pan and bake at 350˚ for 45 minutes.

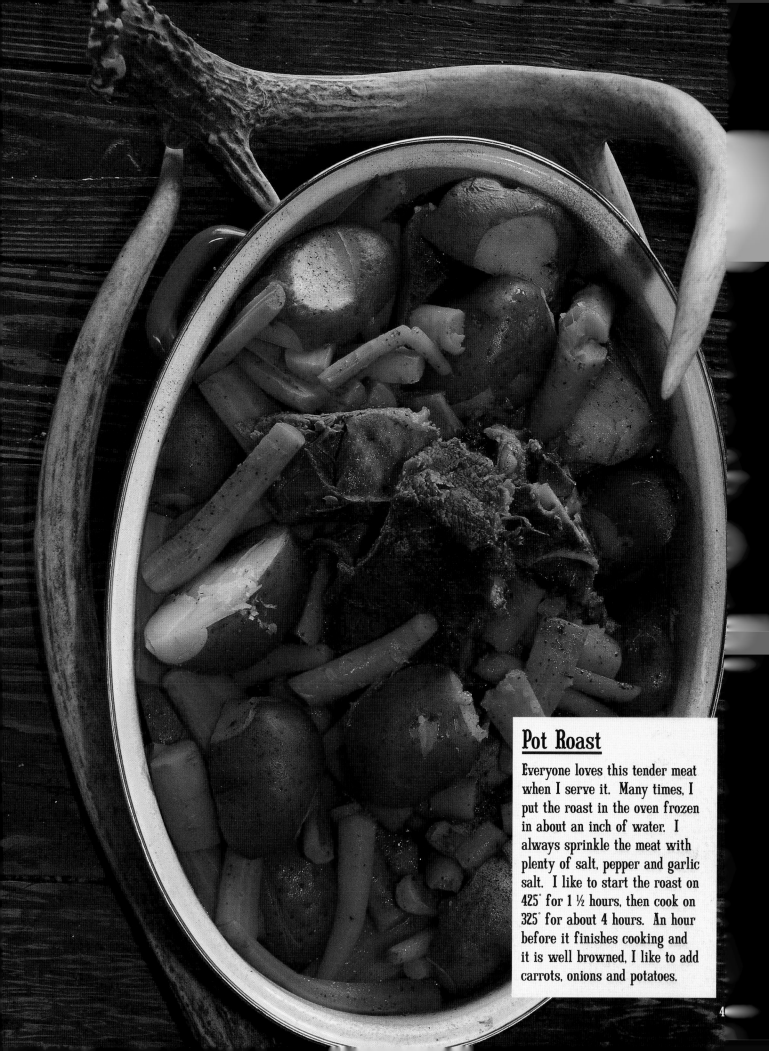

Pot Roast

Everyone loves this tender meat
when I serve it. Many times, I
put the roast in the oven frozen
in about an inch of water. I
always sprinkle the meat with
plenty of salt, pepper and garlic
salt. I like to start the roast on
425˚ for 1 ½ hours, then cook on
325˚ for about 4 hours. An hour
before it finishes cooking and
it is well browned, I like to add
carrots, onions and potatoes.

47

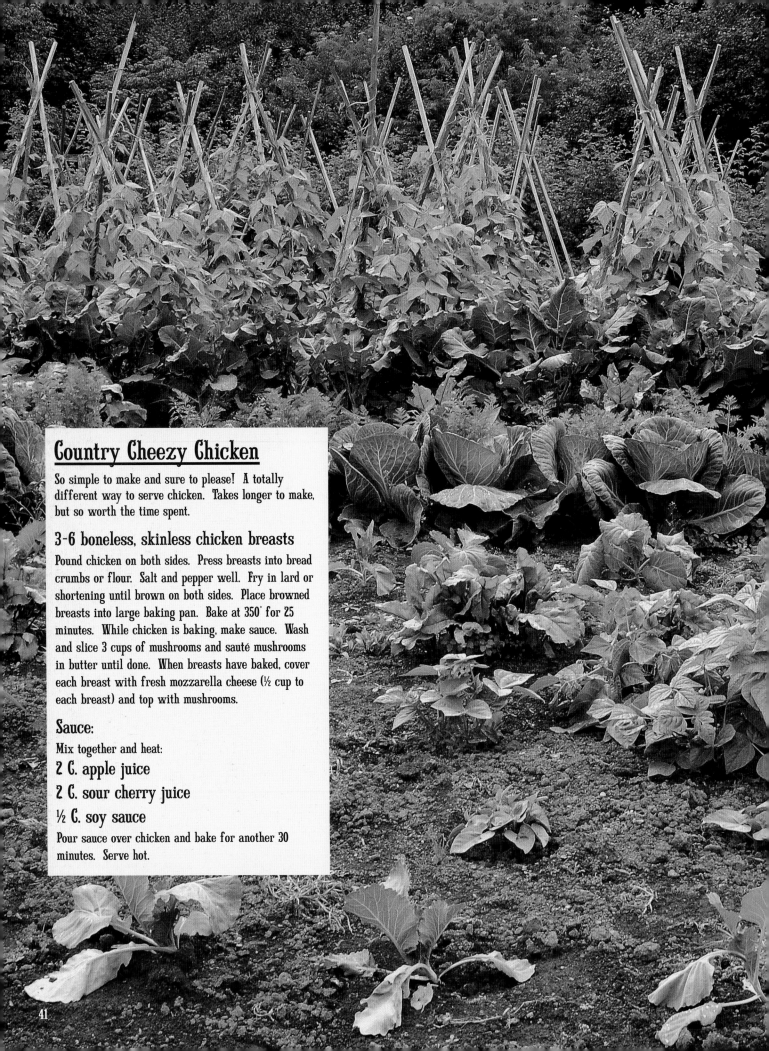

Country Cheezy Chicken

So simple to make and sure to please! A totally different way to serve chicken. Takes longer to make, but so worth the time spent.

3-6 boneless, skinless chicken breasts

Pound chicken on both sides. Press breasts into bread crumbs or flour. Salt and pepper well. Fry in lard or shortening until brown on both sides. Place browned breasts into large baking pan. Bake at 350° for 25 minutes. While chicken is baking, make sauce. Wash and slice 3 cups of mushrooms and sauté mushrooms in butter until done. When breasts have baked, cover each breast with fresh mozzarella cheese (½ cup to each breast) and top with mushrooms.

Sauce:

Mix together and heat:

2 C. apple juice

2 C. sour cherry juice

½ C. soy sauce

Pour sauce over chicken and bake for another 30 minutes. Serve hot.

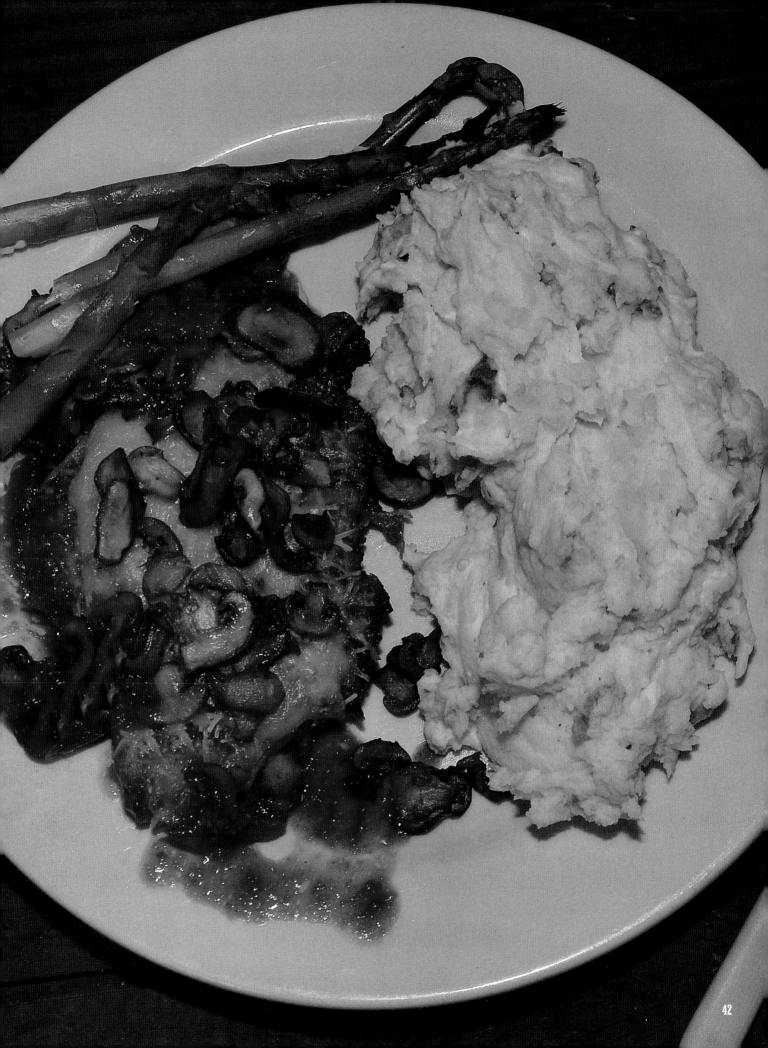

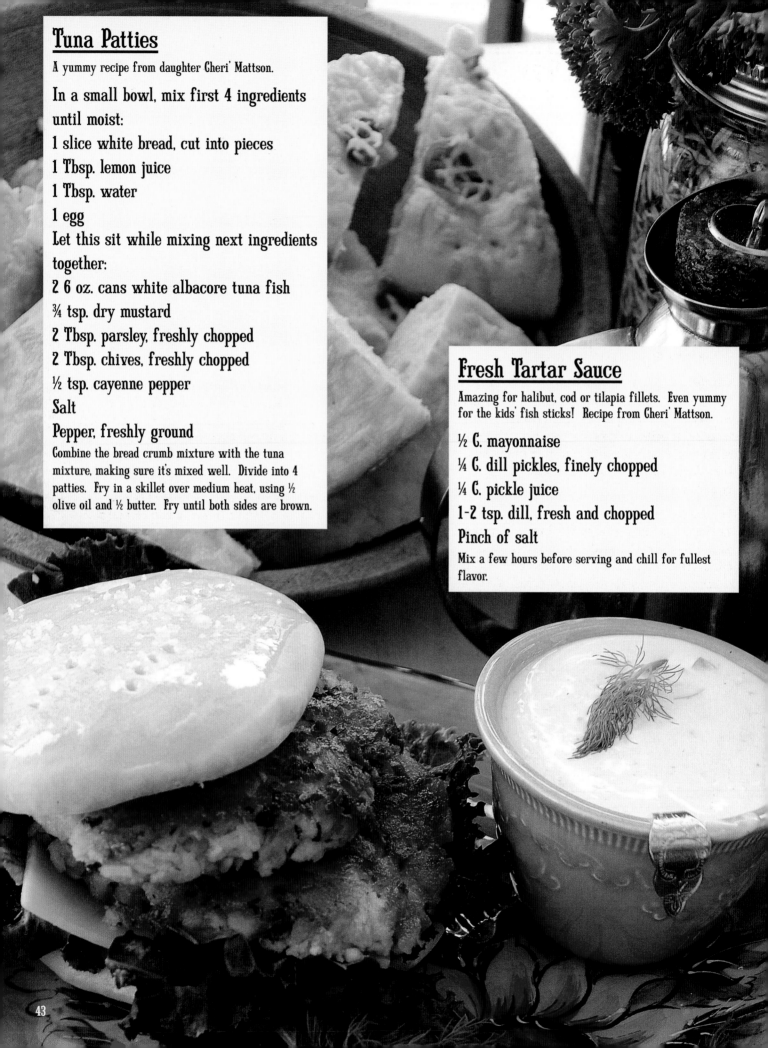

Tuna Patties

A yummy recipe from daughter Cheri' Mattson.

In a small bowl, mix first 4 ingredients until moist:

1 slice white bread, cut into pieces

1 Tbsp. lemon juice

1 Tbsp. water

1 egg

Let this sit while mixing next ingredients together:

2 6 oz. cans white albacore tuna fish

¾ tsp. dry mustard

2 Tbsp. parsley, freshly chopped

2 Tbsp. chives, freshly chopped

½ tsp. cayenne pepper

Salt

Pepper, freshly ground

Combine the bread crumb mixture with the tuna mixture, making sure it's mixed well. Divide into 4 patties. Fry in a skillet over medium heat, using ½ olive oil and ½ butter. Fry until both sides are brown.

Fresh Tartar Sauce

Amazing for halibut, cod or tilapia fillets. Even yummy for the kids' fish sticks! Recipe from Cheri' Mattson.

½ C. mayonnaise

¼ C. dill pickles, finely chopped

¼ C. pickle juice

1-2 tsp. dill, fresh and chopped

Pinch of salt

Mix a few hours before serving and chill for fullest flavor.

Amazing Dough for Hamburger Buns, Focaccia and Pizza Crust

Can't beat this dough recipe from daughter, Cheri' Mattson. So versatile!

7-8 C. flour (can use ½ bread flour)

2 Tbsp. yeast

2 C. water

½ C. olive oil

½ C. sugar

1 Tbsp. salt

2-3 Tbsp. rosemary, fresh and chopped (you may use other fresh herbs such as rosemary, thyme or oregano but do not use dried)

½ tsp. cayenne pepper for a mild zing

2 eggs

Mix the yeast, water and sugar in a small bowl. In a large bowl, stir together all dry ingredients. Add yeast mixture, oil and eggs to the dry ingredients. When the dough has pulled together, pour out on floured surface, and knead until smooth. Place in a greased bowl. Cover and let rise for 20-30 minutes.
Preheat oven to 400°

For Focaccia:
Pat into a ½ inch thick round (doesn't have to be perfect) shape. Make indentations with wooden spoon or your knuckle about 1" apart. Bake for 15 minutes or until golden brown. Makes 4 rounds or two large rectangles. Top with your choice of goodies before baking. Pictured: sundried tomatoes and feta cheese, cheddar cheese and jalapenos.

For Buns:
Roll out dough to ½" thick. Cut with large round cookie cutter (like biscuits). Prick with fork. Bake for 15 minutes or until golden brown. Brush with olive oil and sea salt.

For Pizza:
Press into greased pans by hand, spreading out edges to ¼" thick. Prick with a fork. Bake for 10 minutes before adding pizza toppings and then bake 10-15 minutes more until done.

Pesto - Made Fresh!

For all the pesto lovers, here's a good one! Recipe from daughter Cheri'.

2 C. basil leaves only, packed

½ C. cilantro (optional)

2 Tbsp. elephant garlic (or 2 regular cloves)

¼ C. pine nuts

½ C. Parmesan cheese (loosely packed)

½ tsp. sea salt

⅔ C. olive oil

Mix greens and garlic a bit at a time until they're chopped up pretty fine. Add pine nuts, cheese and sea salt. Pour olive oil slowly into the mixture until pesto is smooth and spreadable. This can be done by hand or blender/processor. Lasts for 3 weeks in refrigerator.

Uses:
Wonderful for a topping on crackers, bread or bagels.
Add pesto and heavy whipping cream to warm, cooked pasta.
Mix pesto and equal parts butter. Spread on fish for grilling.

44

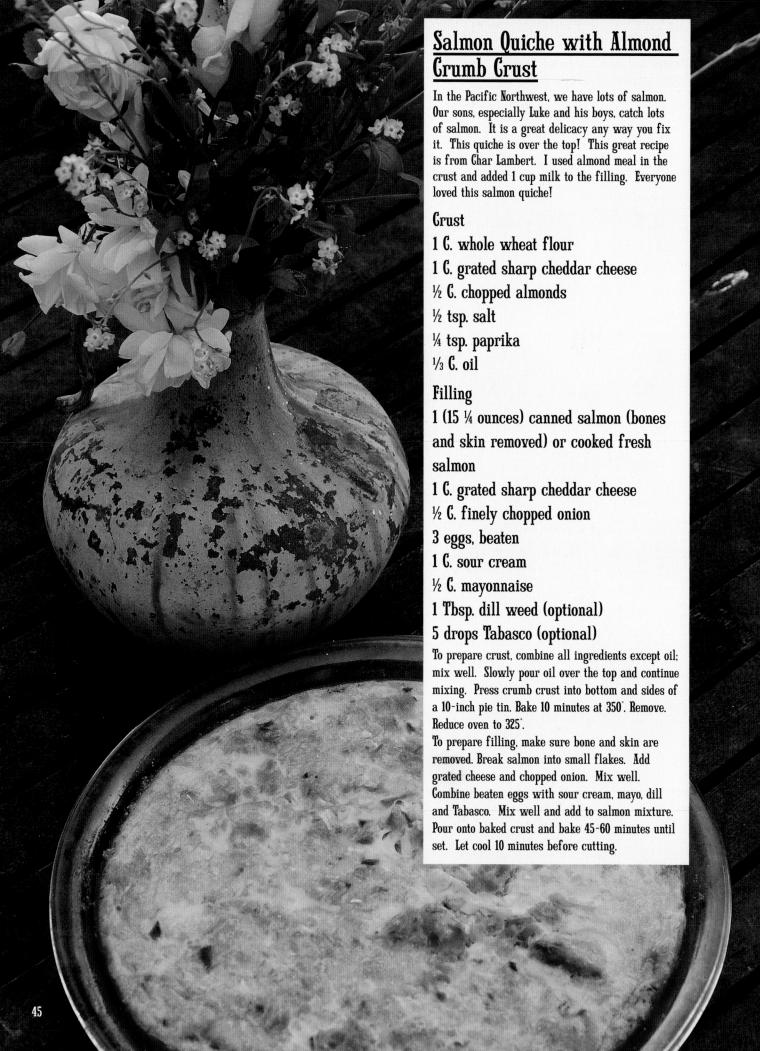

Salmon Quiche with Almond Crumb Crust

In the Pacific Northwest, we have lots of salmon. Our sons, especially Luke and his boys, catch lots of salmon. It is a great delicacy any way you fix it. This quiche is over the top! This great recipe is from Char Lambert. I used almond meal in the crust and added 1 cup milk to the filling. Everyone loved this salmon quiche!

Crust

1 C. whole wheat flour

1 C. grated sharp cheddar cheese

½ C. chopped almonds

½ tsp. salt

¼ tsp. paprika

⅓ C. oil

Filling

1 (15 ¼ ounces) canned salmon (bones and skin removed) or cooked fresh salmon

1 C. grated sharp cheddar cheese

½ C. finely chopped onion

3 eggs, beaten

1 C. sour cream

½ C. mayonnaise

1 Tbsp. dill weed (optional)

5 drops Tabasco (optional)

To prepare crust, combine all ingredients except oil; mix well. Slowly pour oil over the top and continue mixing. Press crumb crust into bottom and sides of a 10-inch pie tin. Bake 10 minutes at 350˚. Remove. Reduce oven to 325˚.

To prepare filling, make sure bone and skin are removed. Break salmon into small flakes. Add grated cheese and chopped onion. Mix well. Combine beaten eggs with sour cream, mayo, dill and Tabasco. Mix well and add to salmon mixture. Pour onto baked crust and bake 45-60 minutes until set. Let cool 10 minutes before cutting.

Baked Timeless Salmon Patties

This recipe is from Bev Amundson. I added the lemon sauce.

Mix together:

2 eggs, beaten

2 C. bread crumbs

2 C. cooked salmon

½ C. onion, minced

¾ C. milk

½ tsp. salt

¼ tsp. pepper

Fill 8-12 compartments of a greased muffin tin (depends on size of muffin tin) with ½ cup of salmon mixture. Bake 30-44 minutes in preheated 350° oven or until golden brown. Very good with a lemon sauce on top of patties.

Lemon sauce:

Melt 2 tablespoons of butter over medium heat. When melted add ¾ cup of milk, ¼ teaspoon salt, ¼ teaspoon of pepper, ¼ cup sugar and 2 tablespoons of lemon juice. Bring to a boil and add 3 tablespoons of cornstarch that has been dissolved in a little water. Boil and remove from heat. Spoon 2-4 tablespoons on top of hot salmon patties and serve.

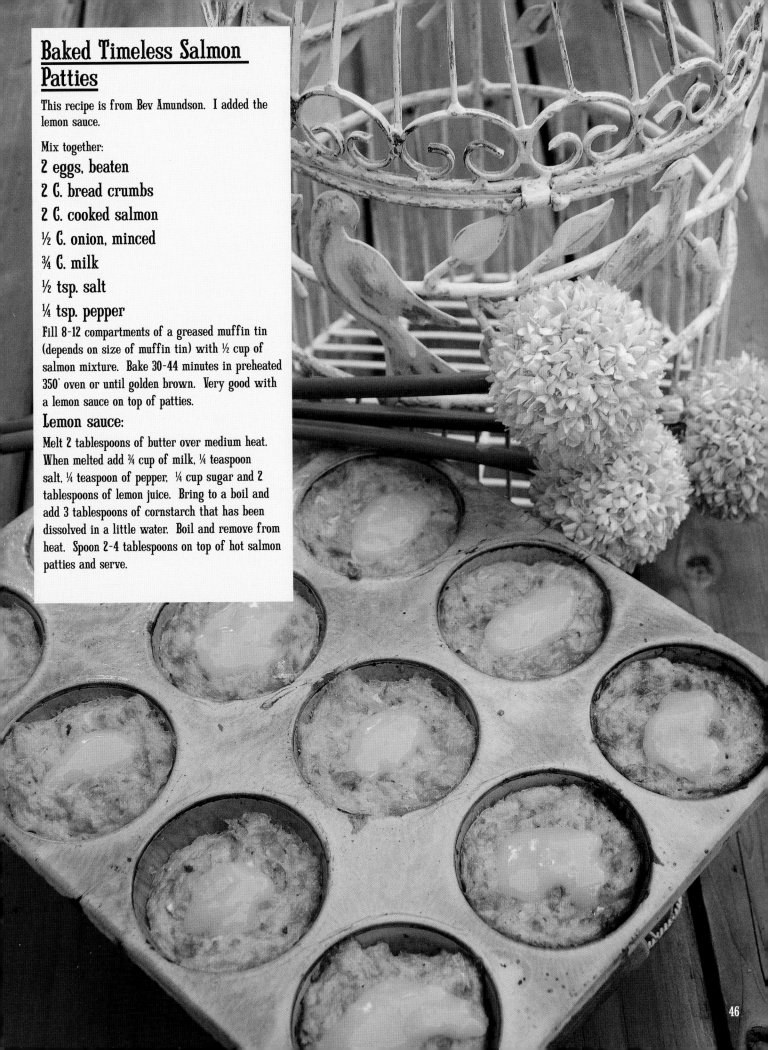

Chicken Pot Pie

This delightful mainstay can be baked in individual small ramekins or a large pan. I buy a cooked chicken. Remember mixture thickens as it cooks.

1 whole chicken, cut into pieces

4 medium potatoes, cut up

1 medium sweet potato, cut up

4 large carrots, cut up

8 oz. fresh mushrooms, sliced

1 pkg. frozen peas

Cook chicken and when cooled, cut up into pieces. Cook the rest of the ingredients with chicken until tender, adding peas in last. Pour sauce over chicken and vegetables. Set aside.

Sauce

1 C. milk

1 can evaporated milk

1 ½ C. half and half

½ medium onion, minced

2 Tbsp. butter

3-4 Tbsp. cornstarch

1 tsp. salt

½ tsp. pepper

Melt butter over low heat, blending in cornstarch and seasonings. Add milk mixture to the sauce. Cook over medium heat until mixture thickens. Add sauce to vegetables and chicken. Pour into desired pan or ramekin. Cover with crust.

Crust

3 C. flour

1 tsp. salt

1 ⅓ C. shortening

Blend with pastry blender and add ice water to hold dough together. Roll out for each receptacle or place large crust over 9x13 pan.

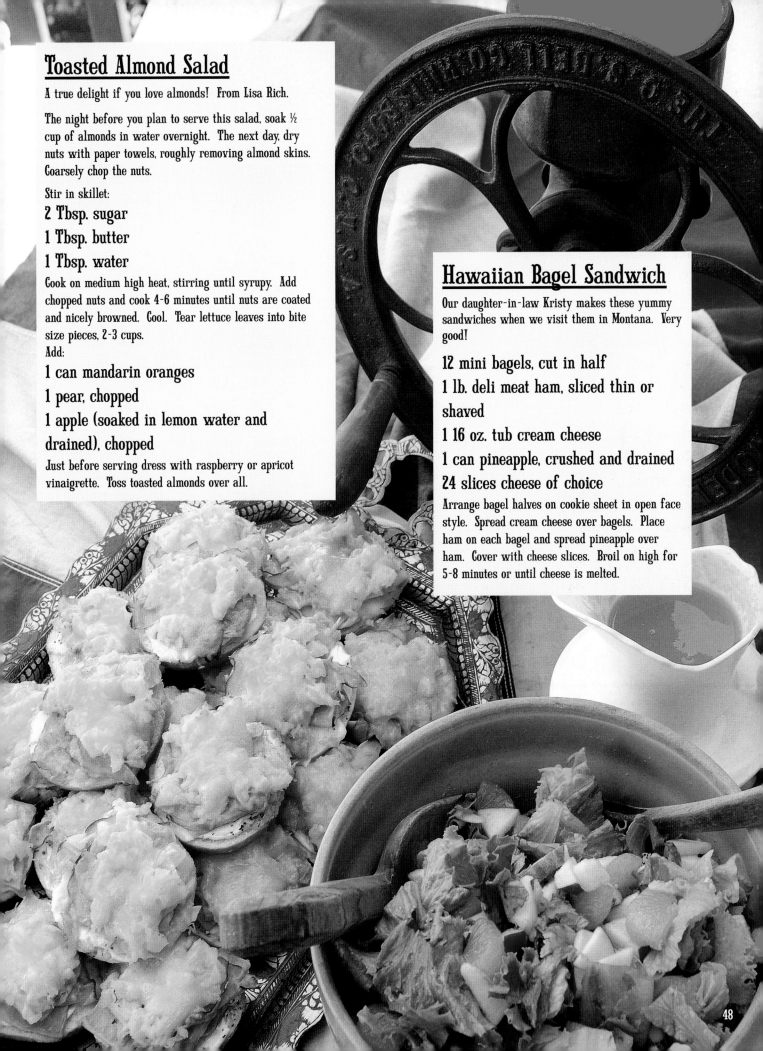

Toasted Almond Salad

A true delight if you love almonds! From Lisa Rich.

The night before you plan to serve this salad, soak ½ cup of almonds in water overnight. The next day, dry nuts with paper towels, roughly removing almond skins. Coarsely chop the nuts.

Stir in skillet:

2 Tbsp. sugar

1 Tbsp. butter

1 Tbsp. water

Cook on medium high heat, stirring until syrupy. Add chopped nuts and cook 4-6 minutes until nuts are coated and nicely browned. Cool. Tear lettuce leaves into bite size pieces, 2-3 cups.

Add:

1 can mandarin oranges

1 pear, chopped

1 apple (soaked in lemon water and drained), chopped

Just before serving dress with raspberry or apricot vinaigrette. Toss toasted almonds over all.

Hawaiian Bagel Sandwich

Our daughter-in-law Kristy makes these yummy sandwiches when we visit them in Montana. Very good!

12 mini bagels, cut in half

1 lb. deli meat ham, sliced thin or shaved

1 16 oz. tub cream cheese

1 can pineapple, crushed and drained

24 slices cheese of choice

Arrange bagel halves on cookie sheet in open face style. Spread cream cheese over bagels. Place ham on each bagel and spread pineapple over ham. Cover with cheese slices. Broil on high for 5-8 minutes or until cheese is melted.

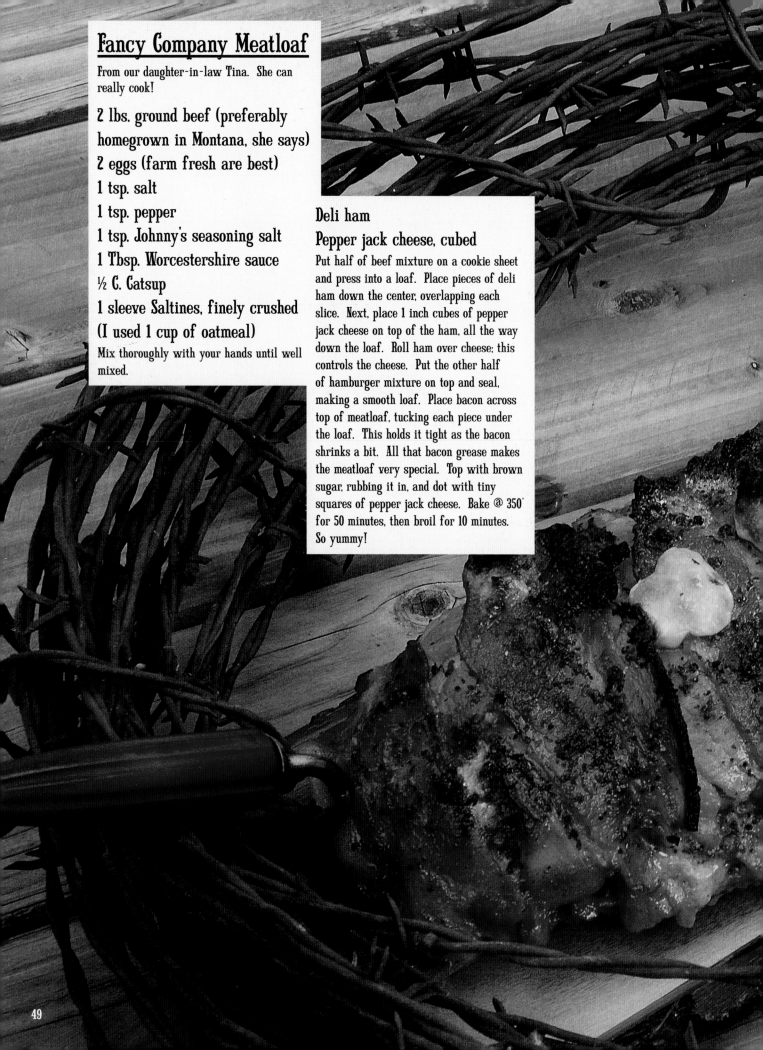

Fancy Company Meatloaf

From our daughter-in-law Tina. She can really cook!

2 lbs. ground beef (preferably homegrown in Montana, she says)
2 eggs (farm fresh are best)
1 tsp. salt
1 tsp. pepper
1 tsp. Johnny's seasoning salt
1 Tbsp. Worcestershire sauce
½ C. Catsup
1 sleeve Saltines, finely crushed (I used 1 cup of oatmeal)

Mix thoroughly with your hands until well mixed.

Deli ham
Pepper jack cheese, cubed

Put half of beef mixture on a cookie sheet and press into a loaf. Place pieces of deli ham down the center, overlapping each slice. Next, place 1 inch cubes of pepper jack cheese on top of the ham, all the way down the loaf. Roll ham over cheese; this controls the cheese. Put the other half of hamburger mixture on top and seal, making a smooth loaf. Place bacon across top of meatloaf, tucking each piece under the loaf. This holds it tight as the bacon shrinks a bit. All that bacon grease makes the meatloaf very special. Top with brown sugar, rubbing it in, and dot with tiny squares of pepper jack cheese. Bake @ 350˚ for 50 minutes, then broil for 10 minutes. So yummy!

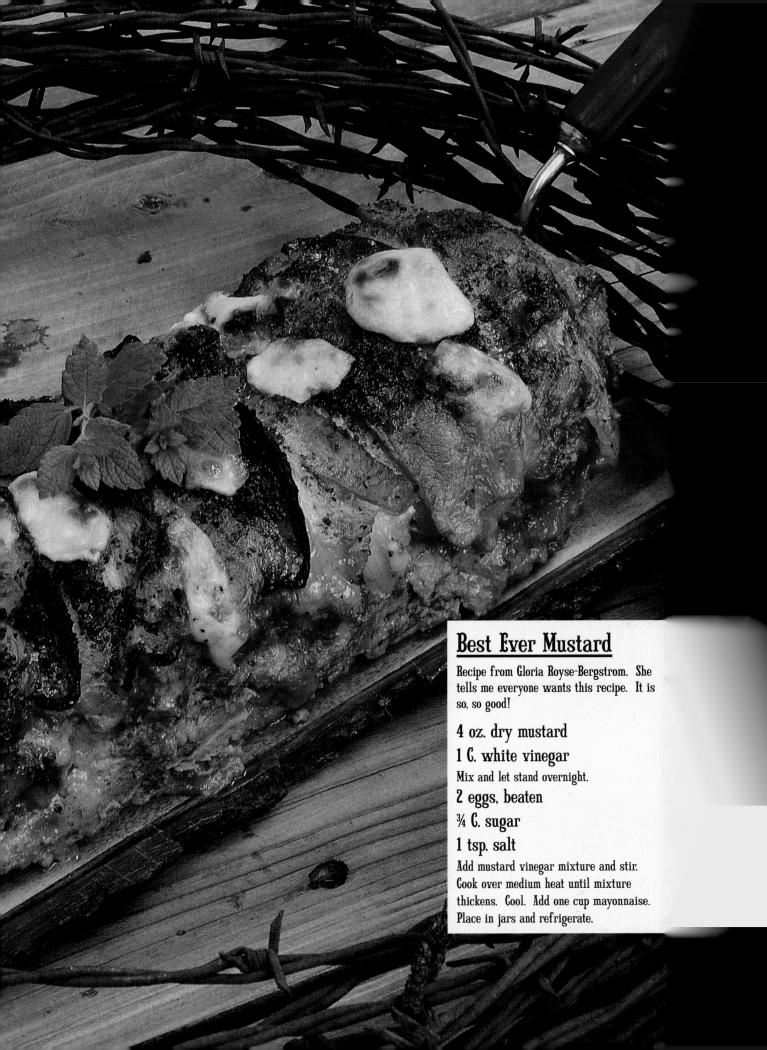

Best Ever Mustard

Recipe from Gloria Royse-Bergstrom. She tells me everyone wants this recipe. It is so, so good!

4 oz. dry mustard

1 C. white vinegar

Mix and let stand overnight.

2 eggs, beaten

¾ C. sugar

1 tsp. salt

Add mustard vinegar mixture and stir. Cook over medium heat until mixture thickens. Cool. Add one cup mayonnaise. Place in jars and refrigerate.

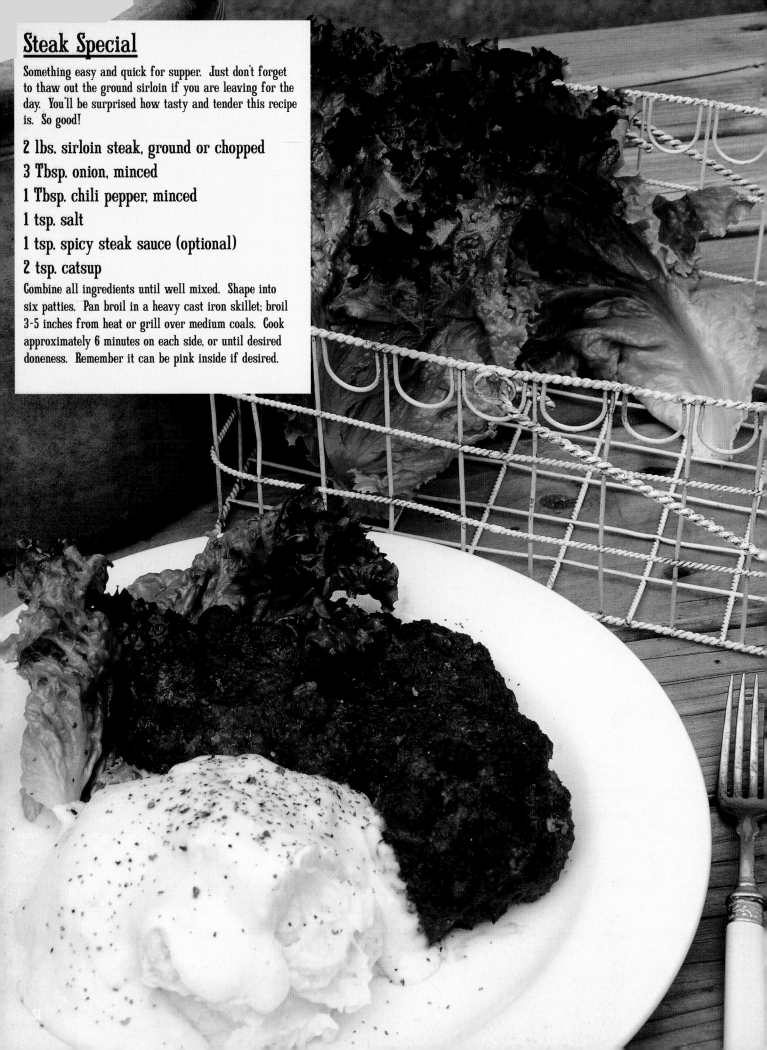

Steak Special

Something easy and quick for supper. Just don't forget to thaw out the ground sirloin if you are leaving for the day. You'll be surprised how tasty and tender this recipe is. So good!

2 lbs. sirloin steak, ground or chopped
3 Tbsp. onion, minced
1 Tbsp. chili pepper, minced
1 tsp. salt
1 tsp. spicy steak sauce (optional)
2 tsp. catsup

Combine all ingredients until well mixed. Shape into six patties. Pan broil in a heavy cast iron skillet; broil 3-5 inches from heat or grill over medium coals. Cook approximately 6 minutes on each side, or until desired doneness. Remember it can be pink inside if desired.

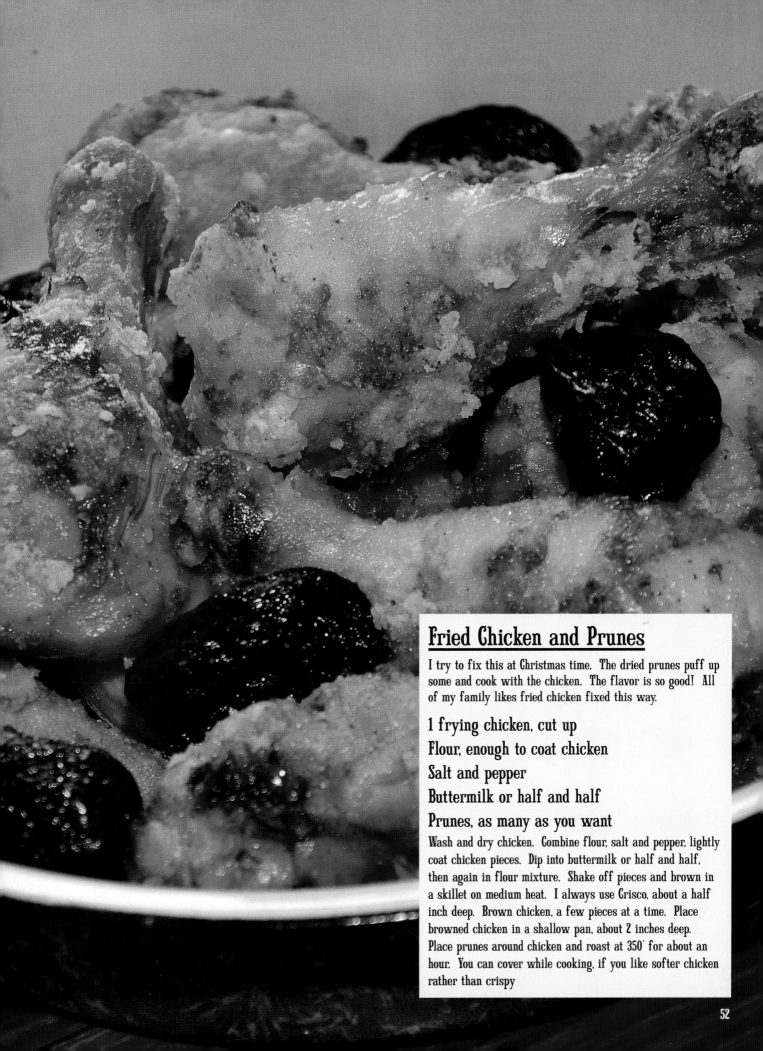

Fried Chicken and Prunes

I try to fix this at Christmas time. The dried prunes puff up some and cook with the chicken. The flavor is so good! All of my family likes fried chicken fixed this way.

1 frying chicken, cut up
Flour, enough to coat chicken
Salt and pepper
Buttermilk or half and half
Prunes, as many as you want

Wash and dry chicken. Combine flour, salt and pepper, lightly coat chicken pieces. Dip into buttermilk or half and half, then again in flour mixture. Shake off pieces and brown in a skillet on medium heat. I always use Crisco, about a half inch deep. Brown chicken, a few pieces at a time. Place browned chicken in a shallow pan, about 2 inches deep. Place prunes around chicken and roast at 350˚ for about an hour. You can cover while cooking, if you like softer chicken rather than crispy

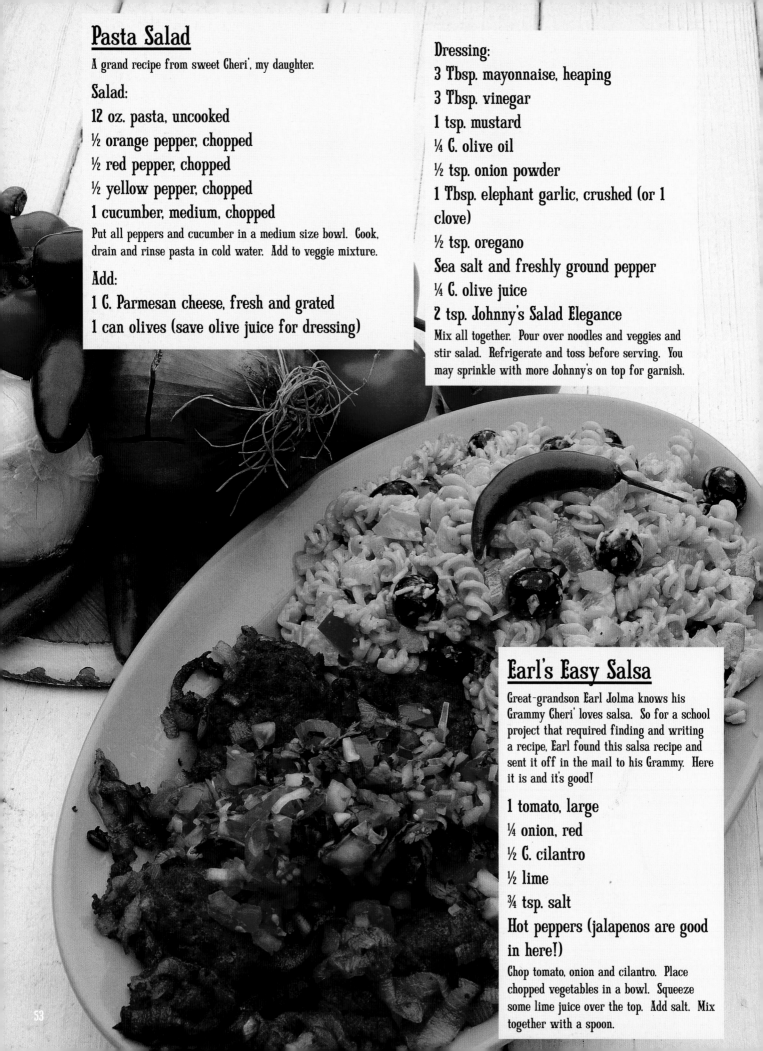

Pasta Salad

A grand recipe from sweet Cheri', my daughter.

Salad:

12 oz. pasta, uncooked

½ orange pepper, chopped

½ red pepper, chopped

½ yellow pepper, chopped

1 cucumber, medium, chopped

Put all peppers and cucumber in a medium size bowl. Cook, drain and rinse pasta in cold water. Add to veggie mixture.

Add:

1 C. Parmesan cheese, fresh and grated

1 can olives (save olive juice for dressing)

Dressing:

3 Tbsp. mayonnaise, heaping

3 Tbsp. vinegar

1 tsp. mustard

¼ C. olive oil

½ tsp. onion powder

1 Tbsp. elephant garlic, crushed (or 1 clove)

½ tsp. oregano

Sea salt and freshly ground pepper

¼ C. olive juice

2 tsp. Johnny's Salad Elegance

Mix all together. Pour over noodles and veggies and stir salad. Refrigerate and toss before serving. You may sprinkle with more Johnny's on top for garnish.

Earl's Easy Salsa

Great-grandson Earl Jolma knows his Grammy Cheri' loves salsa. So for a school project that required finding and writing a recipe, Earl found this salsa recipe and sent it off in the mail to his Grammy. Here it is and it's good!

1 tomato, large

¼ onion, red

½ C. cilantro

½ lime

¾ tsp. salt

Hot peppers (jalapenos are good in here!)

Chop tomato, onion and cilantro. Place chopped vegetables in a bowl. Squeeze some lime juice over the top. Add salt. Mix together with a spoon.

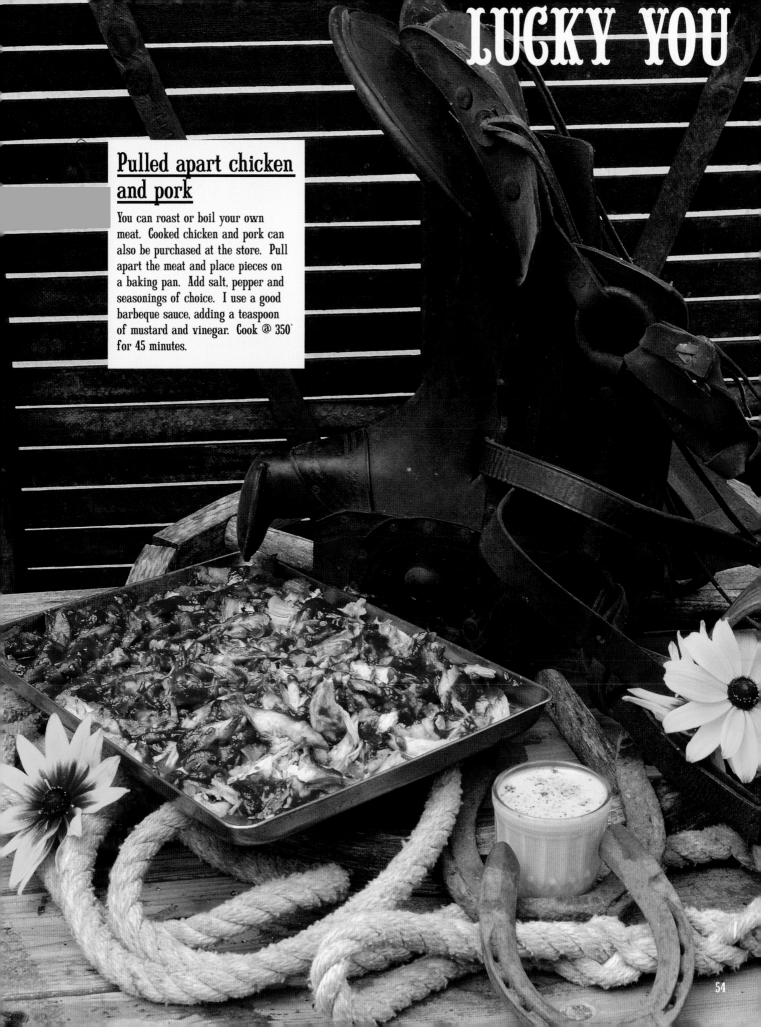

Pulled apart chicken and pork

You can roast or boil your own meat. Cooked chicken and pork can also be purchased at the store. Pull apart the meat and place pieces on a baking pan. Add salt, pepper and seasonings of choice. I use a good barbeque sauce, adding a teaspoon of mustard and vinegar. Cook @ 350° for 45 minutes.

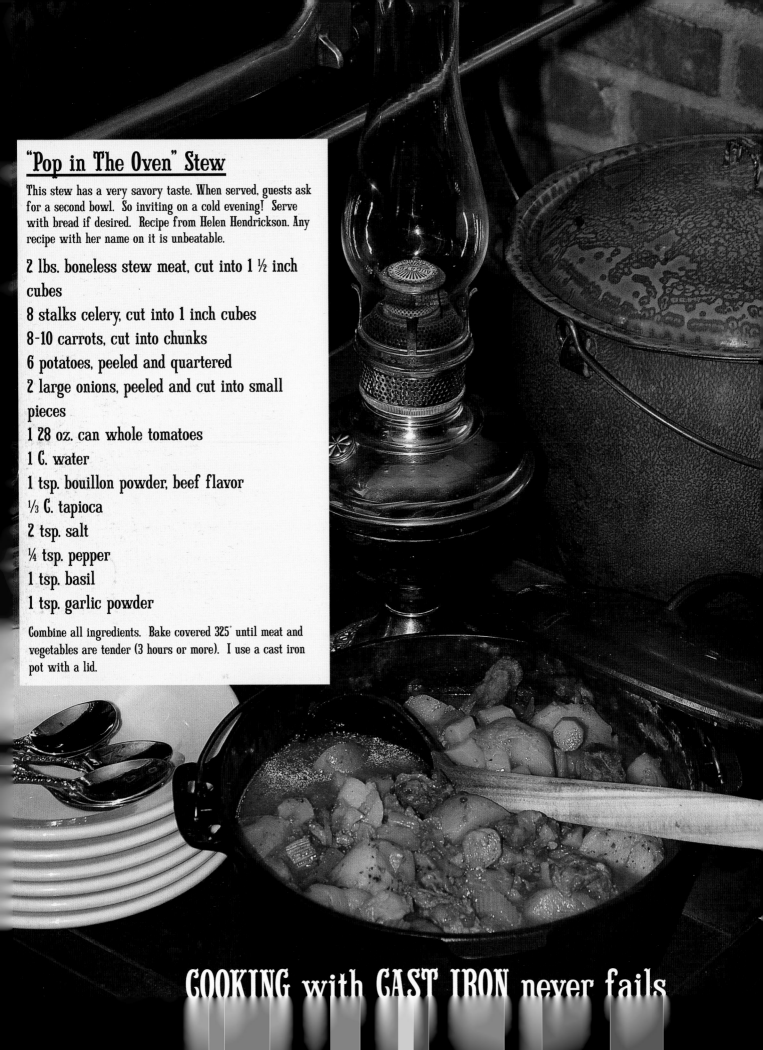

"Pop in The Oven" Stew

This stew has a very savory taste. When served, guests ask for a second bowl. So inviting on a cold evening! Serve with bread if desired. Recipe from Helen Hendrickson. Any recipe with her name on it is unbeatable.

2 lbs. boneless stew meat, cut into 1 ½ inch cubes

8 stalks celery, cut into 1 inch cubes

8-10 carrots, cut into chunks

6 potatoes, peeled and quartered

2 large onions, peeled and cut into small pieces

1 28 oz. can whole tomatoes

1 C. water

1 tsp. bouillon powder, beef flavor

⅓ C. tapioca

2 tsp. salt

¼ tsp. pepper

1 tsp. basil

1 tsp. garlic powder

Combine all ingredients. Bake covered 325° until meat and vegetables are tender (3 hours or more). I use a cast iron pot with a lid.

COOKING with CAST IRON never fails

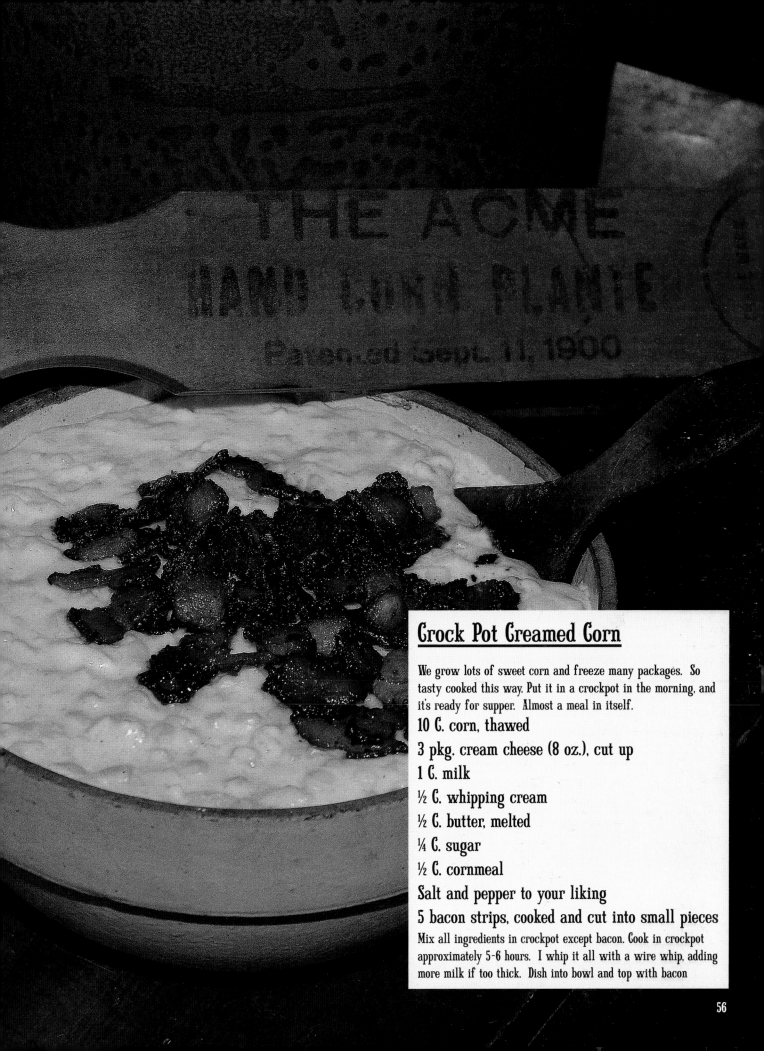

Crock Pot Creamed Corn

We grow lots of sweet corn and freeze many packages. So tasty cooked this way. Put it in a crockpot in the morning, and it's ready for supper. Almost a meal in itself.

10 C. corn, thawed

3 pkg. cream cheese (8 oz.), cut up

1 C. milk

½ C. whipping cream

½ C. butter, melted

¼ C. sugar

½ C. cornmeal

Salt and pepper to your liking

5 bacon strips, cooked and cut into small pieces

Mix all ingredients in crockpot except bacon. Cook in crockpot approximately 5-6 hours. I whip it all with a wire whip, adding more milk if too thick. Dish into bowl and top with bacon

56

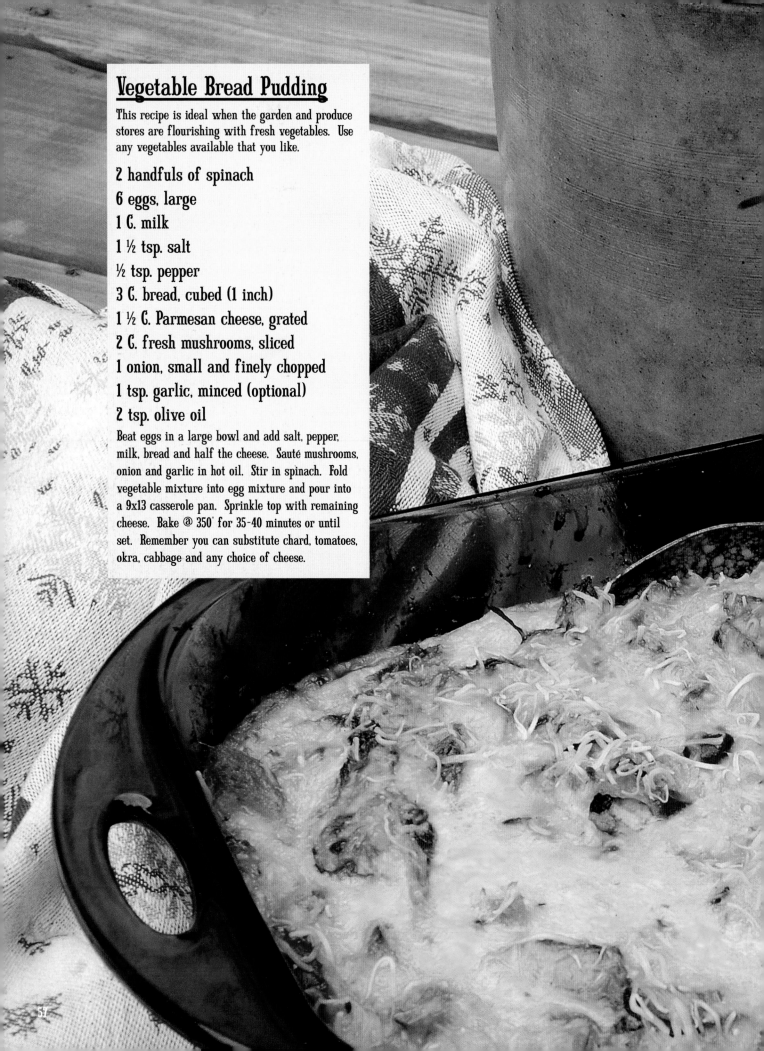

Vegetable Bread Pudding

This recipe is ideal when the garden and produce stores are flourishing with fresh vegetables. Use any vegetables available that you like.

2 handfuls of spinach

6 eggs, large

1 C. milk

1 ½ tsp. salt

½ tsp. pepper

3 C. bread, cubed (1 inch)

1 ½ C. Parmesan cheese, grated

2 C. fresh mushrooms, sliced

1 onion, small and finely chopped

1 tsp. garlic, minced (optional)

2 tsp. olive oil

Beat eggs in a large bowl and add salt, pepper, milk, bread and half the cheese. Sauté mushrooms, onion and garlic in hot oil. Stir in spinach. Fold vegetable mixture into egg mixture and pour into a 9x13 casserole pan. Sprinkle top with remaining cheese. Bake @ 350˚ for 35-40 minutes or until set. Remember you can substitute chard, tomatoes, okra, cabbage and any choice of cheese.

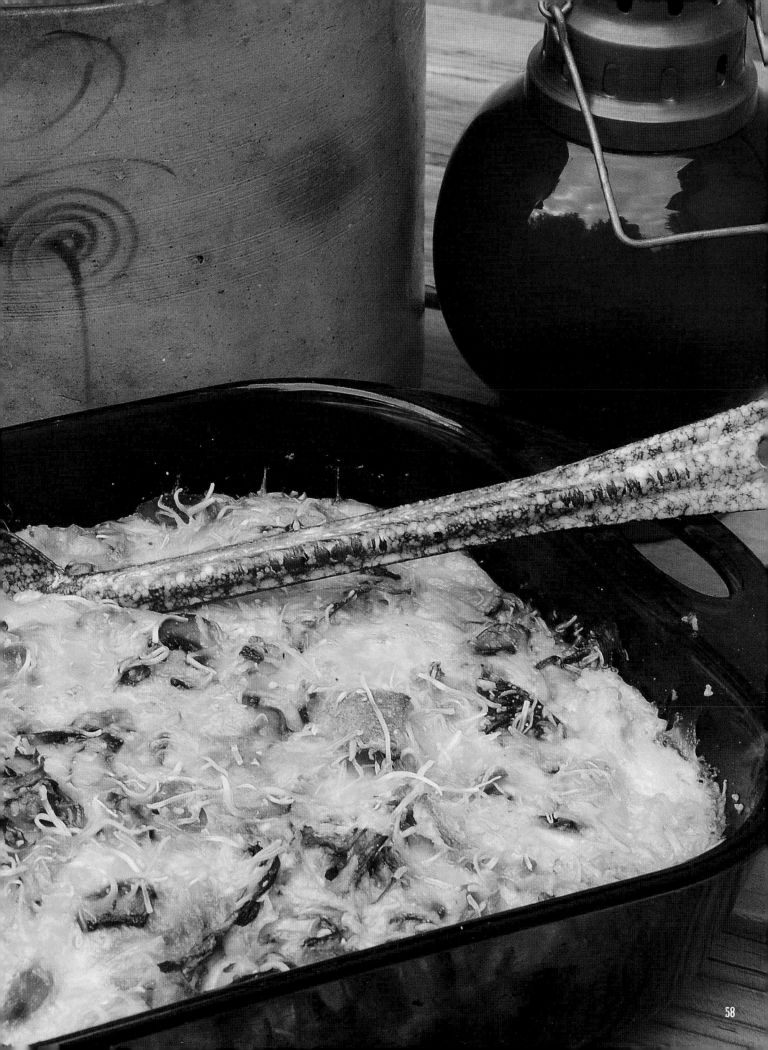

58

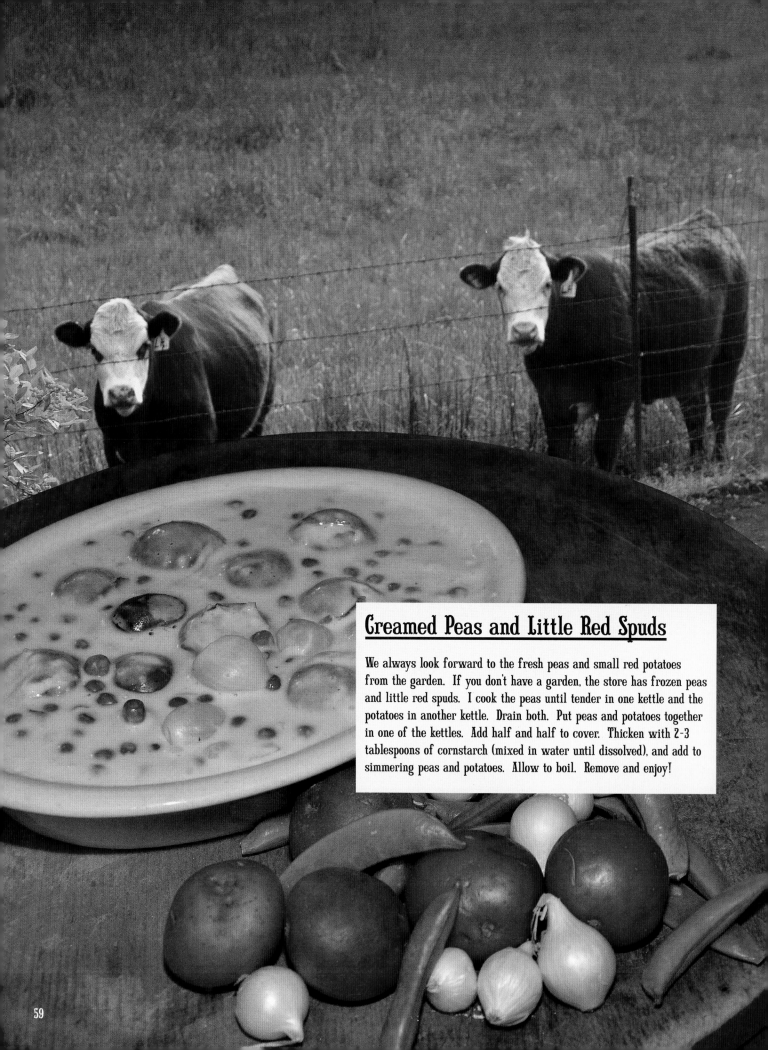

Creamed Peas and Little Red Spuds

We always look forward to the fresh peas and small red potatoes from the garden. If you don't have a garden, the store has frozen peas and little red spuds. I cook the peas until tender in one kettle and the potatoes in another kettle. Drain both. Put peas and potatoes together in one of the kettles. Add half and half to cover. Thicken with 2-3 tablespoons of cornstarch (mixed in water until dissolved), and add to simmering peas and potatoes. Allow to boil. Remove and enjoy!

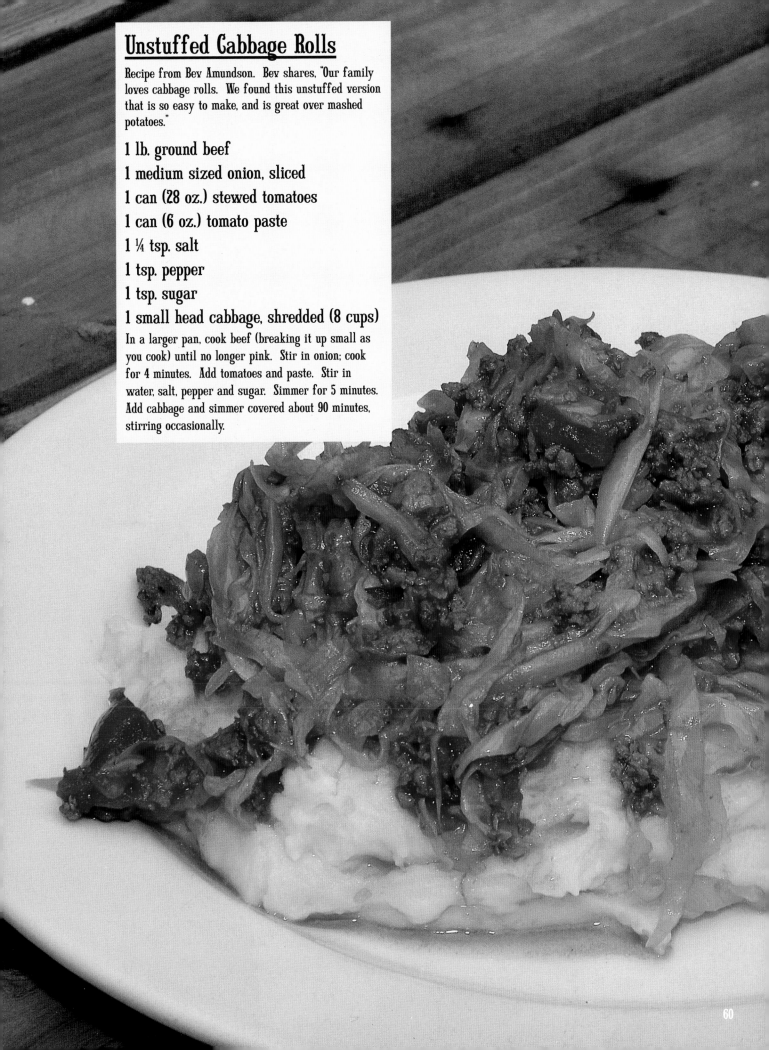

Unstuffed Cabbage Rolls

Recipe from Bev Amundson. Bev shares, "Our family loves cabbage rolls. We found this unstuffed version that is so easy to make, and is great over mashed potatoes."

1 lb. ground beef

1 medium sized onion, sliced

1 can (28 oz.) stewed tomatoes

1 can (6 oz.) tomato paste

1 ¼ tsp. salt

1 tsp. pepper

1 tsp. sugar

1 small head cabbage, shredded (8 cups)

In a larger pan, cook beef (breaking it up small as you cook) until no longer pink. Stir in onion; cook for 4 minutes. Add tomatoes and paste. Stir in water, salt, pepper and sugar. Simmer for 5 minutes. Add cabbage and simmer covered about 90 minutes, stirring occasionally.

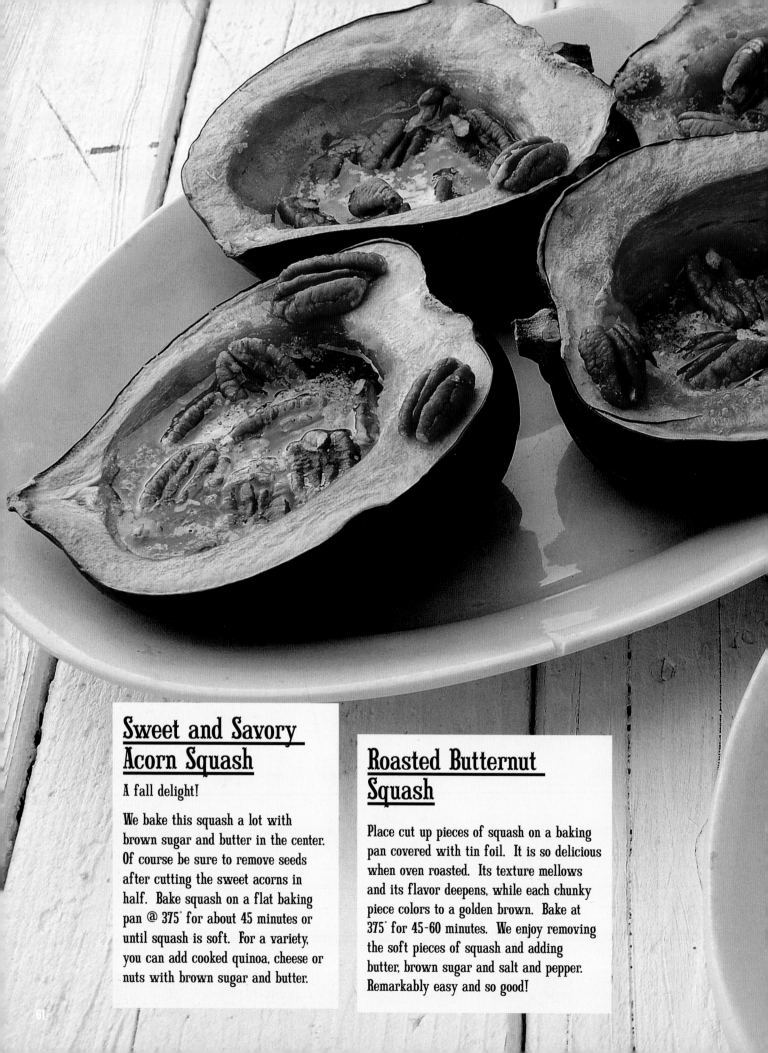

Sweet and Savory Acorn Squash

A fall delight!

We bake this squash a lot with brown sugar and butter in the center. Of course be sure to remove seeds after cutting the sweet acorns in half. Bake squash on a flat baking pan @ 375˚ for about 45 minutes or until squash is soft. For a variety, you can add cooked quinoa, cheese or nuts with brown sugar and butter.

Roasted Butternut Squash

Place cut up pieces of squash on a baking pan covered with tin foil. It is so delicious when oven roasted. Its texture mellows and its flavor deepens, while each chunky piece colors to a golden brown. Bake at 375˚ for 45-60 minutes. We enjoy removing the soft pieces of squash and adding butter, brown sugar and salt and pepper. Remarkably easy and so good!

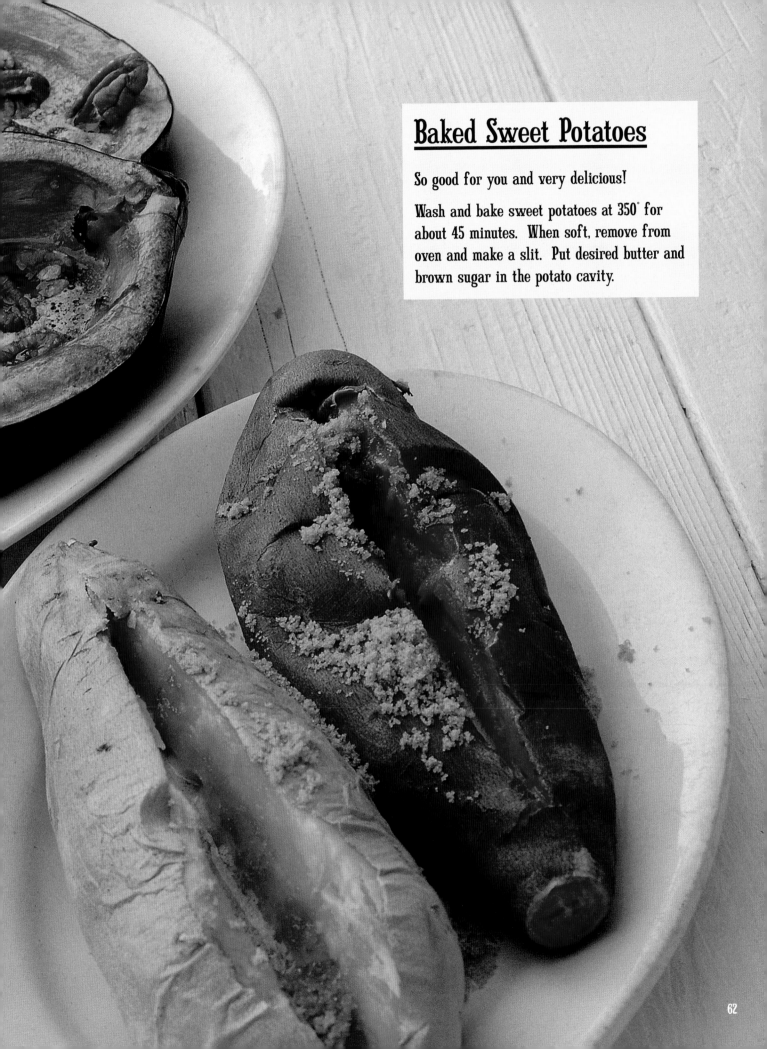

Baked Sweet Potatoes

So good for you and very delicious!

Wash and bake sweet potatoes at 350˚ for about 45 minutes. When soft, remove from oven and make a slit. Put desired butter and brown sugar in the potato cavity.

"A mother is the truest friend we have, when trials heavy and sudden fall upon us, when adversity takes the place of prosperity; when friends desert us; when trouble thickens around us, still will she cling to us, and endeavor by her kind precepts and counsels to dissipate the clouds of darkness, and cause peace to return to our hearts."

-Washington Irving (1783-1859)

SOUPS & SALADS

Fresh Corn Soup

We have an abundance of fresh corn from our garden. This recipe is easy and very delicious. You'll be surprised. Try it!

12 ears (5-6 cups) fresh sweet corn, cut off the cob. You can use frozen corn from the freezer.

2 stalks celery, chopped small

1 small sweet onion, finely chopped

½ C. butter

3 C. milk

1 tsp. salt

⅛ tsp. pepper

2 Tbsp. cornstarch

2 C. half and half

Sauté onion and celery in butter until soft, on low heat. Pour into kettle of corn. Add salt, pepper and milk. Cook over low heat for about 10 minutes. Add cornstarch to half and half; mix well. Stir this mixture into kettle and continue cooking over low heat, stirring constantly until thickened and boiling. If you prefer thicker soup, add more cornstarch.

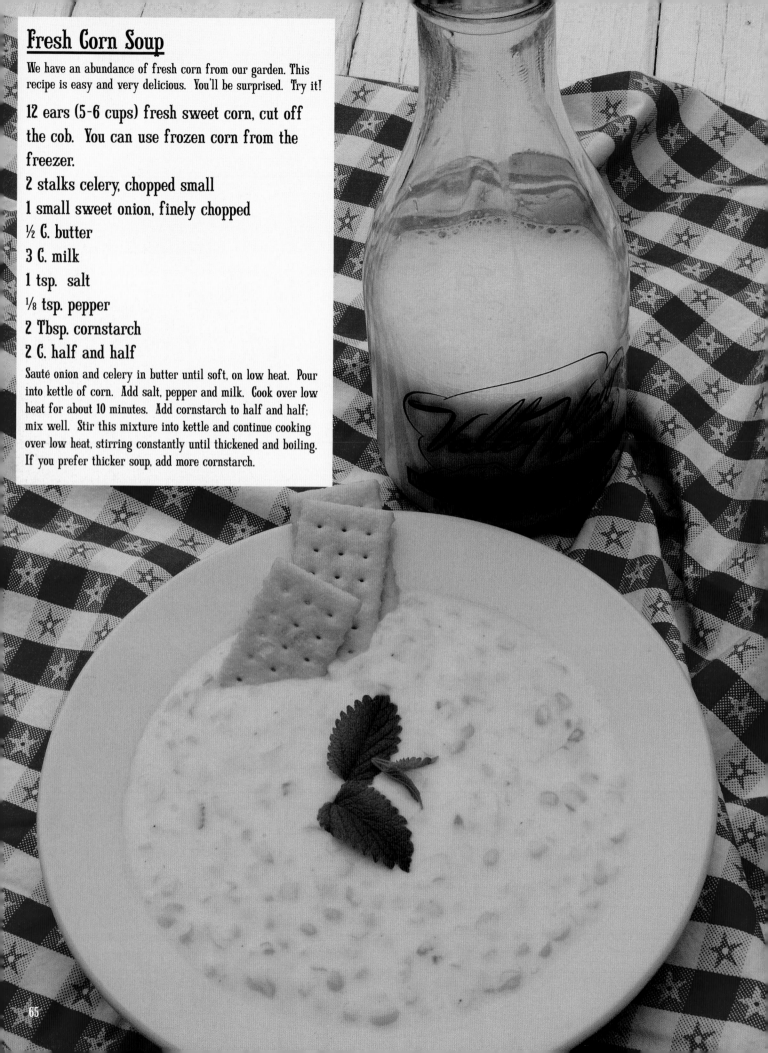

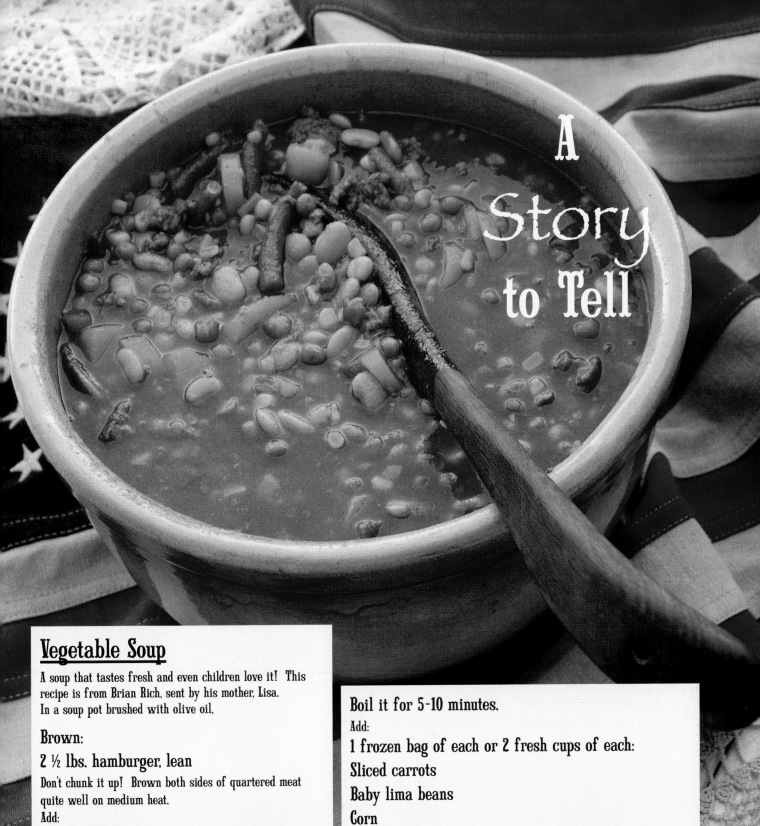

A
Story
to Tell

Vegetable Soup

A soup that tastes fresh and even children love it! This recipe is from Brian Rich, sent by his mother, Lisa. In a soup pot brushed with olive oil,

Brown:
2 ½ lbs. hamburger, lean
Don't chunk it up! Brown both sides of quartered meat quite well on medium heat.
Add:
1 Tbsp. Gaya Adobe seasoning (from the Mexican food section)
1 onion, chopped
3-5 stalks celery, sliced
Stir a few minutes and shred the meat.
Add:
16 oz. beef stock

Boil it for 5-10 minutes.
Add:
1 frozen bag of each or 2 fresh cups of each:
Sliced carrots
Baby lima beans
Corn
Green peas
Cauliflower
Cut green beans
Cook and stir for several minutes.
Add:
2 qt. hot and spicy V8 juice
Bring to a hard boil. Now simmer for 2 hours with the lid off until it thickens up a bit. Serve. Store leftovers in refrigerator or freezer.

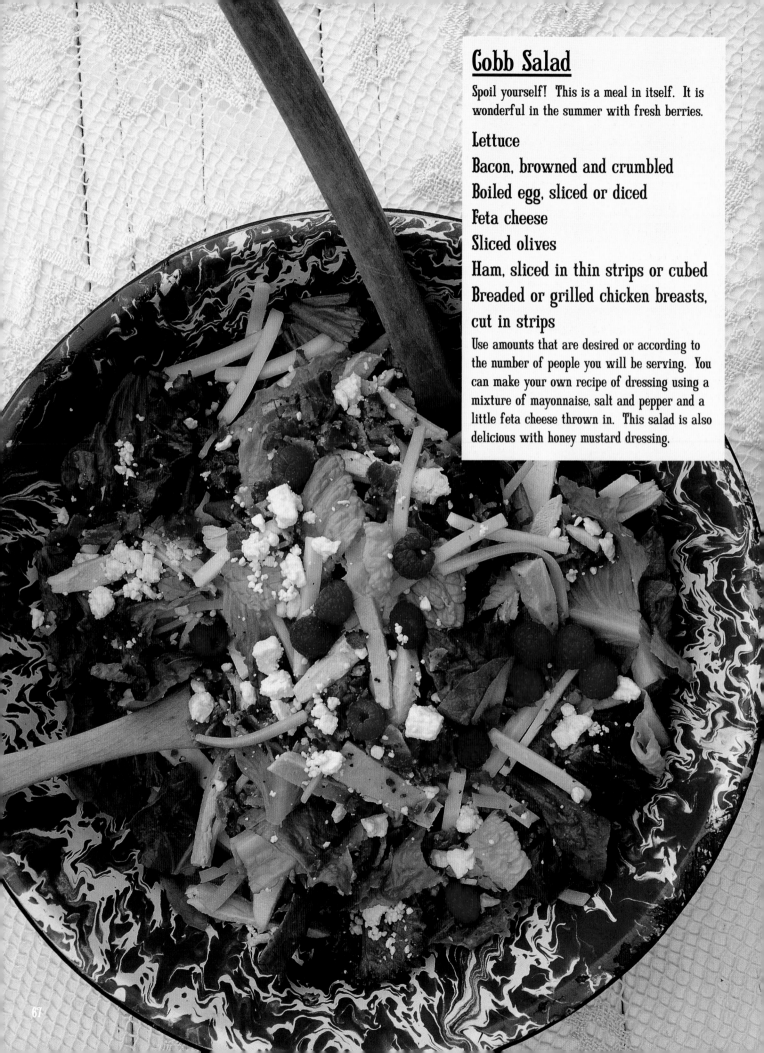

Cobb Salad

Spoil yourself! This is a meal in itself. It is wonderful in the summer with fresh berries.

Lettuce

Bacon, browned and crumbled

Boiled egg, sliced or diced

Feta cheese

Sliced olives

Ham, sliced in thin strips or cubed

Breaded or grilled chicken breasts, cut in strips

Use amounts that are desired or according to the number of people you will be serving. You can make your own recipe of dressing using a mixture of mayonnaise, salt and pepper and a little feta cheese thrown in. This salad is also delicious with honey mustard dressing.

Turkey and Apple Salad

This is good after Thanksgiving, using some of the leftover turkey.

2 C. turkey, chopped or shredded

3 green onions, finely chopped

1 C. celery, chopped

1 large apple, chopped

½ C. bread and butter pickles, chopped

½ C. hazelnuts, roasted and chopped

½ tsp. pepper

¼ tsp. salt

3 tsp. fresh lemon juice

Enough mayonnaise to hold everything together. Serve over a bed of lettuce or just in a bowl.

Chicken Salad

A delightful salad for cook-outs! You can make it ahead and refrigerate. Very popular in the south, many recipes for it are family heirlooms.

Prepare and put into a large bowl; refrigerate until ready to serve:

3 C. chicken, cooked and cubed

2 Tbsp. green onion (optional)

1 C. diced celery

1 C. grapes, seedless and halved

1 C. Mayonnaise

½ tsp. salt

¼ tsp. pepper

¼ C. moist shredded coconut

Just before serving, mix in ½ cup chopped and toasted pecans. Serve over lettuce leaves.

Tuna and Grape Salad

Nancy Uselmann states, "This is an excellent recipe from my Father's Aunt Vera's recipe file. The combination sounds strange but is delicious, especially when chilled." Quick and easy! Can be served over crackers or a bed of lettuce.

1 can tuna, drained

1 C. green grapes, cut in half

½ C. roasted pecans, chopped

Mayonnaise to hold together

Pineapple Apricot Salad

A wonderful refreshing salad from Eunice Harris's recipe box. So delicious!

2 pkgs. orange Jell-O

2 C. hot water

1 large can of apricots (drained and mashed), reserve juice

1 large can of pineapple (drained), reserve juice

1 C. pineapple and apricot juice (mixed)

Mix and refrigerate until set.

Topping:

1 egg

½ C. sugar

1 C. apricot and pineapple juice, mixed together

2 Tbsp. flour

2 Tbsp. butter

Cook until thick. Let cool and add ½ pint of whipped cream. Spread on Jell-O and grate cheese on top.

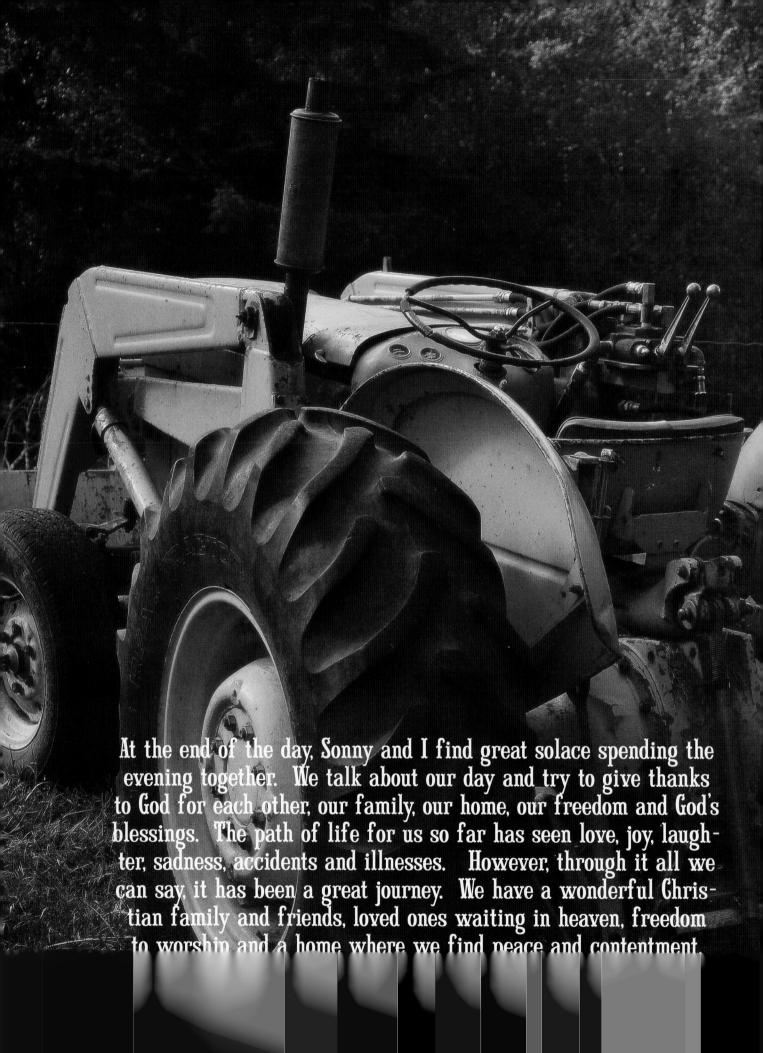

At the end of the day, Sonny and I find great solace spending the evening together. We talk about our day and try to give thanks to God for each other, our family, our home, our freedom and God's blessings. The path of life for us so far has seen love, joy, laughter, sadness, accidents and illnesses. However, through it all we can say, it has been a great journey. We have a wonderful Christian family and friends, loved ones waiting in heaven, freedom to worship and a home where we find peace and contentment.

Cream of Tomato Soup

As a child, we ate lots of tomato soup. I think it was a recipe my dear Mother brought from the South. I do not have my Mother's recipe. This was a recipe from Sonny's Mother, Rose. Serve with toasted cheese sandwiches.

4 C. tomatoes, canned

2 C. milk

2 C. half and half

4 Tbsp. cornstarch or 3 Tbsp. flour

4 Tbsp. butter

½ tsp. soda

1 tsp. salt

¼ tsp. pepper

Puree tomatoes; heat. Remove from heat. Make white sauce with half-n-half, milk, flour or cornstarch and butter; bring to a boil. Add soda, salt and pepper to tomatoes. Pour tomatoes slowly into white sauce, stirring rapidly. If the soup begins to curdle, beat the soup rapidly with a whisk or egg beater. Spices of your own choosing may be added. Bay leaf for flavoring is also good.

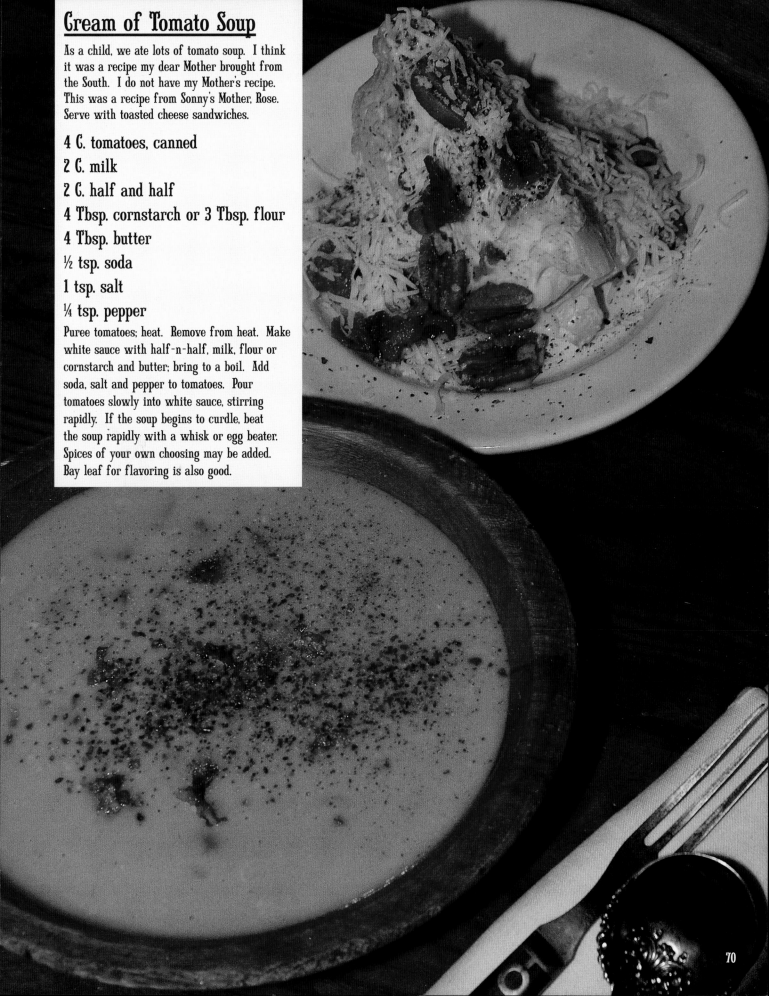

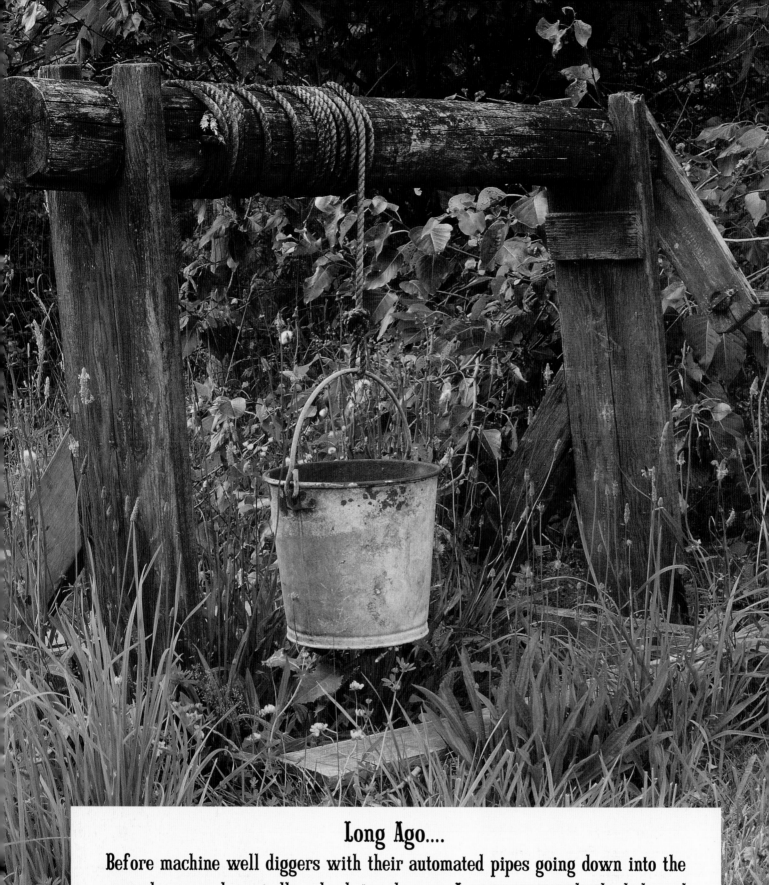

Long Ago....

Before machine well diggers with their automated pipes going down into the ground, we used a windlass bucket and rope. A man was inside the hole and a man up on the ground to empty the dirt from the bucket. They dug and dug, maybe 50 feet, sending the dirt up in the bucket until he hit water. It could be very dangerous; we knew a man who lost his life from a bucket of dirt falling on his head. Here is a picture of the windlass bucket and rope. Do you get the idea?

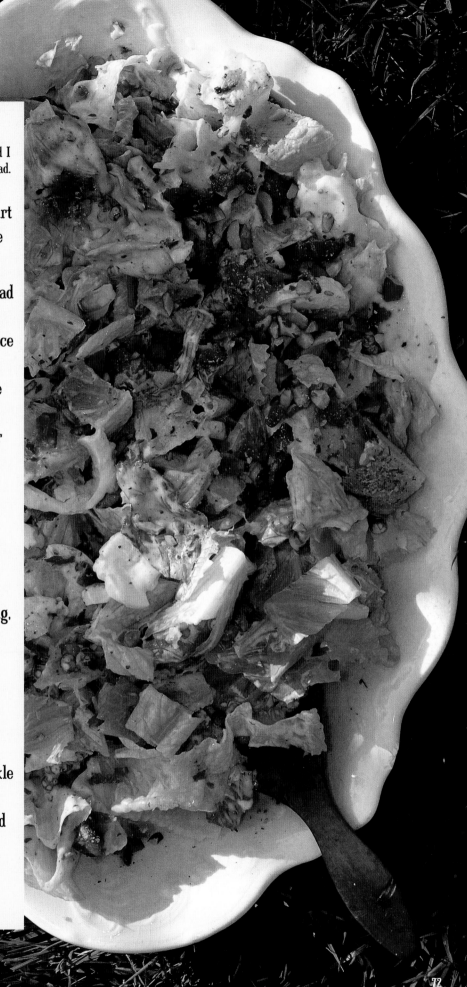

Seriously The Best Salad

Our daughter-in-law Debbie makes this often and I always tell her how it is my favorite lettuce salad. Try it!

Use a large platter. Chop or pull apart your favorite lettuce, enough to make a mound on the platter.

1 C. celery, diced and tossed with salad
½ C. green, yellow or red pepper, cut in small pieces. Layer on top of lettuce and celery.
1 C. frozen peas (cook for one minute then cool and scatter over salad)
1 sweet onion, sliced in rings; scatter over all (optional)

Dressing:
Mix together and spread over salad like frosting:
2 C. mayonnaise
Seasoning of choice (for example: Johnny's seasoning, Lawry's seasoning, cracked pepper)
2 Tbsp. vinegar
¼ C. sugar

Cover and refrigerate for several hours.

Remove from refrigerator and sprinkle the top of the salad with:
8 pieces of bacon, fried and crumbled
8 oz. cheese, grated
1 C. smoked almonds, chopped

It's ready to serve! It is nice to lightly mix by tossing a little.

COOKIES AND BARS

Chocolate Pecan Classic

This recipe can be used all year long. Make this easy Southern treat.

1 C. butter

1 C. brown sugar, packed

1 C. chocolate chips or pieces

1 C. pecans, chopped and toasted

Your choice of crackers (I used Wasa crisp crackers)

Pre-heat oven to 350°. Line a large 12x18 pan with crackers; I put them on foil. Bring butter and brown sugar to a boil over medium heat, stirring often. Boil this mixture for 3 minutes. Carefully spoon brown sugar and butter mixture over crackers. Bake until bubbly for 8-10 minutes. Remove crackers to a wire rack. Let stand a minute and sprinkle with chocolate. Allow to stand for a couple minutes until chocolate is melted and then spread chocolate. Sprinkle with pecans and a little sea salt. Chill until firm, about 30 minutes. Store in an airtight container for a week in the refrigerator.

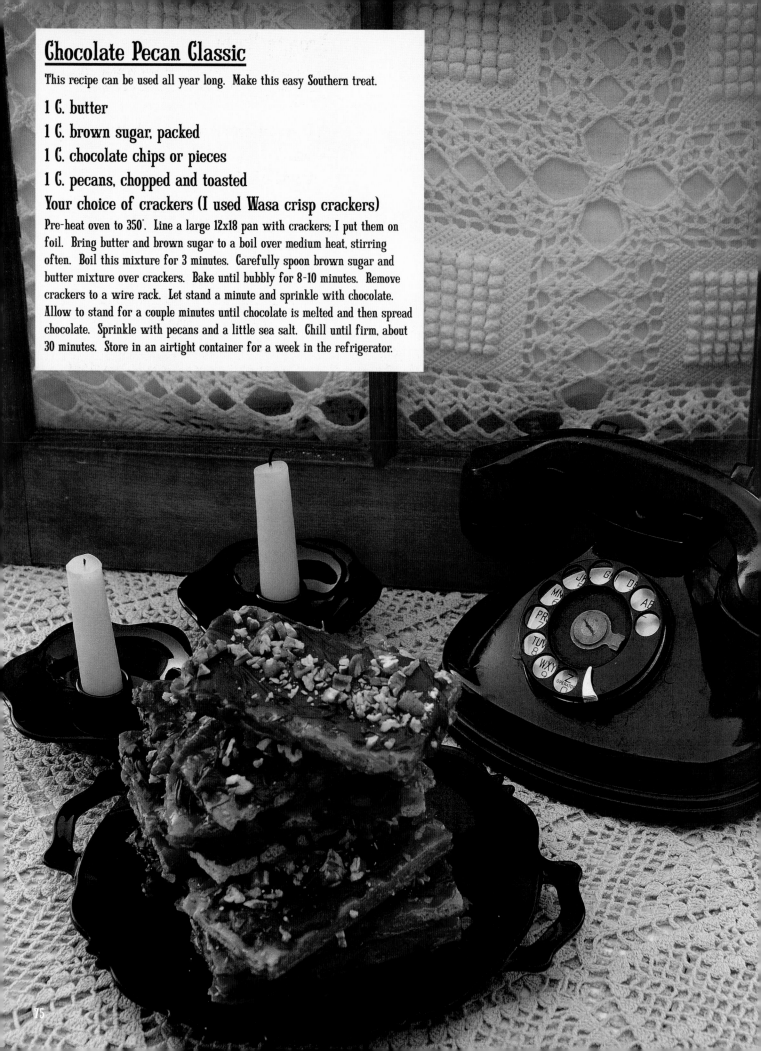

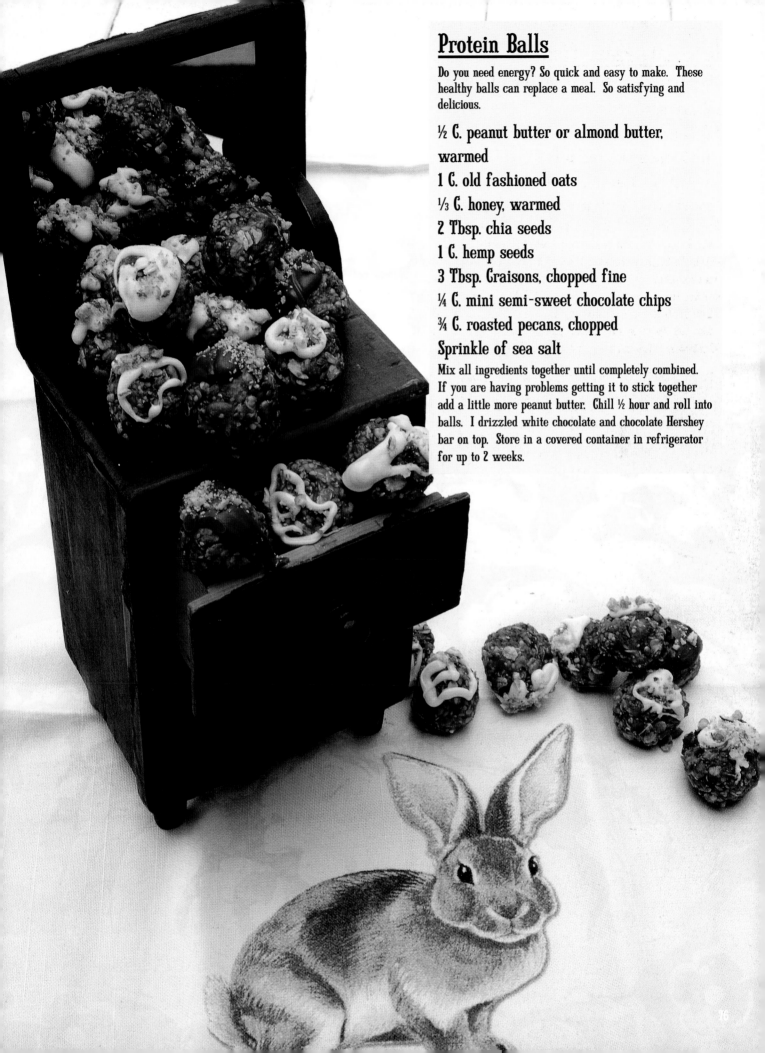

Protein Balls

Do you need energy? So quick and easy to make. These healthy balls can replace a meal. So satisfying and delicious.

½ C. peanut butter or almond butter, warmed

1 C. old fashioned oats

⅓ C. honey, warmed

2 Tbsp. chia seeds

1 C. hemp seeds

3 Tbsp. Craisons, chopped fine

¼ C. mini semi-sweet chocolate chips

¾ C. roasted pecans, chopped

Sprinkle of sea salt

Mix all ingredients together until completely combined. If you are having problems getting it to stick together add a little more peanut butter. Chill ½ hour and roll into balls. I drizzled white chocolate and chocolate Hershey bar on top. Store in a covered container in refrigerator for up to 2 weeks.

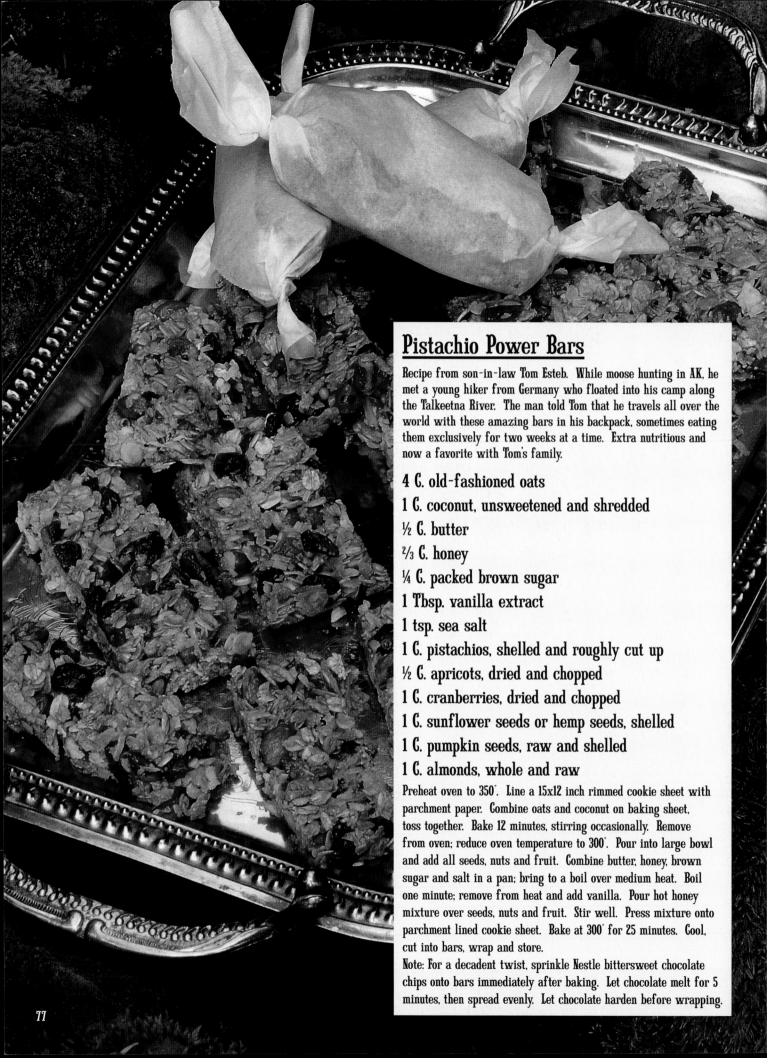

Pistachio Power Bars

Recipe from son-in-law Tom Esteb. While moose hunting in AK, he met a young hiker from Germany who floated into his camp along the Talkeetna River. The man told Tom that he travels all over the world with these amazing bars in his backpack, sometimes eating them exclusively for two weeks at a time. Extra nutritious and now a favorite with Tom's family.

4 C. old-fashioned oats

1 C. coconut, unsweetened and shredded

½ C. butter

⅔ C. honey

¼ C. packed brown sugar

1 Tbsp. vanilla extract

1 tsp. sea salt

1 C. pistachios, shelled and roughly cut up

½ C. apricots, dried and chopped

1 C. cranberries, dried and chopped

1 C. sunflower seeds or hemp seeds, shelled

1 C. pumpkin seeds, raw and shelled

1 C. almonds, whole and raw

Preheat oven to 350°. Line a 15x12 inch rimmed cookie sheet with parchment paper. Combine oats and coconut on baking sheet, toss together. Bake 12 minutes, stirring occasionally. Remove from oven; reduce oven temperature to 300°. Pour into large bowl and add all seeds, nuts and fruit. Combine butter, honey, brown sugar and salt in a pan; bring to a boil over medium heat. Boil one minute; remove from heat and add vanilla. Pour hot honey mixture over seeds, nuts and fruit. Stir well. Press mixture onto parchment lined cookie sheet. Bake at 300° for 25 minutes. Cool, cut into bars, wrap and store.

Note: For a decadent twist, sprinkle Nestle bittersweet chocolate chips onto bars immediately after baking. Let chocolate melt for 5 minutes, then spread evenly. Let chocolate harden before wrapping.

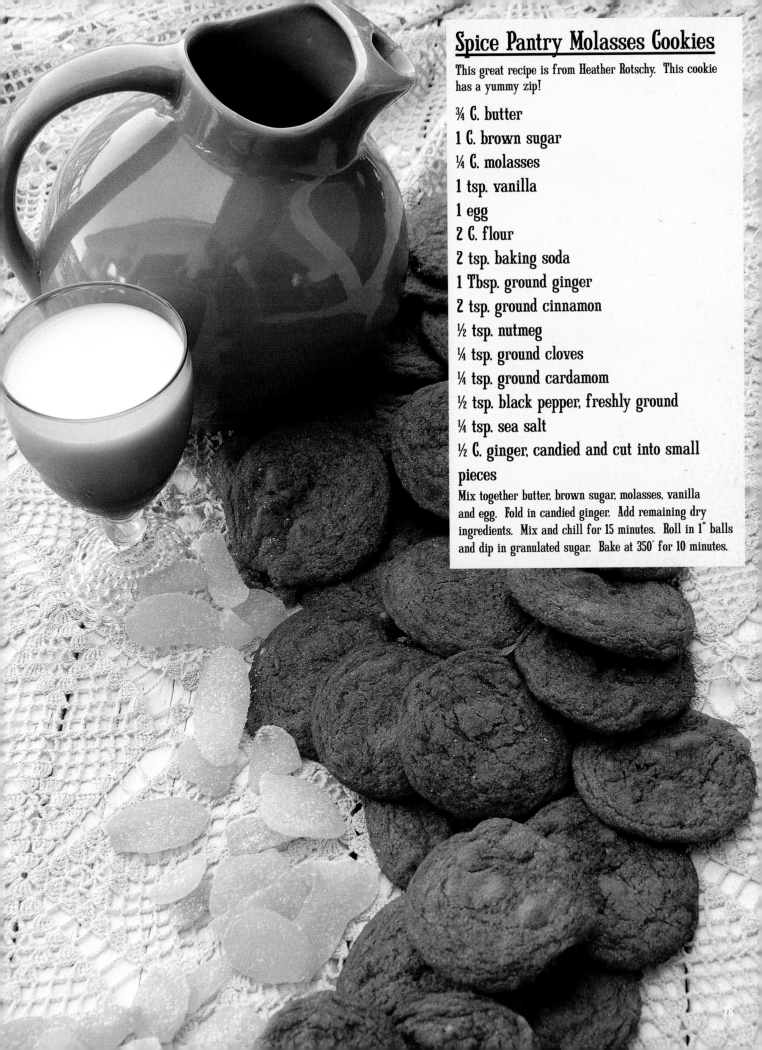

Spice Pantry Molasses Cookies

This great recipe is from Heather Rotschy. This cookie has a yummy zip!

¾ C. butter

1 C. brown sugar

¼ C. molasses

1 tsp. vanilla

1 egg

2 C. flour

2 tsp. baking soda

1 Tbsp. ground ginger

2 tsp. ground cinnamon

½ tsp. nutmeg

¼ tsp. ground cloves

¼ tsp. ground cardamom

½ tsp. black pepper, freshly ground

¼ tsp. sea salt

½ C. ginger, candied and cut into small pieces

Mix together butter, brown sugar, molasses, vanilla and egg. Fold in candied ginger. Add remaining dry ingredients. Mix and chill for 15 minutes. Roll in 1" balls and dip in granulated sugar. Bake at 350° for 10 minutes.

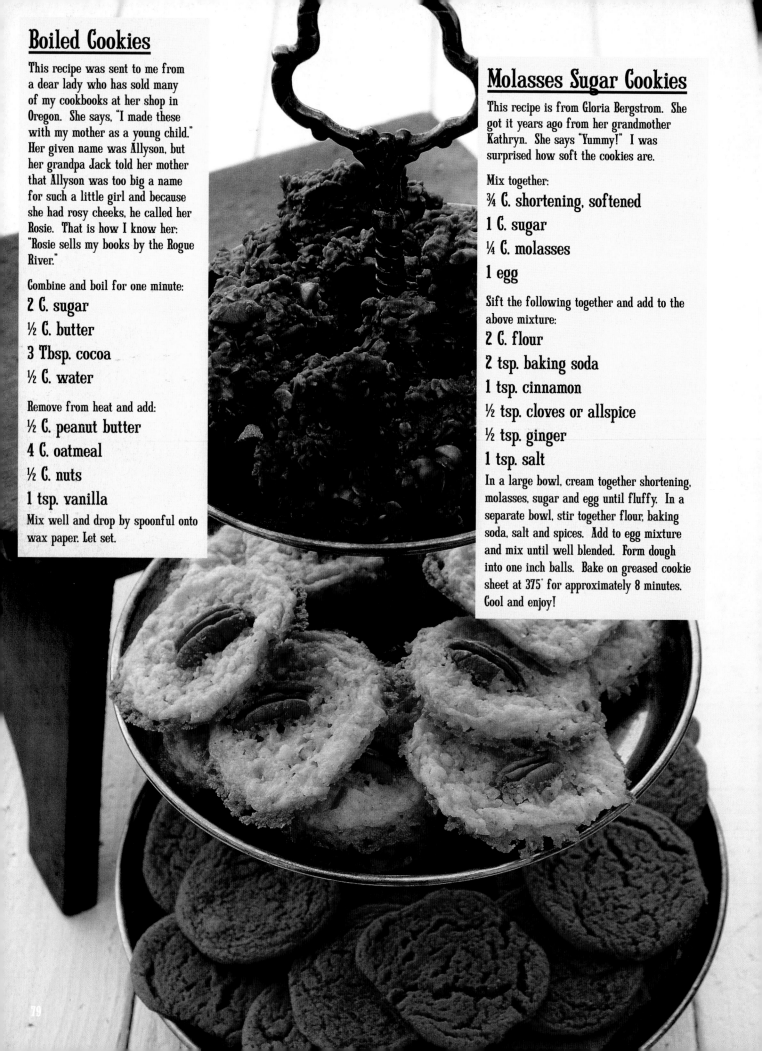

Boiled Cookies

This recipe was sent to me from a dear lady who has sold many of my cookbooks at her shop in Oregon. She says, "I made these with my mother as a young child." Her given name was Allyson, but her grandpa Jack told her mother that Allyson was too big a name for such a little girl and because she had rosy cheeks, he called her Rosie. That is how I know her: "Rosie sells my books by the Rogue River."

Combine and boil for one minute:

2 C. sugar

½ C. butter

3 Tbsp. cocoa

½ C. water

Remove from heat and add:

½ C. peanut butter

4 C. oatmeal

½ C. nuts

1 tsp. vanilla

Mix well and drop by spoonful onto wax paper. Let set.

Molasses Sugar Cookies

This recipe is from Gloria Bergstrom. She got it years ago from her grandmother Kathryn. She says "Yummy!" I was surprised how soft the cookies are.

Mix together:

¾ C. shortening, softened

1 C. sugar

¼ C. molasses

1 egg

Sift the following together and add to the above mixture:

2 C. flour

2 tsp. baking soda

1 tsp. cinnamon

½ tsp. cloves or allspice

½ tsp. ginger

1 tsp. salt

In a large bowl, cream together shortening, molasses, sugar and egg until fluffy. In a separate bowl, stir together flour, baking soda, salt and spices. Add to egg mixture and mix until well blended. Form dough into one inch balls. Bake on greased cookie sheet at 375° for approximately 8 minutes. Cool and enjoy!

Australian Cookies

Satisfy your taste buds. A must try cookie recipe from a longtime friend, Char Lambert.

Mix together:

1 C. butter

1 C. sugar

2 Tbsp. maple syrup

Mix the following ingredients together and add to butter mixture:

1 C. flour

1 tsp. baking powder

1 C. rolled oats

1 C. coconut

Roll into balls; place well apart on greased baking pan. Bake approximately 15 minutes at 350°. Cool on pan before removing.

Gingerbread Men

Soooo fun to make these little men and help the children decorate them. Tell the children to go easy on the flour because too much flour makes cookies tough.

3 C. flour

2 tsp. ground ginger

1 tsp. cinnamon

1 tsp. baking soda

½ tsp. salt

¾ C. butter, softened

¾ C. brown sugar, packed

½ C. molasses

1 egg

1 tsp. vanilla

Cream together butter and sugar, adding molasses, egg and vanilla. Gradually add in the dry ingredients. Refrigerate for a couple hours. Roll dough to ¼ inch thickness on lightly floured board. Cut dough into gingerbread men with a five-inch cookie cutter. Place one inch apart on greased cookie sheet. Bake at 350° 8-10 minutes. Cool for 2 minutes on cookie sheet. Remove to wire rack. Cool. May be frosted.

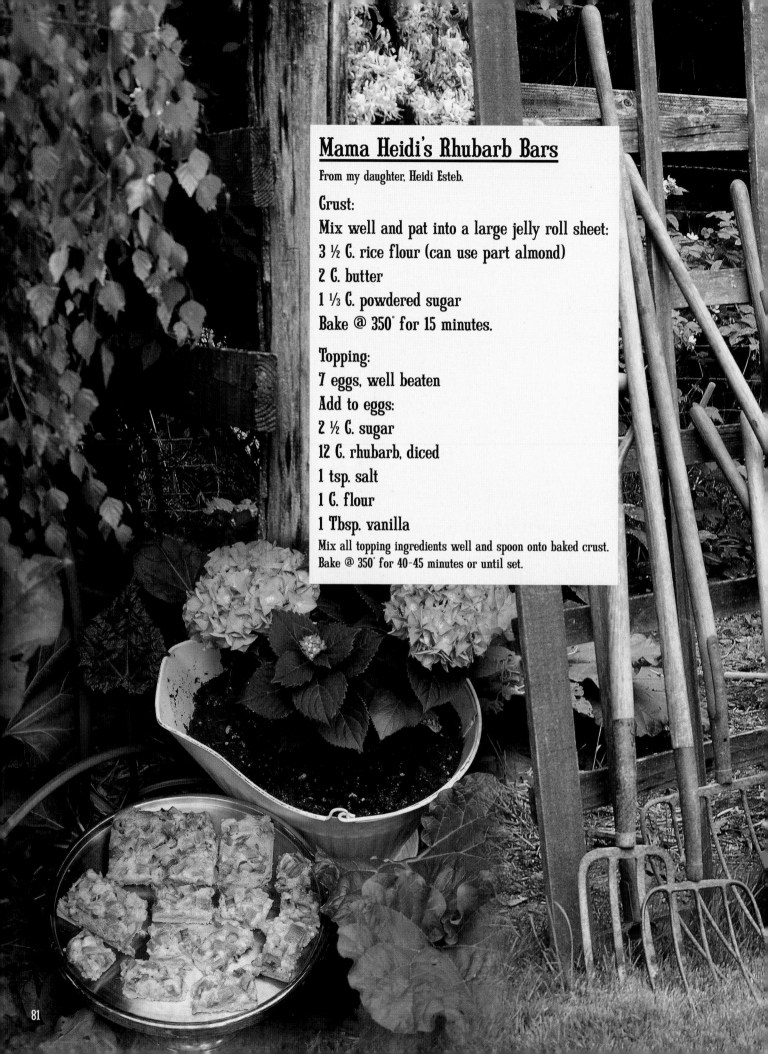

Mama Heidi's Rhubarb Bars

From my daughter, Heidi Esteb.

Crust:

Mix well and pat into a large jelly roll sheet:

3 ½ C. rice flour (can use part almond)

2 C. butter

1 ⅓ C. powdered sugar

Bake @ 350° for 15 minutes.

Topping:

7 eggs, well beaten

Add to eggs:

2 ½ C. sugar

12 C. rhubarb, diced

1 tsp. salt

1 C. flour

1 Tbsp. vanilla

Mix all topping ingredients well and spoon onto baked crust.
Bake @ 350° for 40-45 minutes or until set.

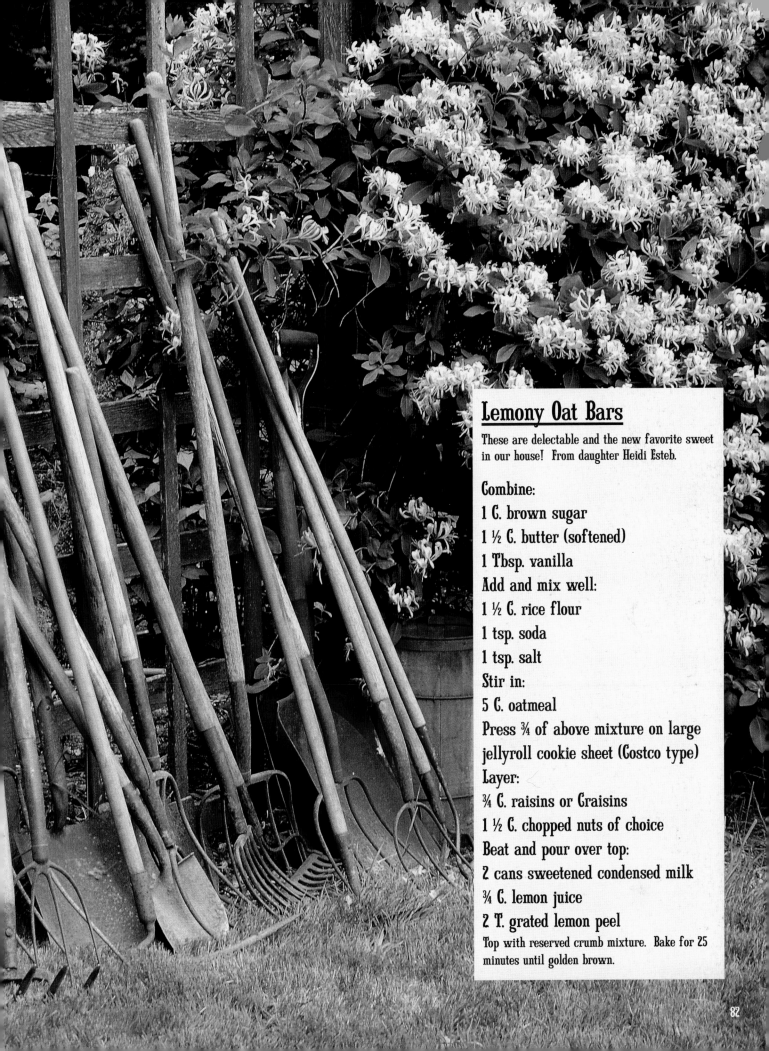

Lemony Oat Bars

These are delectable and the new favorite sweet in our house! From daughter Heidi Esteb.

Combine:

1 C. brown sugar

1 ½ C. butter (softened)

1 Tbsp. vanilla

Add and mix well:

1 ½ C. rice flour

1 tsp. soda

1 tsp. salt

Stir in:

5 C. oatmeal

Press ¾ of above mixture on large jellyroll cookie sheet (Costco type)

Layer:

¾ C. raisins or Craisins

1 ½ C. chopped nuts of choice

Beat and pour over top:

2 cans sweetened condensed milk

¾ C. lemon juice

2 T. grated lemon peel

Top with reserved crumb mixture. Bake for 25 minutes until golden brown.

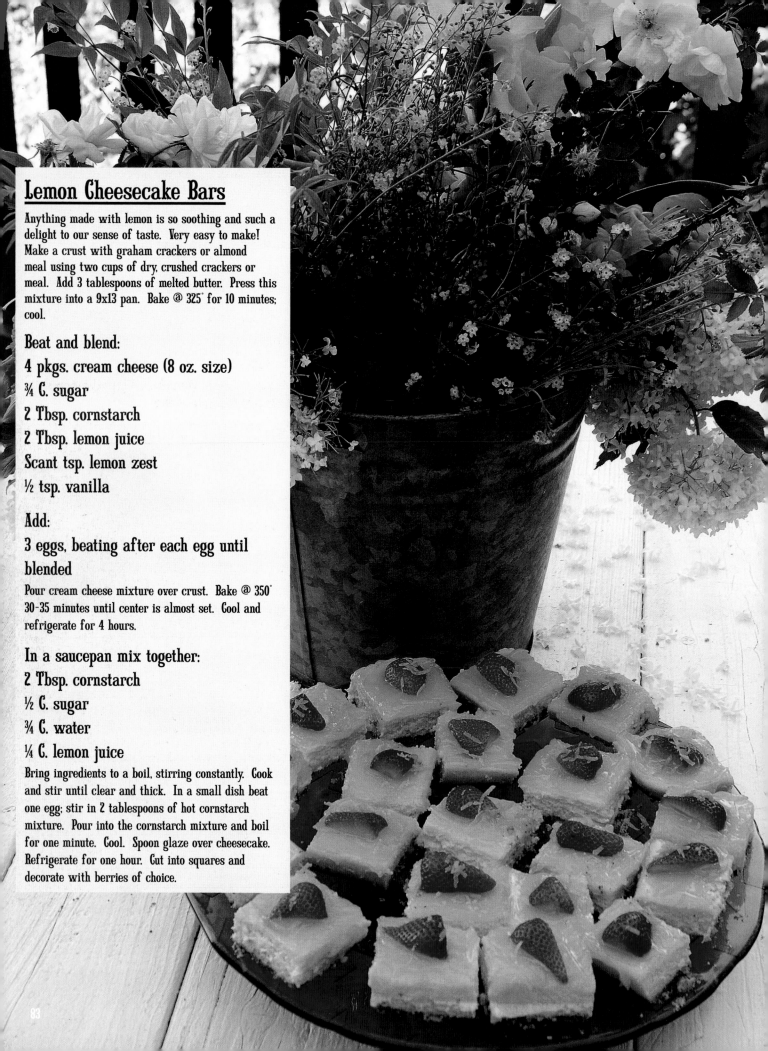

Lemon Cheesecake Bars

Anything made with lemon is so soothing and such a delight to our sense of taste. Very easy to make! Make a crust with graham crackers or almond meal using two cups of dry, crushed crackers or meal. Add 3 tablespoons of melted butter. Press this mixture into a 9x13 pan. Bake @ 325° for 10 minutes; cool.

Beat and blend:

4 pkgs. cream cheese (8 oz. size)

¾ C. sugar

2 Tbsp. cornstarch

2 Tbsp. lemon juice

Scant tsp. lemon zest

½ tsp. vanilla

Add:

3 eggs, beating after each egg until blended

Pour cream cheese mixture over crust. Bake @ 350° 30-35 minutes until center is almost set. Cool and refrigerate for 4 hours.

In a saucepan mix together:

2 Tbsp. cornstarch

½ C. sugar

¾ C. water

¼ C. lemon juice

Bring ingredients to a boil, stirring constantly. Cook and stir until clear and thick. In a small dish beat one egg; stir in 2 tablespoons of hot cornstarch mixture. Pour into the cornstarch mixture and boil for one minute. Cool. Spoon glaze over cheesecake. Refrigerate for one hour. Cut into squares and decorate with berries of choice.

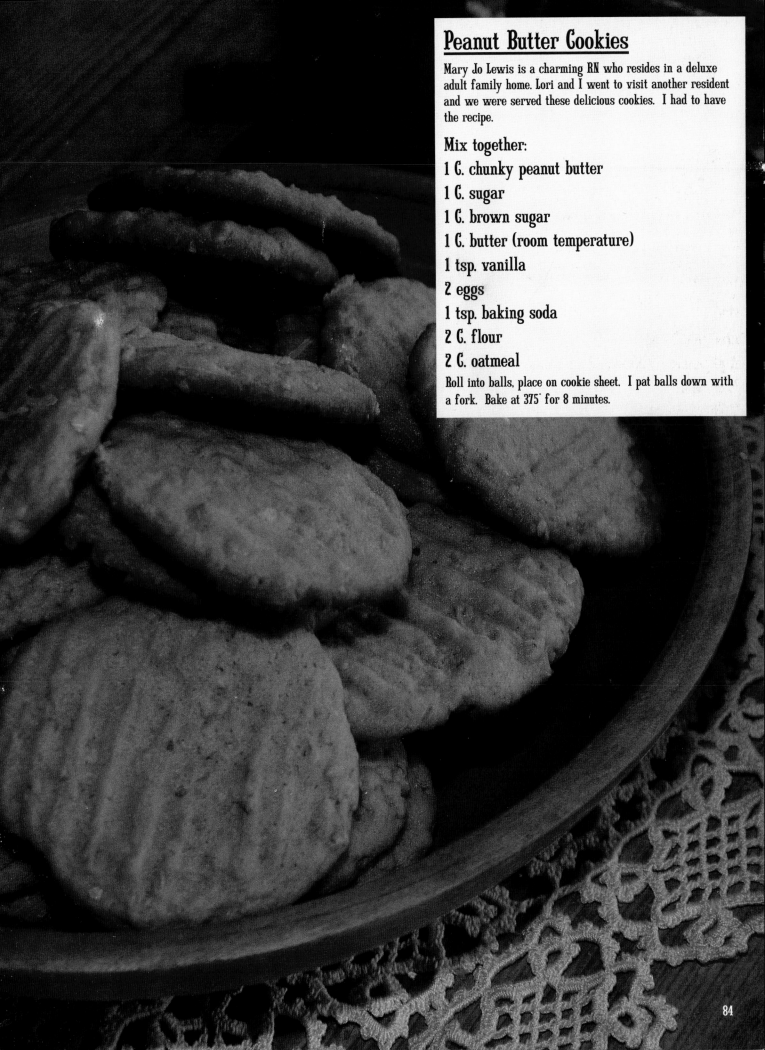

Peanut Butter Cookies

Mary Jo Lewis is a charming RN who resides in a deluxe adult family home. Lori and I went to visit another resident and we were served these delicious cookies. I had to have the recipe.

Mix together:

1 C. chunky peanut butter

1 C. sugar

1 C. brown sugar

1 C. butter (room temperature)

1 tsp. vanilla

2 eggs

1 tsp. baking soda

2 C. flour

2 C. oatmeal

Roll into balls, place on cookie sheet. I pat balls down with a fork. Bake at 375° for 8 minutes.

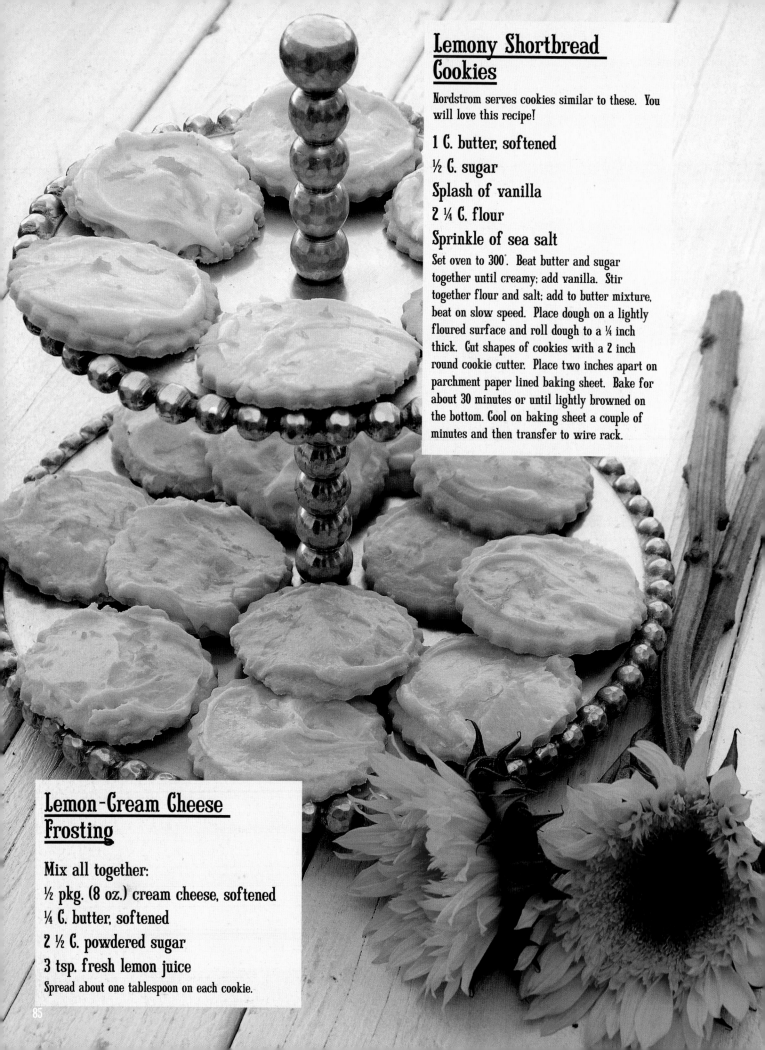

Lemony Shortbread Cookies

Nordstrom serves cookies similar to these. You will love this recipe!

1 C. butter, softened
½ C. sugar
Splash of vanilla
2 ¼ C. flour
Sprinkle of sea salt

Set oven to 300°. Beat butter and sugar together until creamy; add vanilla. Stir together flour and salt; add to butter mixture, beat on slow speed. Place dough on a lightly floured surface and roll dough to a ¼ inch thick. Cut shapes of cookies with a 2 inch round cookie cutter. Place two inches apart on parchment paper lined baking sheet. Bake for about 30 minutes or until lightly browned on the bottom. Cool on baking sheet a couple of minutes and then transfer to wire rack.

Lemon-Cream Cheese Frosting

Mix all together:
½ pkg. (8 oz.) cream cheese, softened
¼ C. butter, softened
2 ½ C. powdered sugar
3 tsp. fresh lemon juice
Spread about one tablespoon on each cookie.

CAKES

SILVER STAR L.O. 6

Rhubarb Coffee Cake

This recipe is from my daughter, Heather. Everyone loves it when she makes it, including me!

1 C. butter

2 C. brown sugar

1 egg

1 tsp. vanilla

1 C. buttermilk

2 ½ C. flour

1 tsp. baking soda

¼ tsp. salt

2 ½ C. rhubarb, fresh and chopped

½ tsp. cinnamon

In a mixing bowl cream butter and one and a half cups of brown sugar together. Set aside. Beat egg and vanilla until fluffy. Add buttermilk, flour, baking soda and salt. Add to creamed mixture and mix well. Next, fold in rhubarb. Pour into a greased 9x13 baking dish. Combine cinnamon and leftover ½ cup brown sugar and sprinkle over batter. Bake @ 325˚ for 30-35 minutes.

Gluten free version:

Substitute regular flour for 2 cups gluten free flour. Add ¾ cup gluten free quick oats and an additional egg.

Pineapple Upside Down Cupcakes

Could serve in the fancy uptown deli specialty shops. So easy to make and quite impressive!

Melt ½ cup butter in a saucepan. Add ¾ cup of brown sugar. Bring to a boil, then set aside. Grease a 12 cup muffin tin. Pour brown sugar/butter mixture evenly into muffin tins. Place drained pineapple pieces on top of mixture in muffin pan.

I make this cake batter gluten free. You can use your favorite yellow cake recipe instead of this gluten free one if preferred.

Gluten Free cake batter:
Mix together:
⅔ C. butter, melted
¾ C. white sugar
2 eggs
1 C. sour cream
1 tsp. vanilla
2 C. Pamela's Gluten Free Baking and Pancake Mix

Pour batter in muffin tins, dividing dough evenly over pineapple mixture. Bake 35-40 minutes at 350˚. Cool for 5 minutes and place each cake upside down on a small plate, so that pineapple is on top. When completely cool, top with whipped cream and a cherry.

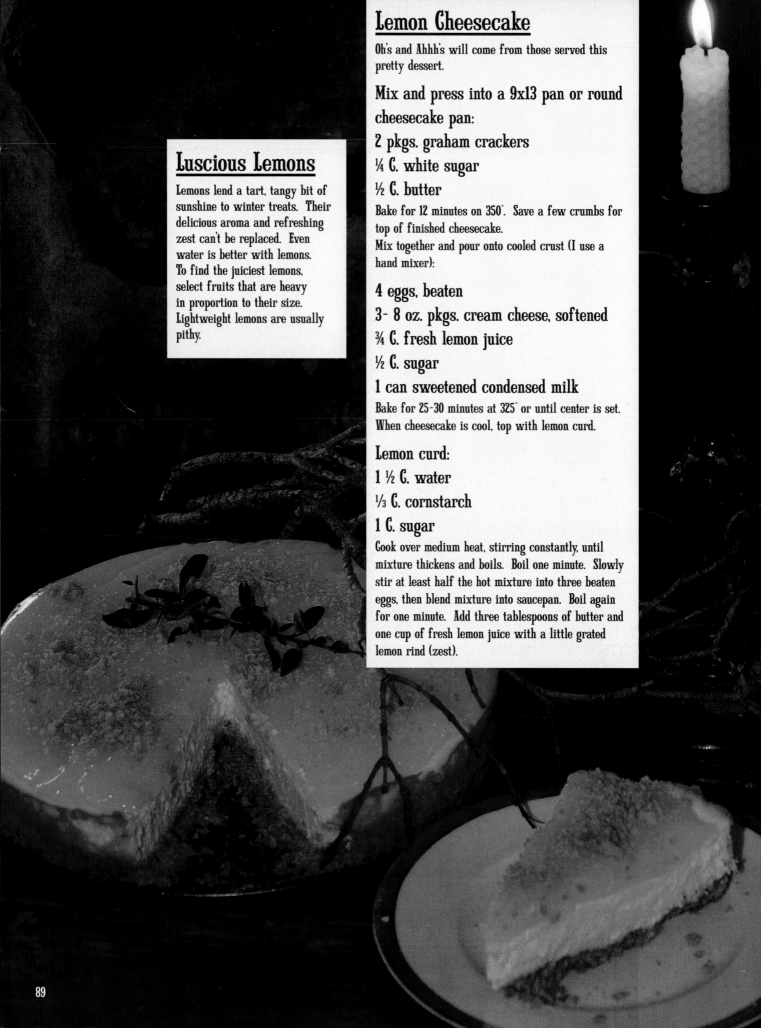

Luscious Lemons

Lemons lend a tart, tangy bit of sunshine to winter treats. Their delicious aroma and refreshing zest can't be replaced. Even water is better with lemons. To find the juiciest lemons, select fruits that are heavy in proportion to their size. Lightweight lemons are usually pithy.

Lemon Cheesecake

Oh's and Ahhh's will come from those served this pretty dessert.

Mix and press into a 9x13 pan or round cheesecake pan:

2 pkgs. graham crackers

¼ C. white sugar

½ C. butter

Bake for 12 minutes on 350˙. Save a few crumbs for top of finished cheesecake.

Mix together and pour onto cooled crust (I use a hand mixer):

4 eggs, beaten

3- 8 oz. pkgs. cream cheese, softened

¾ C. fresh lemon juice

½ C. sugar

1 can sweetened condensed milk

Bake for 25-30 minutes at 325˙ or until center is set. When cheesecake is cool, top with lemon curd.

Lemon curd:

1 ½ C. water

⅓ C. cornstarch

1 C. sugar

Cook over medium heat, stirring constantly, until mixture thickens and boils. Boil one minute. Slowly stir at least half the hot mixture into three beaten eggs, then blend mixture into saucepan. Boil again for one minute. Add three tablespoons of butter and one cup of fresh lemon juice with a little grated lemon rind (zest).

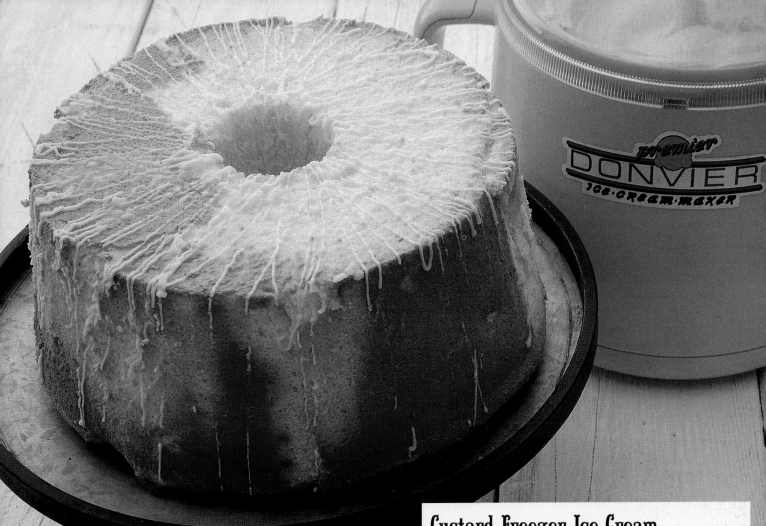

Angel Food Cake Deluxe

A fantastic angel food cake recipe. We've eaten this cake several times at Lucy and Basil Rotschy's. Lucy has mastered this to perfection.

1 C. cake flour

¾ C. plus 2 Tbsp. confectioners' sugar

12 egg whites (1 ½ C.)

1 ½ tsp. cream of tartar

¼ tsp. salt

1 C. granulated sugar

1 ½ tsp. vanilla

½ tsp. almond extract

Heat oven to 375˚. Stir together flour and confectioners' sugar; set aside. In a large mixing bowl beat egg whites, cream of tartar and salt until foamy. Add granulated sugar, 2 tablespoons at a time, beating on high speed until meringue holds stiff peaks. Gently fold in vanilla and almond flavorings. Sprinkle flour-sugar mixture ¼ cup at a time over meringue, folding in gently just until flour-sugar mixture disappears. Place batter carefully into ungreased tube pan. Bake 30-35 minutes or until top springs back when touched. Invert pan on funnel or pop bottle until cake is completely cooled. Cake can be frosted.

Custard Freezer Ice Cream

We really like this recipe. I usually make it the evening before I plan to make ice cream. This recipe is great for any and all freezers. Thoroughly chill mixture before freezing. Basil and Lucy Rotschy usually use a recipe with custard like this one.

1 qt. heavy whipping cream

1 qt. half and half

1 pt. milk

4 eggs

¾ C. sweetened condensed milk

1 ¼ C. sugar

½ tsp. salt

1 tsp. vanilla

Heat 2 cups cream with milk in a heavy pan. Beat eggs and add sweetened condensed milk, sugar and salt. Blend in a little hot cream, then slowly add mixture to the pan. Bring to a boil, stirring to keep mixture from scorching. Remove from stove and add remaining cream and vanilla. Place in refrigerator in any container until ready to use. If you put the cream mixture into the ice cream maker shown in the picture, it will only hold one qt. We are most fortunate that Lucy and Basil Rotschy have found two of these one qt. ice cream makers for us at the thrift stores. The brand is Donvier; it could probably be ordered online. So easy!

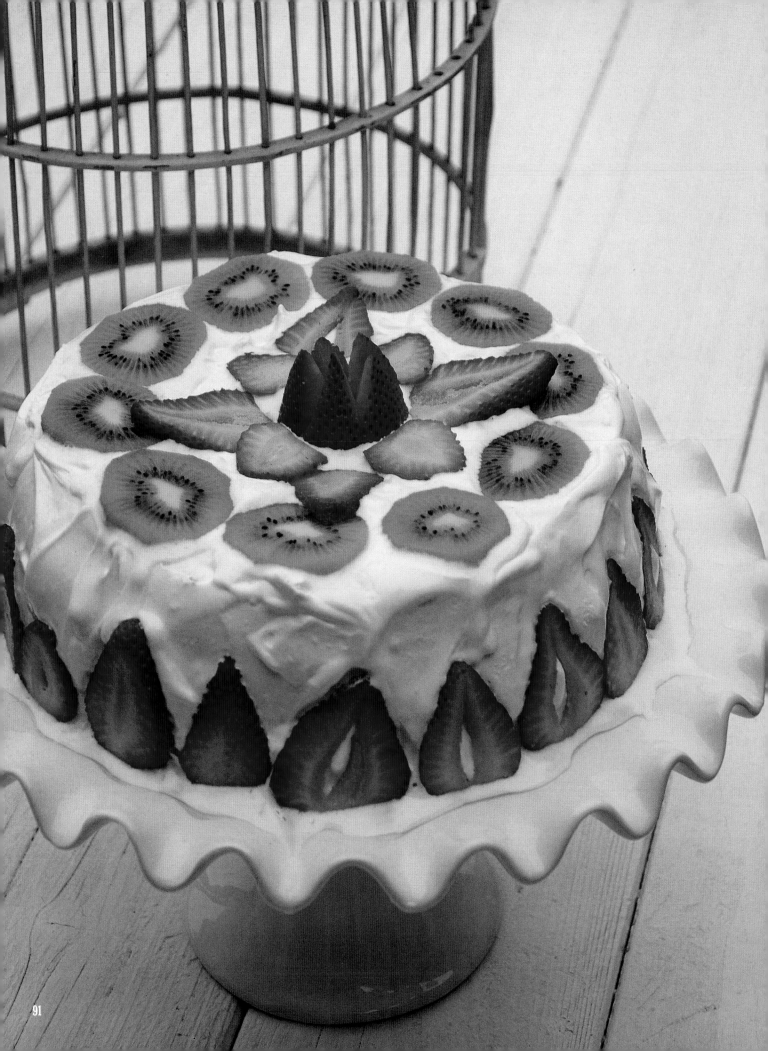

Strawberry Angel Cheesecake

Great recipe from a good cook, Gail Schmeusser.

Plan ahead for baking time of cake or use store made cake.

ANGEL FOOD CAKE:

1 C. sifted cake flour

1 ¼ C. sifted confectioner's sugar

1 ½ C. (12) egg whites

1 ½ tsp. cream of tartar

¼ tsp. salt

1 ½ tsp. vanilla extract

¼ tsp. almond extract

1 C. sugar

Sift flour with confectioner's sugar 3 times. Beat egg whites with cream of tartar, salt, vanilla and almond extracts until stiff enough to hold soft peaks, but still moist and glossy. Beat in sugar, 2 tablespoons at a time, continuing to beat until it holds soft peaks. Sift ¼ of the flour mixture over the egg white mixture; fold in lightly with an up and down motion, turning bowl. Fold in remaining flour mixture ¼ at a time. Bake in ungreased 10-inch tube pan @ 375° for about 30 minutes. Invert pan on cooling rack; let cool completely before removing. When cooled, cut off top and hollow out center.

FILLING:

8 oz. pkg. cream cheese, softened

1 can sweetened condensed milk

¼ C. lemon juice

8 oz. whipped topping

2 C. chopped strawberries

3-6 drops red food coloring (optional)

Beat cream cheese with mixer for 30 seconds; add sweetened condensed milk. Beat until combined; add lemon juice; beat some more. Fold in whipped topping. Add strawberries and food coloring. Fill cake with filling and replace top.

FROSTING:

2 egg whites, unbeaten

1 ½ C. sugar

1 ½ tsp. light corn syrup or ¼ tsp. cream of tartar

⅓ C. cold water

Dash of salt

1 tsp. vanilla extract

Place all ingredients except vanilla in top of double boiler (not over heat); beat 1 minute with electric mixer. Place over boiling water and cook, beating constantly until frosting forms stiff peaks (about 7 minutes). Don't overcook. Remove top pan from boiling water. Add vanilla; beat until spreading consistency, about 2 minutes. Frost and refrigerate.

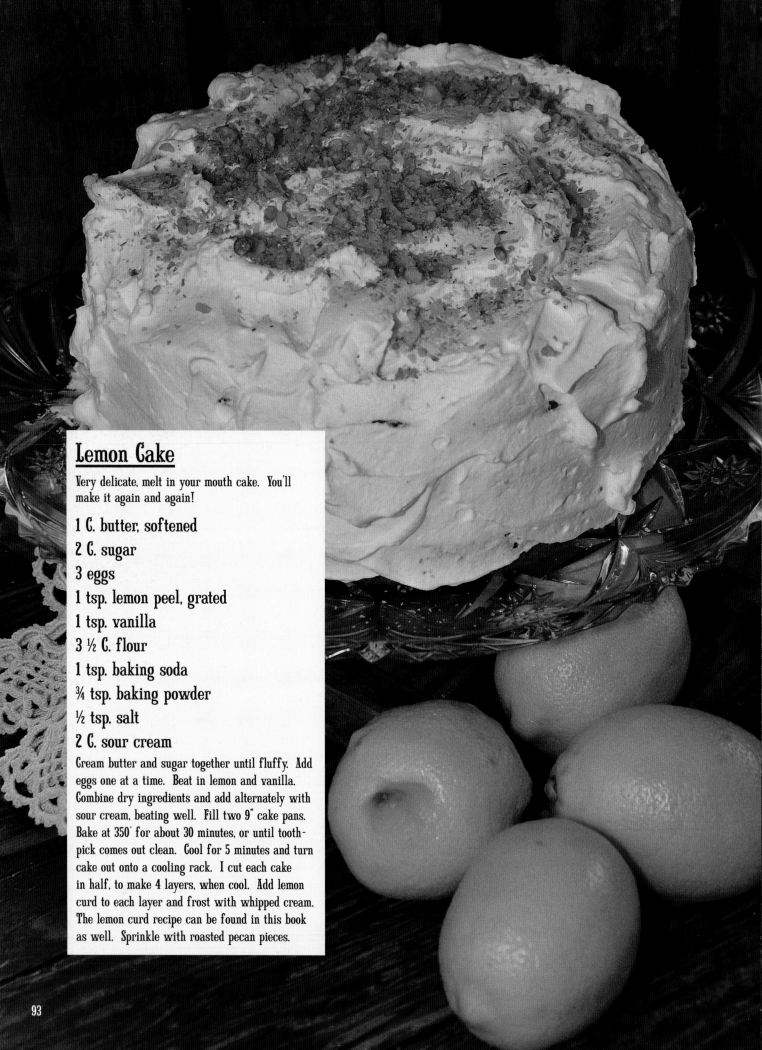

Lemon Cake

Very delicate, melt in your mouth cake. You'll make it again and again!

1 C. butter, softened

2 C. sugar

3 eggs

1 tsp. lemon peel, grated

1 tsp. vanilla

3 ½ C. flour

1 tsp. baking soda

¾ tsp. baking powder

½ tsp. salt

2 C. sour cream

Cream butter and sugar together until fluffy. Add eggs one at a time. Beat in lemon and vanilla. Combine dry ingredients and add alternately with sour cream, beating well. Fill two 9" cake pans. Bake at 350° for about 30 minutes, or until tooth-pick comes out clean. Cool for 5 minutes and turn cake out onto a cooling rack. I cut each cake in half, to make 4 layers, when cool. Add lemon curd to each layer and frost with whipped cream. The lemon curd recipe can be found in this book as well. Sprinkle with roasted pecan pieces.

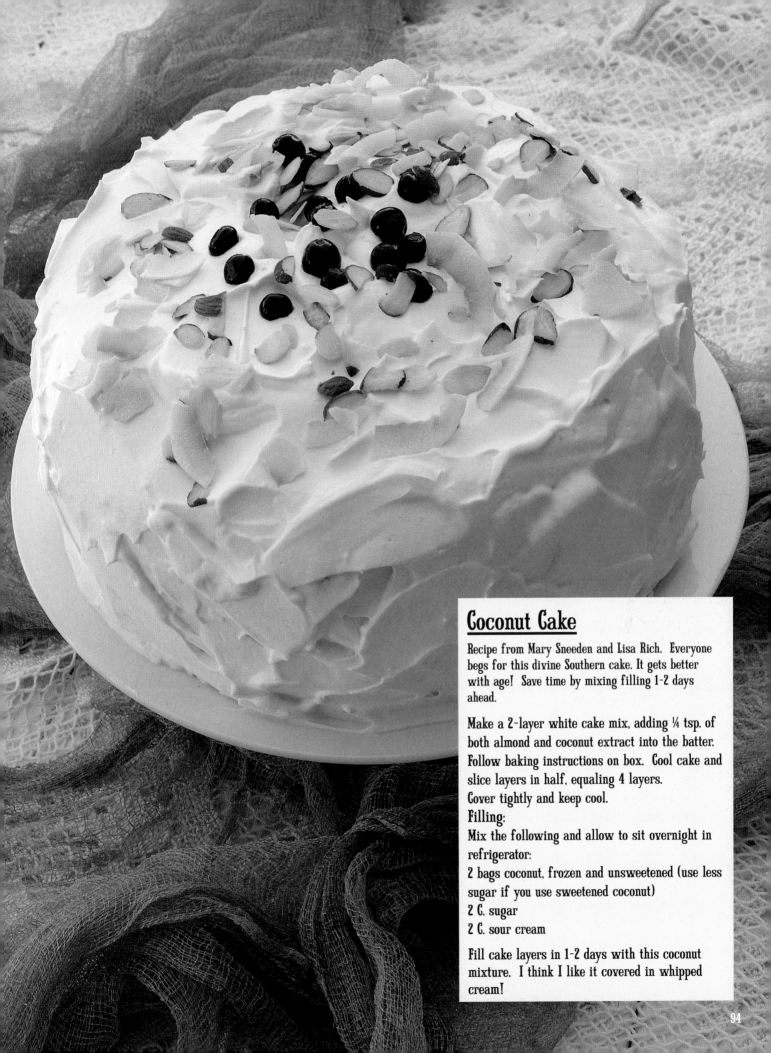

Coconut Cake

Recipe from Mary Sneeden and Lisa Rich. Everyone begs for this divine Southern cake. It gets better with age! Save time by mixing filling 1-2 days ahead.

Make a 2-layer white cake mix, adding ¼ tsp. of both almond and coconut extract into the batter. Follow baking instructions on box. Cool cake and slice layers in half, equaling 4 layers.
Cover tightly and keep cool.
Filling:
Mix the following and allow to sit overnight in refrigerator:
2 bags coconut, frozen and unsweetened (use less sugar if you use sweetened coconut)
2 C. sugar
2 C. sour cream

Fill cake layers in 1-2 days with this coconut mixture. I think I like it covered in whipped cream!

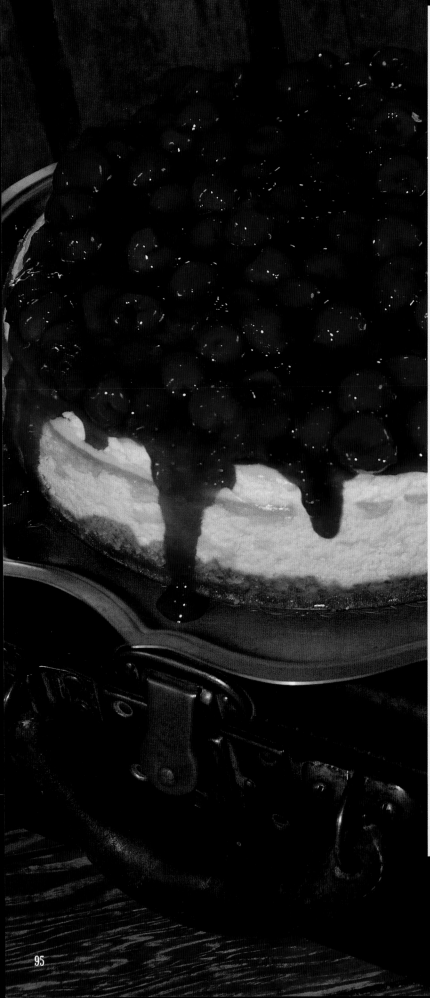

Cherry Cheesecake

You'll taste sweet success with this splendid dessert! It is a favorite of many. Lisa Rich sent me a recipe very similar to this one. She says, "Dick had me make this cheesecake for very special business people."

Crust:

¾ C. almonds, ground

1 C. almond meal or graham cracker crumbs

½ C. brown sugar

½ C. butter, melted

Mix together and press into the bottom of a 10-inch spring form pan.

Filling:

4 pkgs. (8 oz. each) cream cheese, softened

1 C. sugar

1 Tbsp. lemon juice

2 tsp vanilla

4 eggs

Beat filling mixture until smooth. Spoon over crust. Bake at 350˚ for 50 minutes. Let stand for 15 minutes.

Mix together and smooth over top of cheesecake:

2 C. sour cream

¼ C. sugar

1 tsp. vanilla

Return to oven for 8 minutes. Refrigerate cheesecake and cool.

Thicken:

2-3 C. sour cherries

½ C. sugar

2-3 Tbsp. cornstarch

Mix cornstarch with 2 tablespoons of water. Mix into cherries and sugar in saucepan. Cook over medium heat, stirring often. Allow to boil for one minute. Cool mixture.

Pour over cooled cheesecake. Loosen and remove sides of the spring form pan. People will rave!

PIES PASTRIES & DESSERTS

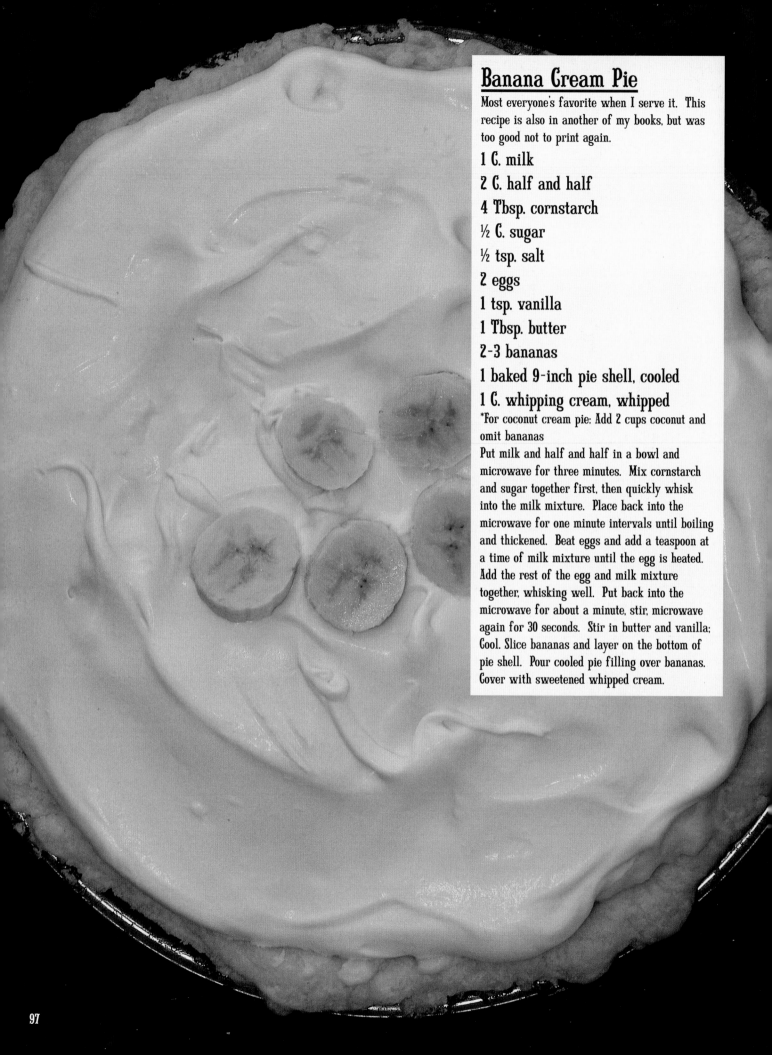

Banana Cream Pie

Most everyone's favorite when I serve it. This recipe is also in another of my books, but was too good not to print again.

1 C. milk

2 C. half and half

4 Tbsp. cornstarch

½ C. sugar

½ tsp. salt

2 eggs

1 tsp. vanilla

1 Tbsp. butter

2-3 bananas

1 baked 9-inch pie shell, cooled

1 C. whipping cream, whipped

*For coconut cream pie: Add 2 cups coconut and omit bananas

Put milk and half and half in a bowl and microwave for three minutes. Mix cornstarch and sugar together first, then quickly whisk into the milk mixture. Place back into the microwave for one minute intervals until boiling and thickened. Beat eggs and add a teaspoon at a time of milk mixture until the egg is heated. Add the rest of the egg and milk mixture together, whisking well. Put back into the microwave for about a minute, stir, microwave again for 30 seconds. Stir in butter and vanilla; Cool. Slice bananas and layer on the bottom of pie shell. Pour cooled pie filling over bananas. Cover with sweetened whipped cream.

REMEMBER
When...

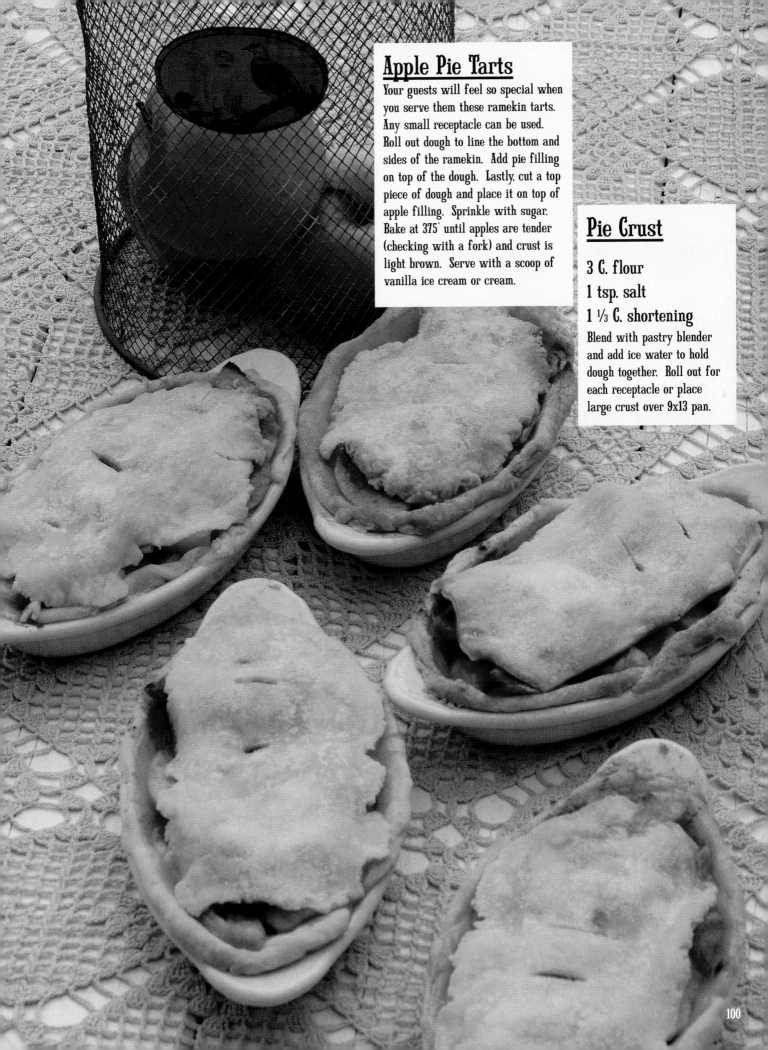

Apple Pie Tarts

Your guests will feel so special when
you serve them these ramekin tarts.
Any small receptacle can be used.
Roll out dough to line the bottom and
sides of the ramekin. Add pie filling
on top of the dough. Lastly, cut a top
piece of dough and place it on top of
apple filling. Sprinkle with sugar.
Bake at 375° until apples are tender
(checking with a fork) and crust is
light brown. Serve with a scoop of
vanilla ice cream or cream.

Pie Crust

3 C. flour
1 tsp. salt
1 ⅓ C. shortening

Blend with pastry blender
and add ice water to hold
dough together. Roll out for
each receptacle or place
large crust over 9x13 pan.

100

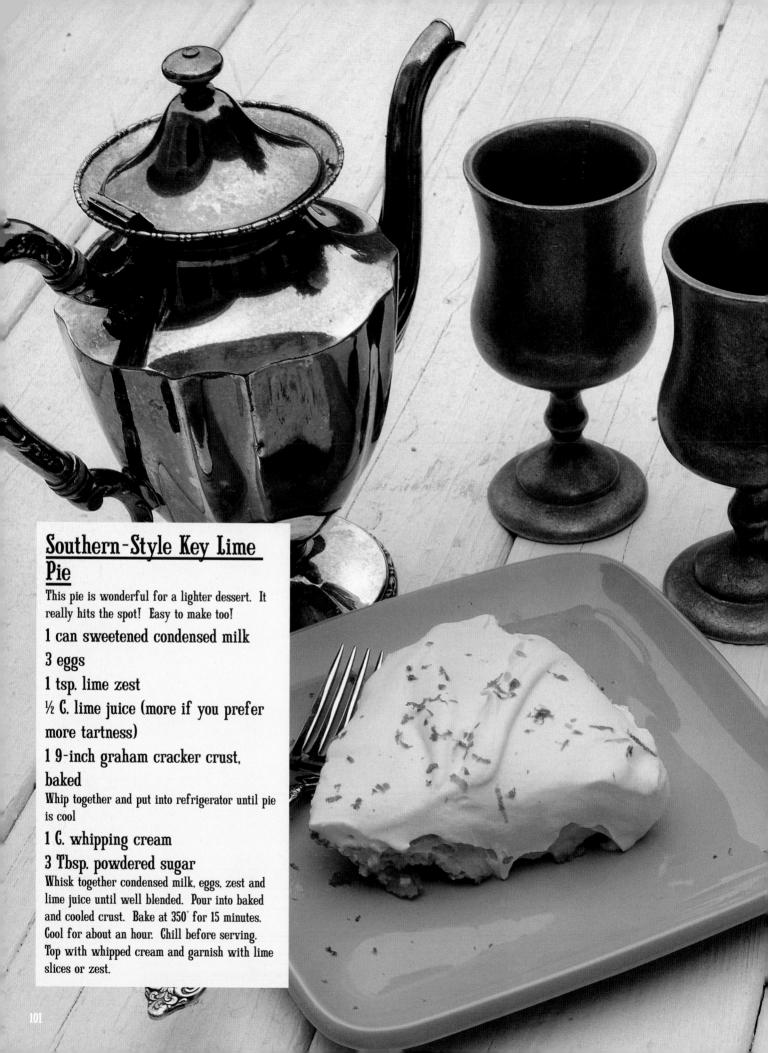

Southern-Style Key Lime Pie

This pie is wonderful for a lighter dessert. It really hits the spot! Easy to make too!

1 can sweetened condensed milk

3 eggs

1 tsp. lime zest

½ C. lime juice (more if you prefer more tartness)

1 9-inch graham cracker crust, baked

Whip together and put into refrigerator until pie is cool

1 C. whipping cream

3 Tbsp. powdered sugar

Whisk together condensed milk, eggs, zest and lime juice until well blended. Pour into baked and cooled crust. Bake at 350˚ for 15 minutes. Cool for about an hour. Chill before serving. Top with whipped cream and garnish with lime slices or zest.

Southern White Chocolate Tart

Very rich and very good. Those Southerners can surely serve some great food!

1 pkg. (4 oz.) white chocolate, divided

3 Tbsp. butter

½ C. almond flour

2 C. almonds, ground

1 pkg. white chocolate Jell-O instant pudding

1 C. plus 2 Tbsp. milk, divided

1 C. heavy whipping cream, whipped

10 Kraft caramels

¼ tsp. sea salt

Coconut, shaved and toasted or toasted almonds

Place 2 oz. white chocolate and butter in a bowl. Heat in microwave until butter is melted. Stir until chocolate is completely melted. Stir in ground almonds and almond flour. Spread nut mixture on the bottom of buttered pie pan and up the sides. Bake @ 350° for 15 minutes or until lightly browned. Cool. Melt remaining chocolate. Beat pudding mix as package directs with 1 cup milk. Stir in melted chocolate then 1 cup whipped cream until blended. Pour into crust and refrigerate until firm. Microwave caramels and remaining 2 tablespoons milk about 45 seconds, stirring until caramels are melted. Cool about 8-10 minutes. Drizzle caramel sauce over top of tart. Sprinkle with salt and toasted almonds or coconut.

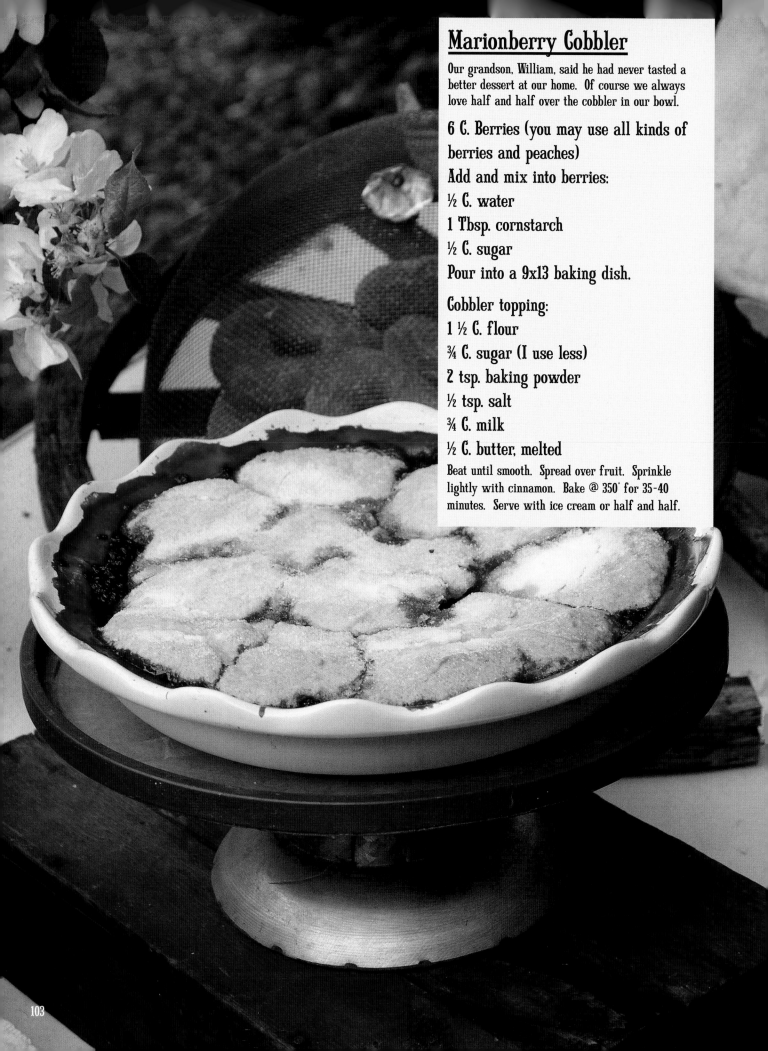

Marionberry Cobbler

Our grandson, William, said he had never tasted a better dessert at our home. Of course we always love half and half over the cobbler in our bowl.

6 C. Berries (you may use all kinds of berries and peaches)

Add and mix into berries:

½ C. water

1 Tbsp. cornstarch

½ C. sugar

Pour into a 9x13 baking dish.

Cobbler topping:

1 ½ C. flour

¾ C. sugar (I use less)

2 tsp. baking powder

½ tsp. salt

¾ C. milk

½ C. butter, melted

Beat until smooth. Spread over fruit. Sprinkle lightly with cinnamon. Bake @ 350° for 35-40 minutes. Serve with ice cream or half and half.

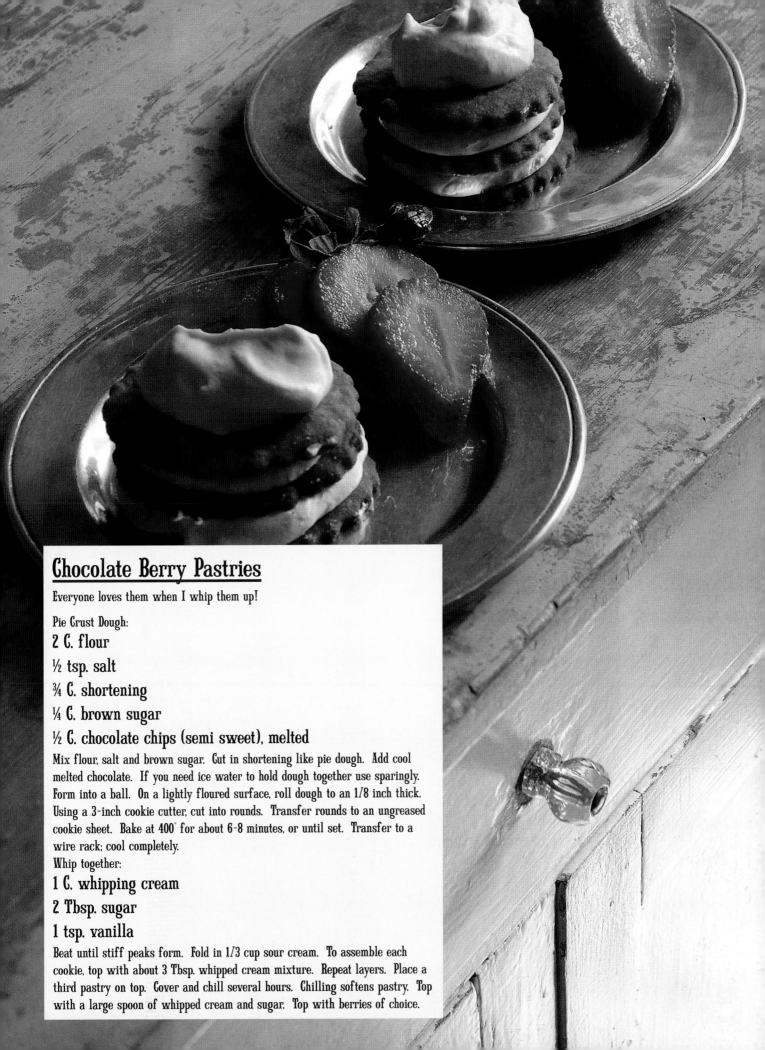

Chocolate Berry Pastries

Everyone loves them when I whip them up!

Pie Crust Dough:

2 C. flour

½ tsp. salt

¾ C. shortening

¼ C. brown sugar

½ C. chocolate chips (semi sweet), melted

Mix flour, salt and brown sugar. Cut in shortening like pie dough. Add cool melted chocolate. If you need ice water to hold dough together use sparingly. Form into a ball. On a lightly floured surface, roll dough to an 1/8 inch thick. Using a 3-inch cookie cutter, cut into rounds. Transfer rounds to an ungreased cookie sheet. Bake at 400˚ for about 6-8 minutes, or until set. Transfer to a wire rack; cool completely.

Whip together:

1 C. whipping cream

2 Tbsp. sugar

1 tsp. vanilla

Beat until stiff peaks form. Fold in 1/3 cup sour cream. To assemble each cookie, top with about 3 Tbsp. whipped cream mixture. Repeat layers. Place a third pastry on top. Cover and chill several hours. Chilling softens pastry. Top with a large spoon of whipped cream and sugar. Top with berries of choice.

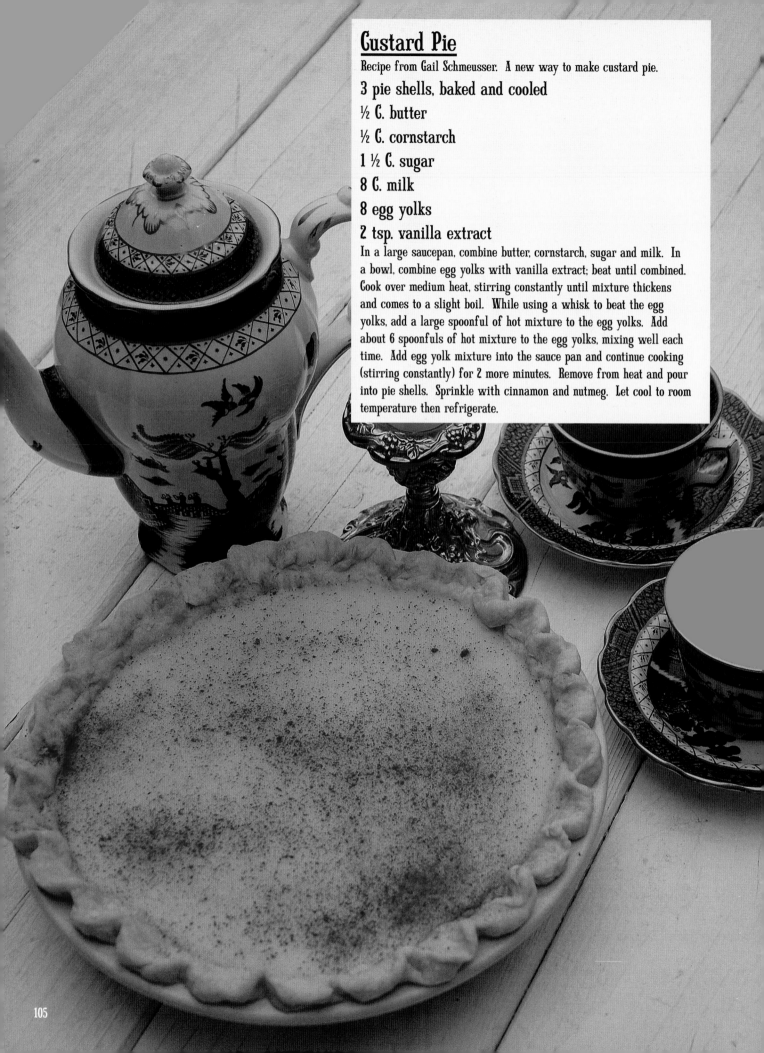

Custard Pie

Recipe from Gail Schmeusser. A new way to make custard pie.

3 pie shells, baked and cooled
½ C. butter
½ C. cornstarch
1 ½ C. sugar
8 C. milk
8 egg yolks
2 tsp. vanilla extract

In a large saucepan, combine butter, cornstarch, sugar and milk. In a bowl, combine egg yolks with vanilla extract; beat until combined. Cook over medium heat, stirring constantly until mixture thickens and comes to a slight boil. While using a whisk to beat the egg yolks, add a large spoonful of hot mixture to the egg yolks. Add about 6 spoonfuls of hot mixture to the egg yolks, mixing well each time. Add egg yolk mixture into the sauce pan and continue cooking (stirring constantly) for 2 more minutes. Remove from heat and pour into pie shells. Sprinkle with cinnamon and nutmeg. Let cool to room temperature then refrigerate.

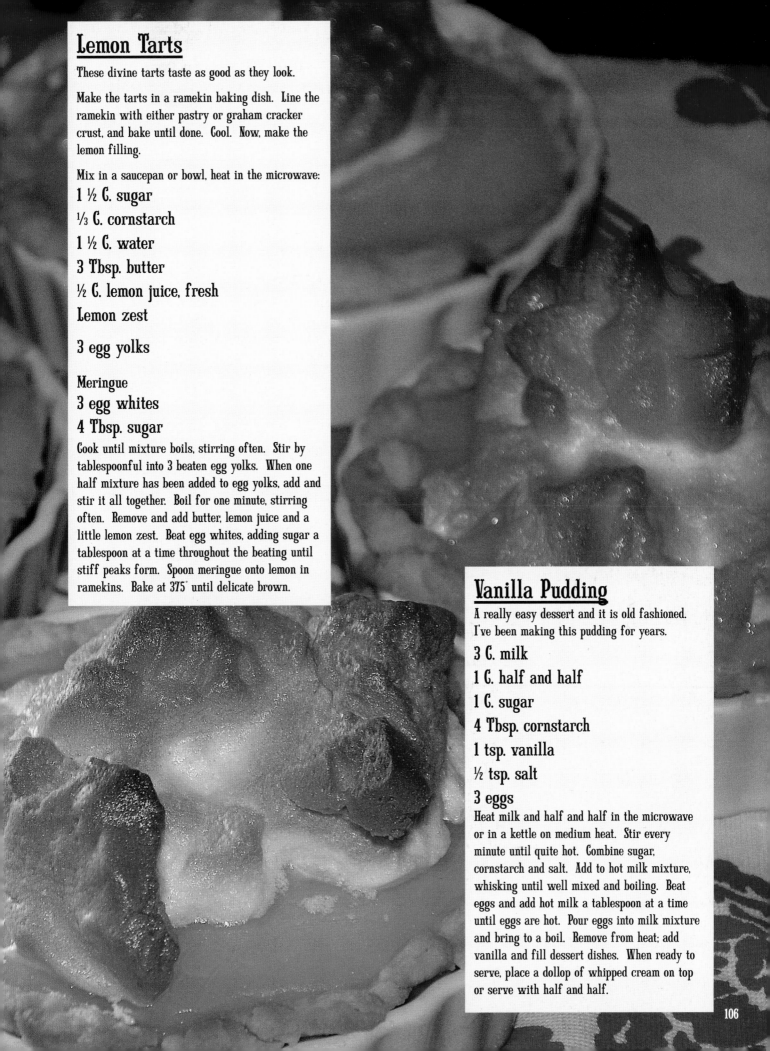

Lemon Tarts

These divine tarts taste as good as they look.

Make the tarts in a ramekin baking dish. Line the ramekin with either pastry or graham cracker crust, and bake until done. Cool. Now, make the lemon filling.

Mix in a saucepan or bowl, heat in the microwave:

1 ½ C. sugar

⅓ C. cornstarch

1 ½ C. water

3 Tbsp. butter

½ C. lemon juice, fresh

Lemon zest

3 egg yolks

Meringue

3 egg whites

4 Tbsp. sugar

Cook until mixture boils, stirring often. Stir by tablespoonful into 3 beaten egg yolks. When one half mixture has been added to egg yolks, add and stir it all together. Boil for one minute, stirring often. Remove and add butter, lemon juice and a little lemon zest. Beat egg whites, adding sugar a tablespoon at a time throughout the beating until stiff peaks form. Spoon meringue onto lemon in ramekins. Bake at 375˚ until delicate brown.

Vanilla Pudding

A really easy dessert and it is old fashioned. I've been making this pudding for years.

3 C. milk

1 C. half and half

1 C. sugar

4 Tbsp. cornstarch

1 tsp. vanilla

½ tsp. salt

3 eggs

Heat milk and half and half in the microwave or in a kettle on medium heat. Stir every minute until quite hot. Combine sugar, cornstarch and salt. Add to hot milk mixture, whisking until well mixed and boiling. Beat eggs and add hot milk a tablespoon at a time until eggs are hot. Pour eggs into milk mixture and bring to a boil. Remove from heat; add vanilla and fill dessert dishes. When ready to serve, place a dollop of whipped cream on top or serve with half and half.

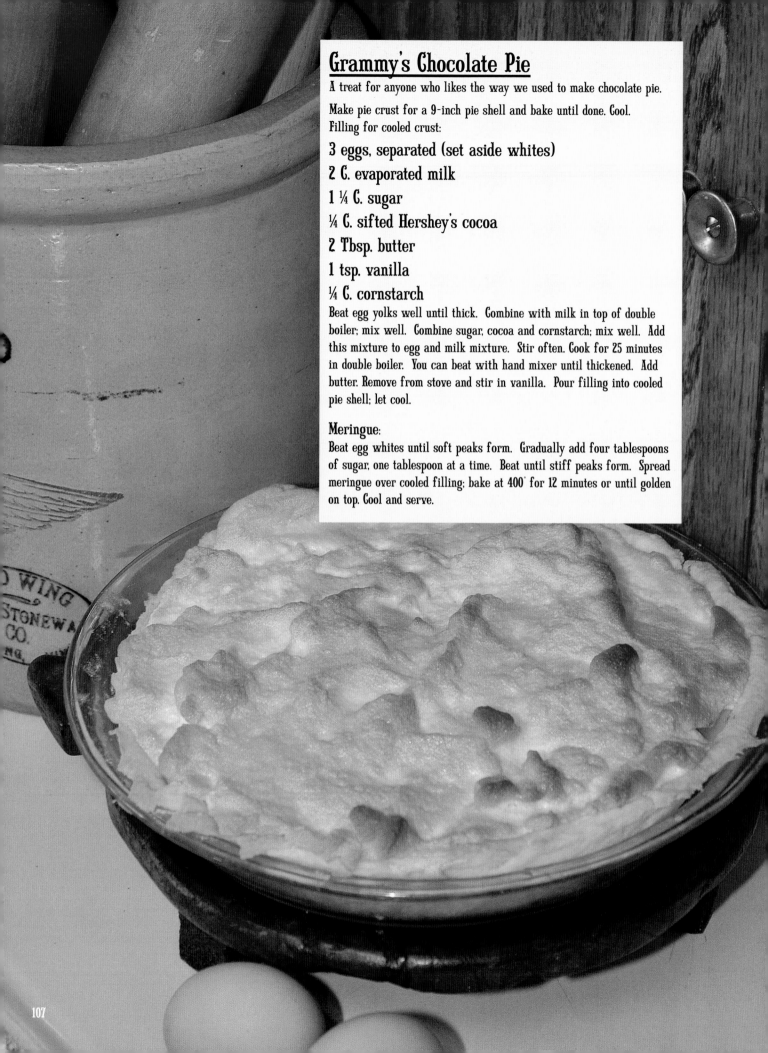

Grammy's Chocolate Pie

A treat for anyone who likes the way we used to make chocolate pie.

Make pie crust for a 9-inch pie shell and bake until done. Cool. Filling for cooled crust:

3 eggs, separated (set aside whites)

2 C. evaporated milk

1 ¼ C. sugar

¼ C. sifted Hershey's cocoa

2 Tbsp. butter

1 tsp. vanilla

¼ C. cornstarch

Beat egg yolks well until thick. Combine with milk in top of double boiler; mix well. Combine sugar, cocoa and cornstarch; mix well. Add this mixture to egg and milk mixture. Stir often. Cook for 25 minutes in double boiler. You can beat with hand mixer until thickened. Add butter. Remove from stove and stir in vanilla. Pour filling into cooled pie shell; let cool.

Meringue:

Beat egg whites until soft peaks form. Gradually add four tablespoons of sugar, one tablespoon at a time. Beat until stiff peaks form. Spread meringue over cooled filling; bake at 400° for 12 minutes or until golden on top. Cool and serve.

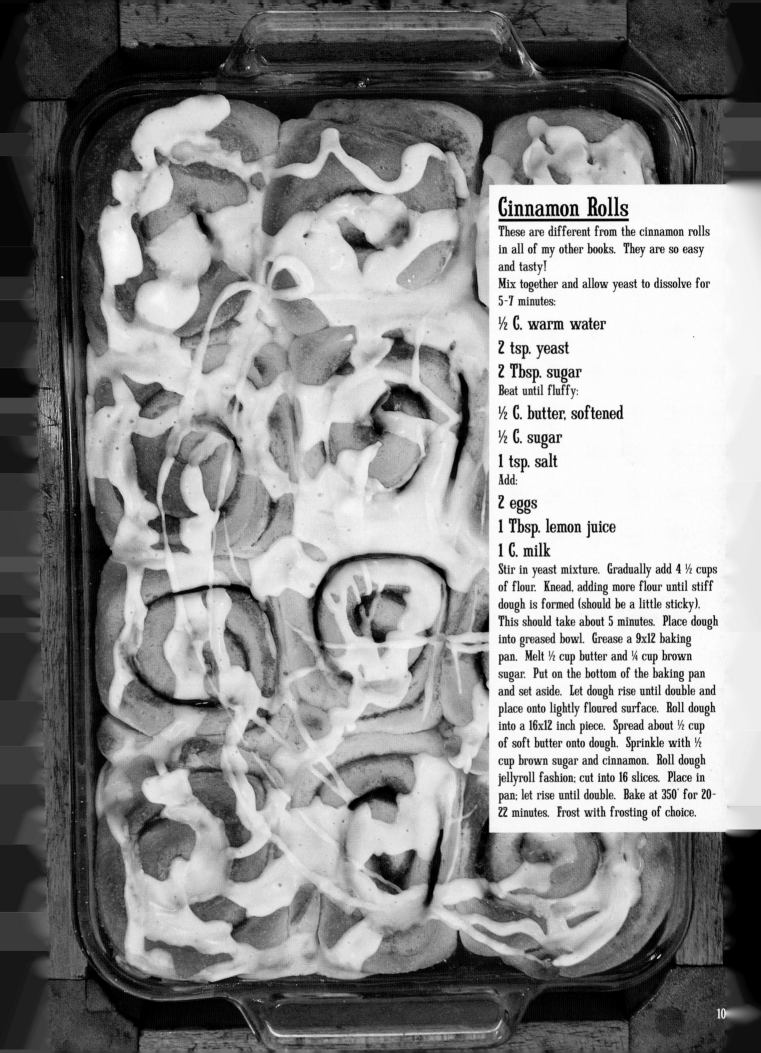

Cinnamon Rolls

These are different from the cinnamon rolls in all of my other books. They are so easy and tasty!

Mix together and allow yeast to dissolve for 5-7 minutes:

½ C. warm water

2 tsp. yeast

2 Tbsp. sugar

Beat until fluffy:

½ C. butter, softened

½ C. sugar

1 tsp. salt

Add:

2 eggs

1 Tbsp. lemon juice

1 C. milk

Stir in yeast mixture. Gradually add 4 ½ cups of flour. Knead, adding more flour until stiff dough is formed (should be a little sticky). This should take about 5 minutes. Place dough into greased bowl. Grease a 9x12 baking pan. Melt ½ cup butter and ¼ cup brown sugar. Put on the bottom of the baking pan and set aside. Let dough rise until double and place onto lightly floured surface. Roll dough into a 16x12 inch piece. Spread about ½ cup of soft butter onto dough. Sprinkle with ½ cup brown sugar and cinnamon. Roll dough jellyroll fashion; cut into 16 slices. Place in pan; let rise until double. Bake at 350° for 20-22 minutes. Frost with frosting of choice.

Char's Black Hawk Fudge Sauce

Charlotte Lambert has served this delicious fudge sauce since 1972. Char has never shared this recipe before. Aren't we lucky?

I like to chop pecans (about ½ cup), and add to the cooked sauce, or put on top of the hot fudge when served.

1 C. butter

2 squares (1 oz. each) semi-sweet chocolate

1 ½ C. granulated sugar

½ C. unsweetened cocoa powder

1 C. heavy whipping cream

2 tsp. pure vanilla extract

Melt the butter and chocolate in a saucepan. Add sugar, cocoa and cream. Stir constantly, bringing to a full, rolling boil. Remove from heat and add vanilla. Blend well. Refrigerate in a glass jar. Heat before using.

Kids nowadays really aren't like we were, growing up in the country on a farm. My first date with Sonny was in an old red and white 1952 Studebaker pick-up truck. Oh my goodness, what a classy truck! At least that's what I thought. Maybe it was just who was driving the pickup! Wishing we had a truck like that now...wondering what happened to Sonny's gorgeous Studebaker?!

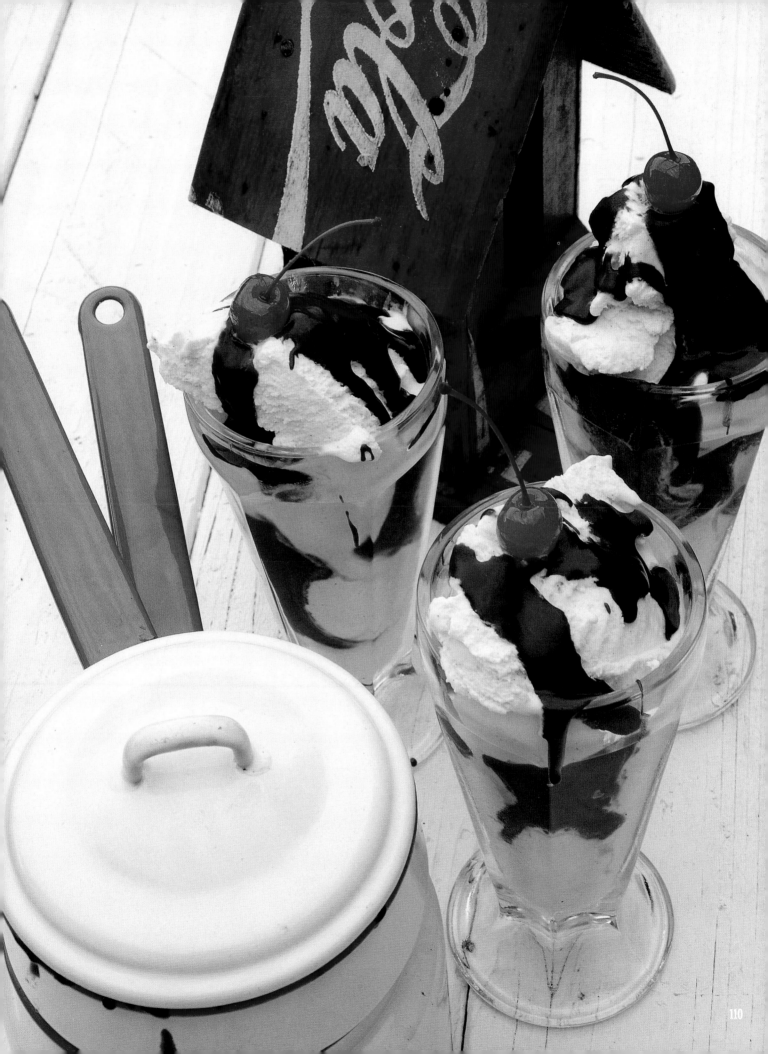

Grandma's Prune Pastry

This recipe is simple and will delight anyone you serve it to.
Use the recipe of choice for prune tart pastry crust. Cook and sweeten
about 3 cups of pitted prunes. Cool. Roll half of dough for a large
baking pan, quite thin. Place dough on pan, cover with cooked prunes.
Roll another piece of dough thin and place on top of prunes. Sprinkle
with white sugar and prick dough with a fork before baking. Bake for
25-35 minutes at 375° until a nice golden brown. Cut into desired pieces.

Prune Tarts

This recipe is from Marie Rotschy.

Mix like pie crust:

4 C. flour

¼ C. sugar

1 lb. margarine

Add and chill:

2 eggs, beaten

½ C. milk

Cook over medium heat, until they are falling apart:

2 lbs. prunes, pitted

Add a little sugar, depending on taste.

Roll out small amounts of dough to pie crust thickness.
Cut dough into small squares (about 2 inches). Put
spoonful of prunes in center and fold opposite corners
together or cut corners ½ inch up and fold every other
corner to center. Sprinkle with sugar and bake at 375°
for 10-15 minutes. Do not overbake.

"Sing we joyous all together, fa, la, la, la,
La, la, la, la..."
- from "Deck The Halls"

Custard Peach Pie

This pie is a must for you to try! "The best peach pie ever," voices Kelly White. Kelly is a special hunting partner. He invited us to hunt on his vast acreage in Kettle Falls, WA, near the Canadian border. It was well worth the cost and also my first hunting trip! I was able to shoot my first white tailed buck. Wow! Too scary, I can't hunt anymore, although I was very satisfied with my prize.

Mix well:

7-8 ripe peaches, sliced (fresh peaches are best)

1 C. sugar

2 Tbsp. cornstarch

Splash of vanilla

Shake of cinnamon

Add and mix:

1 C. thick whipping cream

Dump into an unbaked pie crust. Bake @ 375° for about an hour. Pie should be bubbling in the center and the crust browned. Cool and eat cold. You won't have any left over for tomorrow!

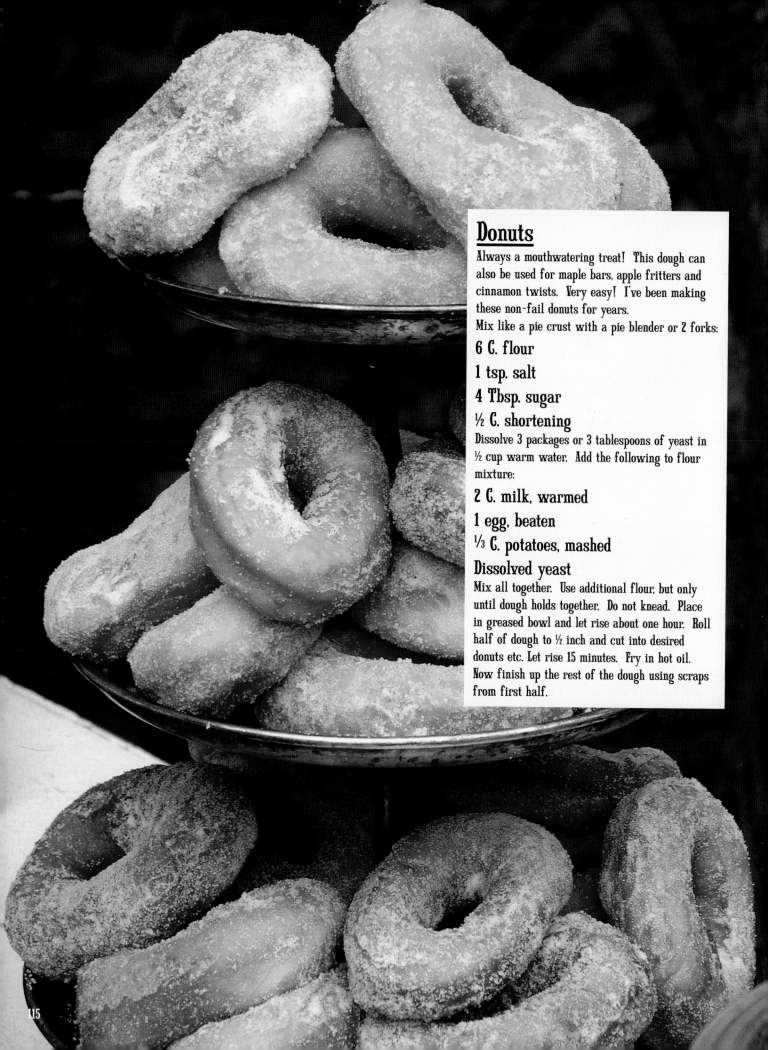

Donuts

Always a mouthwatering treat! This dough can also be used for maple bars, apple fritters and cinnamon twists. Very easy! I've been making these non-fail donuts for years.

Mix like a pie crust with a pie blender or 2 forks:

6 C. flour

1 tsp. salt

4 Tbsp. sugar

½ C. shortening

Dissolve 3 packages or 3 tablespoons of yeast in ½ cup warm water. Add the following to flour mixture:

2 C. milk, warmed

1 egg, beaten

⅓ C. potatoes, mashed

Dissolved yeast

Mix all together. Use additional flour, but only until dough holds together. Do not knead. Place in greased bowl and let rise about one hour. Roll half of dough to ½ inch and cut into desired donuts etc. Let rise 15 minutes. Fry in hot oil. Now finish up the rest of the dough using scraps from first half.

Mementos of Past Times

If you live on a farm or your house in the city is old, you are lucky! If you have old construction elements, think twice about replacing them with new! Very often you will find old pieces of wooden items from windows, door frames, and even old stove parts will work with a little elbow grease! Renovate them into your home, adding history and unique details. Oh, the remarks your friends will make, "where did you get that?" I have two old stoves from estate sales in my house. One works and one collects this and that, but the charm they add is beautiful and the visions of past times go through your mind. What more can you wish for?

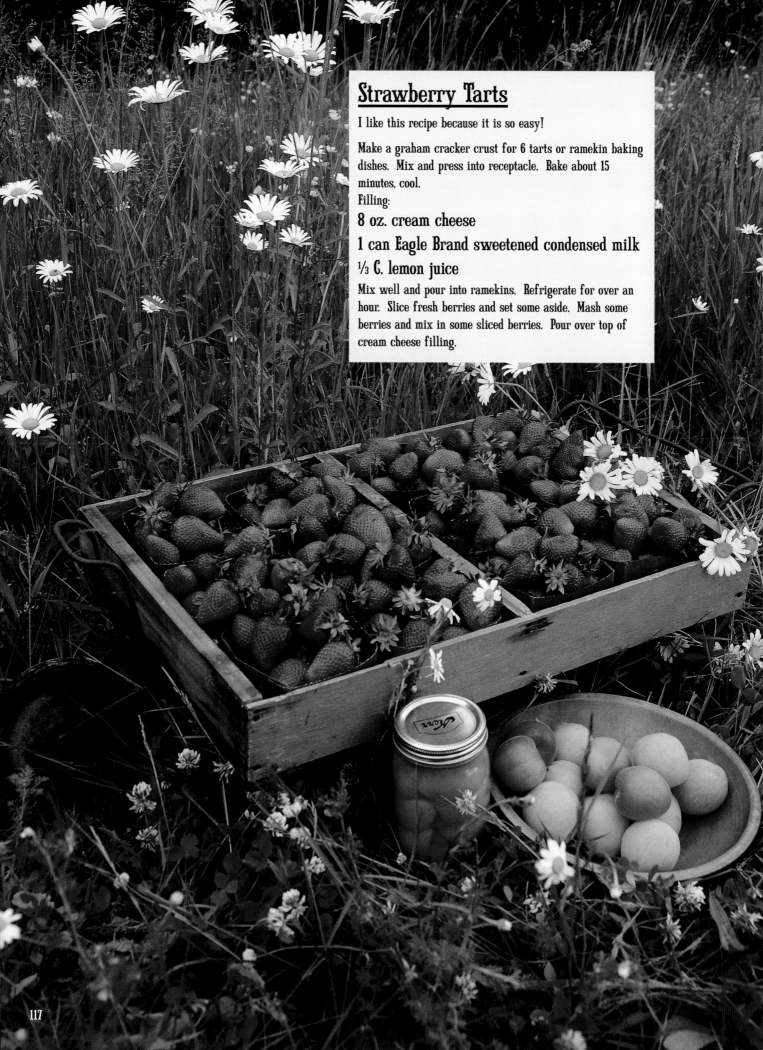

Strawberry Tarts

I like this recipe because it is so easy!

Make a graham cracker crust for 6 tarts or ramekin baking dishes. Mix and press into receptacle. Bake about 15 minutes, cool.

Filling:

8 oz. cream cheese

1 can Eagle Brand sweetened condensed milk

⅓ C. lemon juice

Mix well and pour into ramekins. Refrigerate for over an hour. Slice fresh berries and set some aside. Mash some berries and mix in some sliced berries. Pour over top of cream cheese filling.

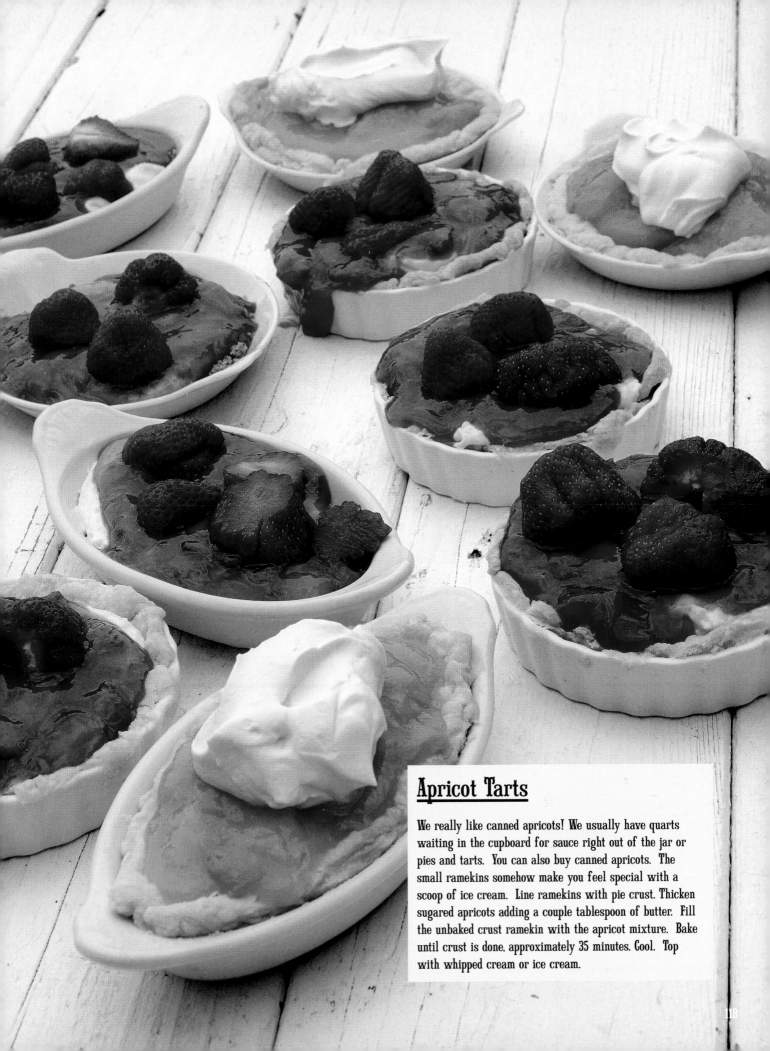

Apricot Tarts

We really like canned apricots! We usually have quarts
waiting in the cupboard for sauce right out of the jar or
pies and tarts. You can also buy canned apricots. The
small ramekins somehow make you feel special with a
scoop of ice cream. Line ramekins with pie crust. Thicken
sugared apricots adding a couple tablespoon of butter. Fill
the unbaked crust ramekin with the apricot mixture. Bake
until crust is done, approximately 35 minutes. Cool. Top
with whipped cream or ice cream.

My brother Mark and I ran wild on our farm. We have five younger siblings who often followed in our footsteps. Linda, Stanly, Jack, Lyle and Keith experienced much of the same remarkable life with parents to guide and direct us. It was a good life on that farm, so long ago! We built 2x4' tall playhouses. There were always the cows to milk and the pigs to feed. The sound of the pigs squealing was fascinating to hear. Always the hiss of the cats rang out in the barn, and the dark corners were scary. My cousins, Sharon, Kay and Leila lived close by and words can never express the joy and fun we shared. No telephones, no computers, no television, only the overwhelming interesting things nature supplied. We welcomed each new discovery with unbounded anticipation. We found life's greatest joys come not on the fast track, but on rugged trails, corn fields, beaver ponds and creeks slowly flowing along. There was not much money to spend when we were children. Instead of wanting everything money can buy, and wanting it right now, we never knew what we were missing because we were happy and content just like it was. We appreciated and loved each other. Oh, I must confess we had a few quarrels, squabbles and tears. Life!

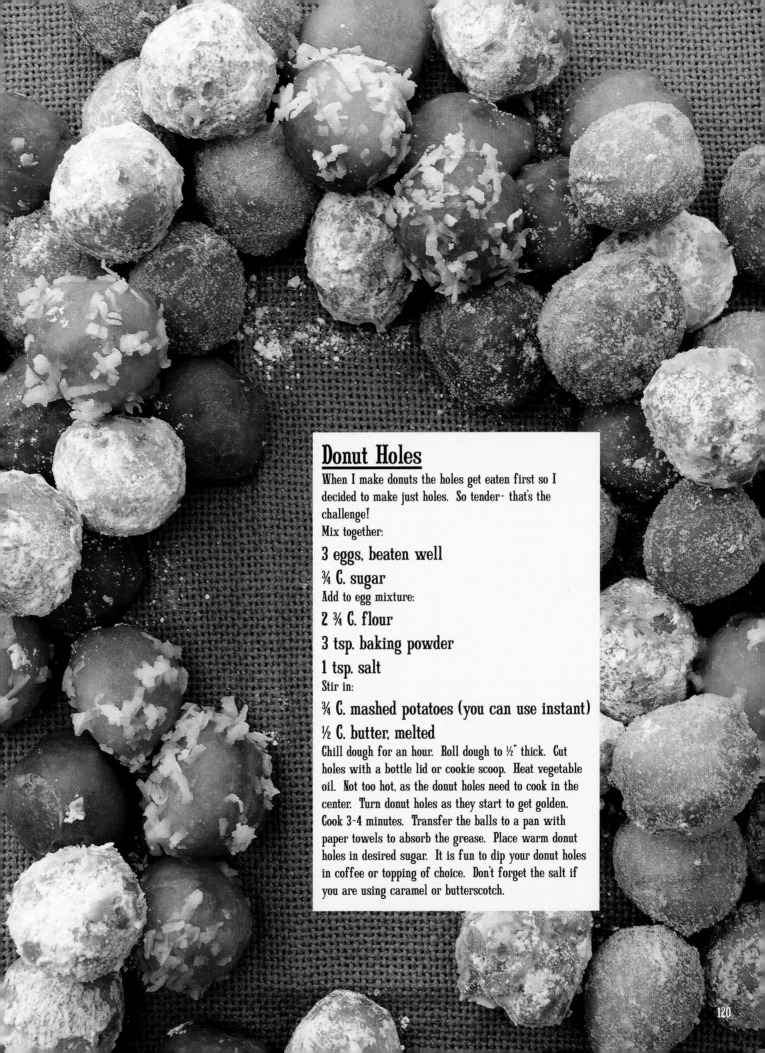

Donut Holes

When I make donuts the holes get eaten first so I decided to make just holes. So tender- that's the challenge!

Mix together:

3 eggs, beaten well

¾ C. sugar

Add to egg mixture:

2 ¾ C. flour

3 tsp. baking powder

1 tsp. salt

Stir in:

¾ C. mashed potatoes (you can use instant)

½ C. butter, melted

Chill dough for an hour. Roll dough to ½" thick. Cut holes with a bottle lid or cookie scoop. Heat vegetable oil. Not too hot, as the donut holes need to cook in the center. Turn donut holes as they start to get golden. Cook 3-4 minutes. Transfer the balls to a pan with paper towels to absorb the grease. Place warm donut holes in desired sugar. It is fun to dip your donut holes in coffee or topping of choice. Don't forget the salt if you are using caramel or butterscotch.

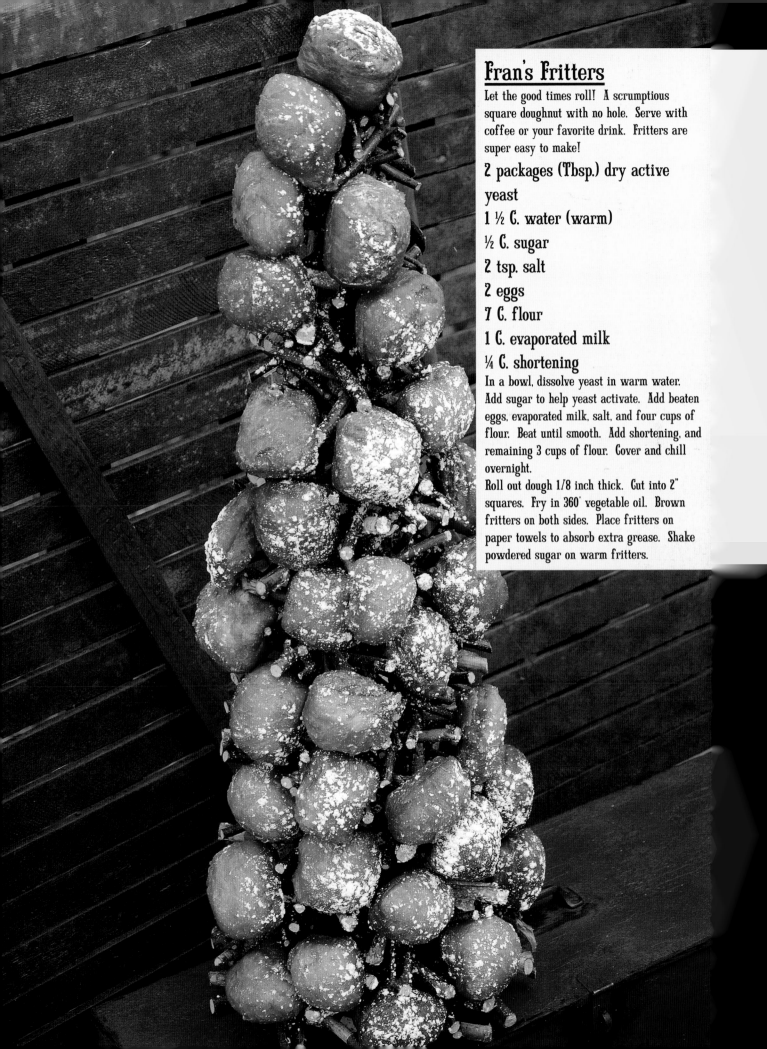

Fran's Fritters

Let the good times roll! A scrumptious square doughnut with no hole. Serve with coffee or your favorite drink. Fritters are super easy to make!

2 packages (Tbsp.) dry active yeast

1 ½ C. water (warm)

½ C. sugar

2 tsp. salt

2 eggs

7 C. flour

1 C. evaporated milk

¼ C. shortening

In a bowl, dissolve yeast in warm water. Add sugar to help yeast activate. Add beaten eggs, evaporated milk, salt, and four cups of flour. Beat until smooth. Add shortening, and remaining 3 cups of flour. Cover and chill overnight.

Roll out dough 1/8 inch thick. Cut into 2" squares. Fry in 360˚ vegetable oil. Brown fritters on both sides. Place fritters on paper towels to absorb extra grease. Shake powdered sugar on warm fritters.

Would you like to cozy up to your valentine next
to a crackling fireplace, an open fire in a teepee,
or would you enjoy walking along the ocean?
Whatever you do enjoy...do it... life is short!

Cream Puffs

Recipe from daughter Heidi Esteb. These are
a hit anytime. In years gone by, we had lots
of eggs, so... we made cream puffs!

1 C. water

½ C. butter

1 C. flour

4 eggs

Bring water and butter to a boil. Stir in
flour. Stir vigorously over low heat until
a ball forms. Remove from heat. Beat in
the eggs all at once. Continue beating until
smooth. Drop dough by scant ¼ cupful an
inch apart onto ungreased cookie sheet.
Bake at 400° until puffed and golden, about
35-38 minutes. Cool away from a draft. Cut
off tops, pull out filaments of soft dough.
Fill puffs with your favorite filling.

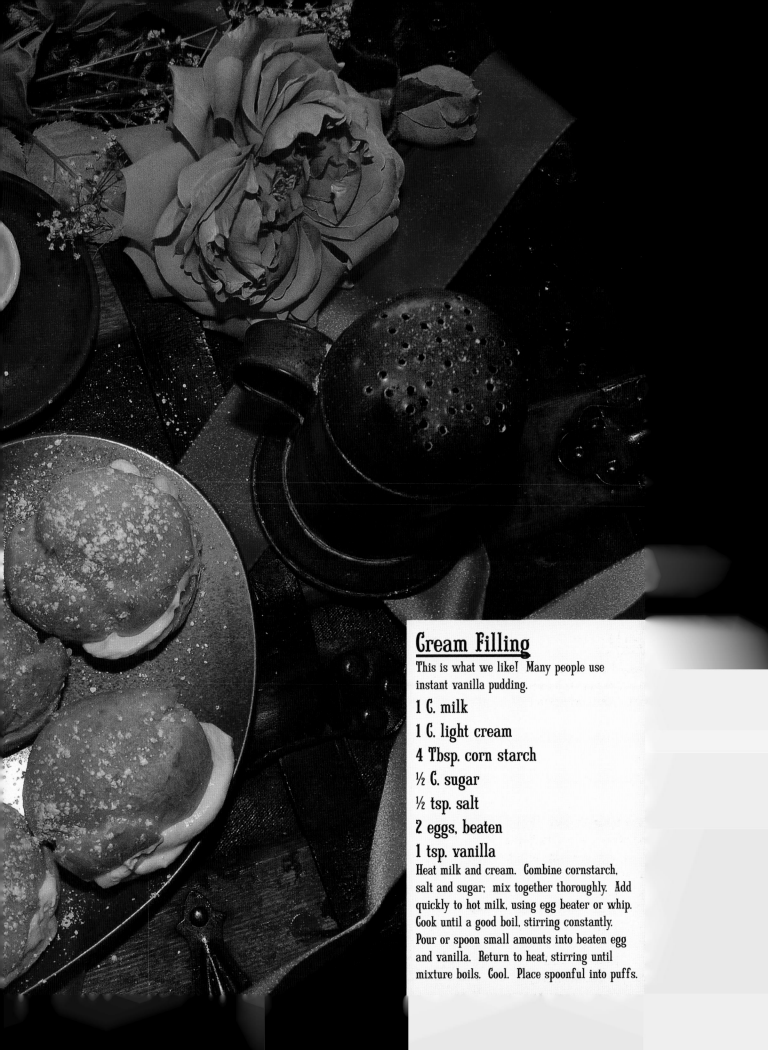

Cream Filling

This is what we like! Many people use instant vanilla pudding.

1 C. milk

1 C. light cream

4 Tbsp. corn starch

½ C. sugar

½ tsp. salt

2 eggs, beaten

1 tsp. vanilla

Heat milk and cream. Combine cornstarch, salt and sugar; mix together thoroughly. Add quickly to hot milk, using egg beater or whip. Cook until a good boil, stirring constantly. Pour or spoon small amounts into beaten egg and vanilla. Return to heat, stirring until mixture boils. Cool. Place spoonful into puffs.

Southern Sheet Cake

Somehow Texas claimed this sheet cake as its own. We've made a similar sheet cake for years called "Lark's Chocolate Cake" that can be found in one of my other cookbooks.

1 ½ C. any fizzy soft drink

1 C. vegetable oil

½ C. unsweetened cocoa

2 C. flour

1 C. white sugar

1 C. light brown sugar, packed

1 ½ tsp. baking soda

½ tsp. salt

½ C. buttermilk

2 large eggs, beaten

2 tsp. vanilla

1 ½ C. roasted pecans, chopped

Preheat oven to 350˚. Bring first three ingredients to a boil, stirring continuously. Remove from heat. Mix together dry ingredients. Add boiled mixture to dry ingredients and mix until blended. Mix in buttermilk, eggs and vanilla. Pour batter into a greased 12x17 inch sheet pan. Bake for 20-22 minutes until toothpick comes out clean. Frost cake while warm and immediately sprinkle with 1 ½ cups of chopped roasted pecans.

Fudge Icing:

½ C. butter

6.8 oz. Hershey's Special chocolate bar

3 Tbsp. milk

3 Tbsp. any fizzy soft drink

4 C. powdered sugar

1 tsp. vanilla

Cook butter and chocolate over medium heat until smooth and melted completely, stirring continuously. Remove from heat and add milk and soft drink. Gradually add powdered sugar and vanilla, whisking until smooth.

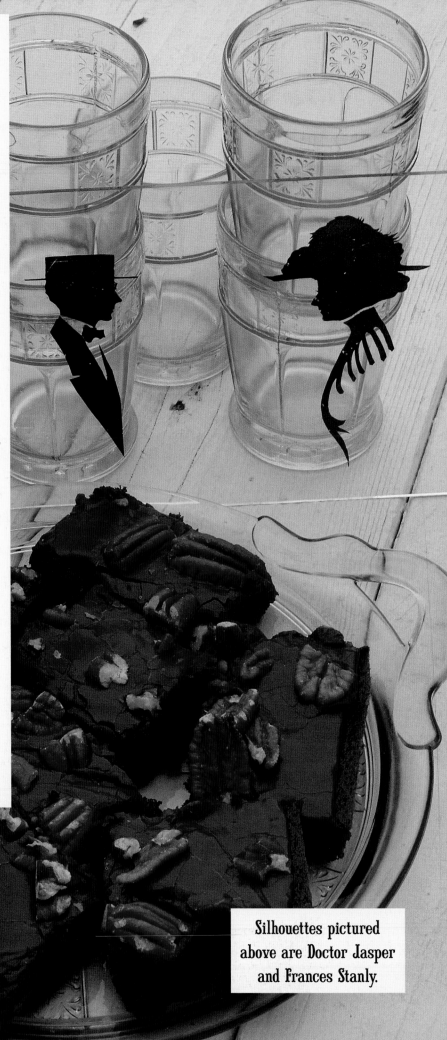

Silhouettes pictured above are Doctor Jasper and Frances Stanly.

Wilmington, North Carolina

The next few pages are dedicated to my lovely steadfast grandparents. Doctor Jasper and Frances Stanly lived in Wilmington, North Carolina, six miles from the Atlantic Ocean. My grandfather had a flourishing practice of dentistry and my grandmother was truly a southern lady. True examples of love and forgiveness were practiced in their home for all their children and grandchildren. They were abundantly supplied with assets and had more than enough to gratify normal needs, always sharing and helping someone.

Our great-granddaughter, Marilla Carlson, made
this flag picture in school and gave it to us!

Southern Banana Pudding

My daughter Lori always makes a delightful
and rich version of this timeless recipe,
passed down from my Mother.

1 box Vanilla Wafer cookies
1 (5.1 oz.) box instant vanilla
pudding
2 ½ C. milk or half-n-half
2 tsp. vanilla
Bananas, 4 large
2 C. heavy whipping cream

Mix vanilla pudding with milk according
to box directions, mix in vanilla and set
aside. Line a 9x13 pan along bottom and
sides of the dish with vanilla wafers. Slice
bananas and layer over wafers. Whip heavy
whipping cream until it peaks and fold into
pudding mixture. Cover wafers and bananas
completely with pudding/whipping cream
mixture. Garnish top with crushed vanilla
wafers.

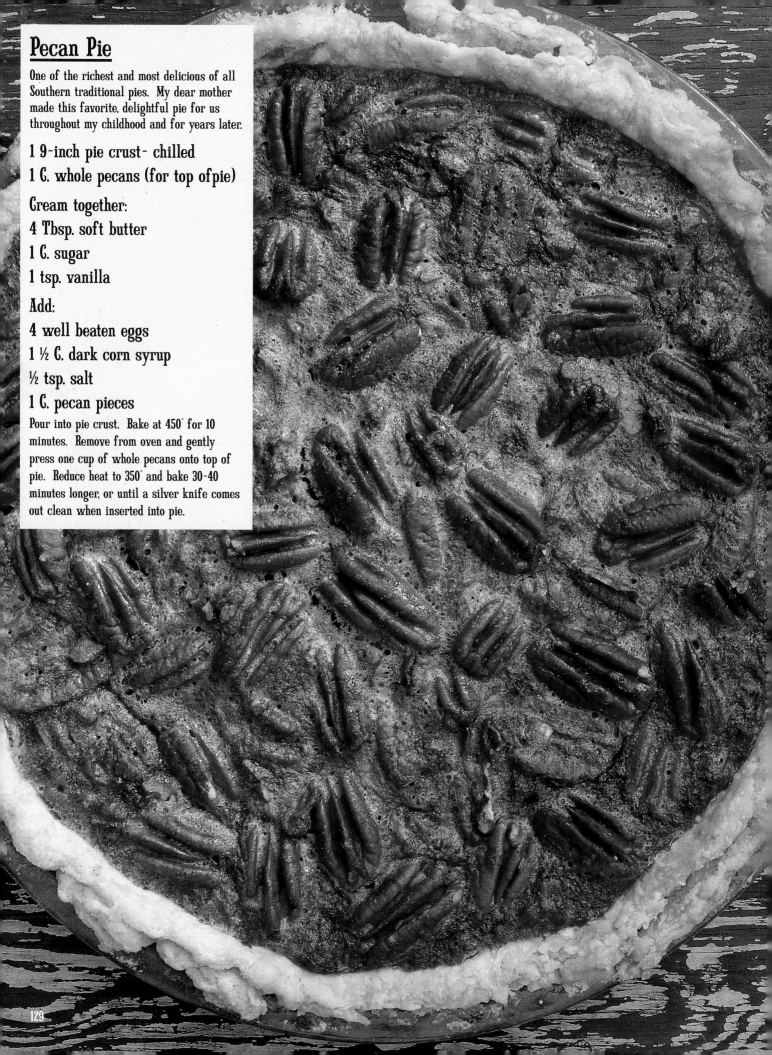

Pecan Pie

One of the richest and most delicious of all Southern traditional pies. My dear mother made this favorite, delightful pie for us throughout my childhood and for years later.

1 9-inch pie crust- chilled
1 C. whole pecans (for top of pie)

Cream together:

4 Tbsp. soft butter
1 C. sugar
1 tsp. vanilla

Add:

4 well beaten eggs
1 ½ C. dark corn syrup
½ tsp. salt
1 C. pecan pieces

Pour into pie crust. Bake at 450° for 10 minutes. Remove from oven and gently press one cup of whole pecans onto top of pie. Reduce heat to 350° and bake 30-40 minutes longer, or until a silver knife comes out clean when inserted into pie.

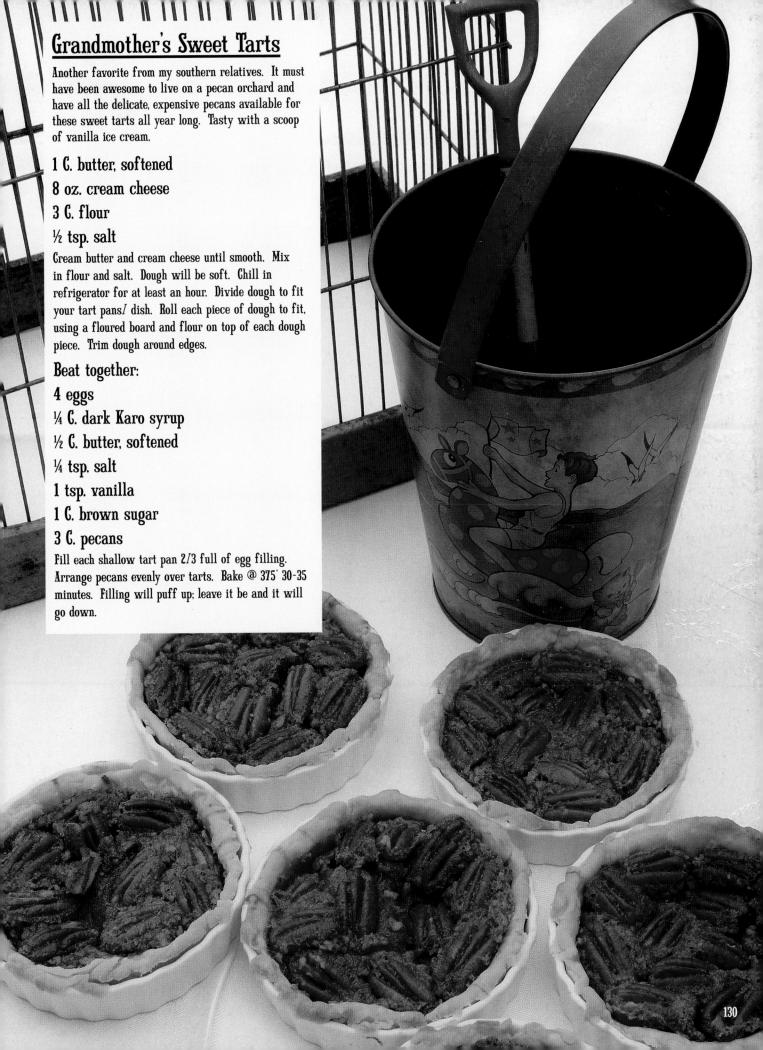

Grandmother's Sweet Tarts

Another favorite from my southern relatives. It must have been awesome to live on a pecan orchard and have all the delicate, expensive pecans available for these sweet tarts all year long. Tasty with a scoop of vanilla ice cream.

1 C. butter, softened

8 oz. cream cheese

3 C. flour

½ tsp. salt

Cream butter and cream cheese until smooth. Mix in flour and salt. Dough will be soft. Chill in refrigerator for at least an hour. Divide dough to fit your tart pans/ dish. Roll each piece of dough to fit, using a floured board and flour on top of each dough piece. Trim dough around edges.

Beat together:

4 eggs

¼ C. dark Karo syrup

½ C. butter, softened

¼ tsp. salt

1 tsp. vanilla

1 C. brown sugar

3 C. pecans

Fill each shallow tart pan 2/3 full of egg filling. Arrange pecans evenly over tarts. Bake @ 375° 30-35 minutes. Filling will puff up; leave it be and it will go down.

Ambrosia

All over the South, ambrosia is traditional at Christmas. When available, fresh coconut (grated) and fresh pineapple (cut in small pieces) are used. You can serve this delicious treat as a dessert or salad. We prefer using it as a salad here in the Northwest. Very easy to make a day ahead of your planned meal.

2 cans (16 oz. cans) mandarin oranges (in the South they use real oranges cutting away membranes).

1 small, fresh pineapple cut into pieces

1 ½ C. shredded coconut

Sugar, if desired

Mix together in a clear serving dish and chill for at least a couple of hours. Just before serving, add a banana or two, if desired. Sprinkle top of serving dish with coconut.

Hush Puppies

Legends from the South say, "Hush Puppies originated at a fish fry when someone dropped corn bread batter into the kettle of heated oil and then tossed the fried corn bread to the hungry dogs to quit their whining. The cakes looked and smelled so yummy, the folks, not dogs, have been eating these little morsels ever since!" My relatives served hush puppies to us Northwesterners when we went south to visit.

I make them in a kettle with four inches of oil heated to about 375°.

Mix:

2 C. cornmeal

2 Tbsp. onion, grated

2 Tbsp. cornstarch

1 tsp. baking powder

1 tsp. baking soda

1 tsp. salt

Beat thoroughly:

1 egg

1 ½ C. buttermilk

Make a well in the center of the dry ingredients. Add liquid mixture all at one time. Mix until well blended. It will feel like dough is not staying together, but it does. Drop one tablespoon (formed into a ball) at a time into hot oil. Drop only as many balls as will float uncrowded into oil. Cook 3-4 minutes or until browned on both sides. Turn cakes several times.

Crescent Pecan Cookies

When the sack of pecans arrived in the mail from my grandparents in North Carolina, my precious Mother would always crack enough pecans for these delicious, memory-making cookies. So tender!

½ C. butter
1 C. flour
3 Tbsp. powdered sugar
1 C. pecans, chopped

Cream soft butter with powdered sugar. Add flour and nuts. Form a small amount of dough between your fingers, into crescents. Bake 12-15 minutes at 350˚. Roll in additional powdered sugar while still warm. Yields 2 dozen cookies.

The Reading Mother
You may have tangible wealth untold, caskets of jewels and coffers of gold,
Richer than I you can never be....I had a mother that read to me.
-Strickland Gilliam

It's Tea Party Time

There is nothing as cozy as setting your table with an old tablecloth and using some of Grandmother's beautiful old cups and teapot. If you don't have a tea set, go shopping. Every cup doesn't have to be the same. Now, bake some goodies for your invited guests. Decorate your table with simple twigs, greenery or flowers to give the feel of "I'm special" to your guests. This little tea party will make memories for sure. You can also have your tea party outside under a tree that offers shade on a warm day.

"The sound of a kiss is not so loud as that of a cannon, but it's echo lasts a great deal longer."

-Oliver Wendell Holmes

"The best and most beautiful things in the world cannot be seen or even touched, they must be felt with the heart."

-Helen Keller

Seafood Jambalaya

Good ol' southern chow! If you live in the Northwest, just try this delicious and hearty menu!
You can add or take away whatever you want.

½ lb. bacon, diced

1 lb. sausage, fresh or frozen

½ lb. kielbasa sausage, smoked and cut in pieces

½ C. butter

4 cooked chicken thighs, de-boned, de-skinned and cut into 1-inch cubes

1 tsp. salt

¾ tsp. freshly ground pepper

1 tsp. ground red pepper

1 medium sweet onion, chopped

1 bell pepper, diced

4 celery ribs, diced

2 garlic cloves, minced

2 C. white rice

1 C. canned crushed tomatoes

2 C. chicken broth

1 ½ lbs. raw shrimp

1 bunch green onions, chopped

Use a large Dutch oven, heat until hot; cook bacon, sausages and butter. Cook over medium heat stirring slowly about 10-15 minutes. Season chicken thighs with salt and pepper, add to Dutch oven and stir until chicken is browned. Add onion, bell pepper, celery and garlic, stirring often so everything cooks evenly. Add rice and ground red pepper. Increase heat and add tomatoes and chicken broth. Bring to a boil. Reduce heat and simmer 15 minutes. Lastly, add shrimp and green onion. Turn off heat and let everything continue to cook in hot covered Dutch oven for at least 10 minutes. Remove lid and fluff jambalaya. Ready to serve!

*When I made this southern jambalaya, I did not add the rice. I cooked two cups of rice in 4 cups of broth from chicken thighs with one teaspoon of salt for 20 minutes. Then I put a large scoop of rice with the jambalaya in a large bowl for serving. It was a hit to all samplers!

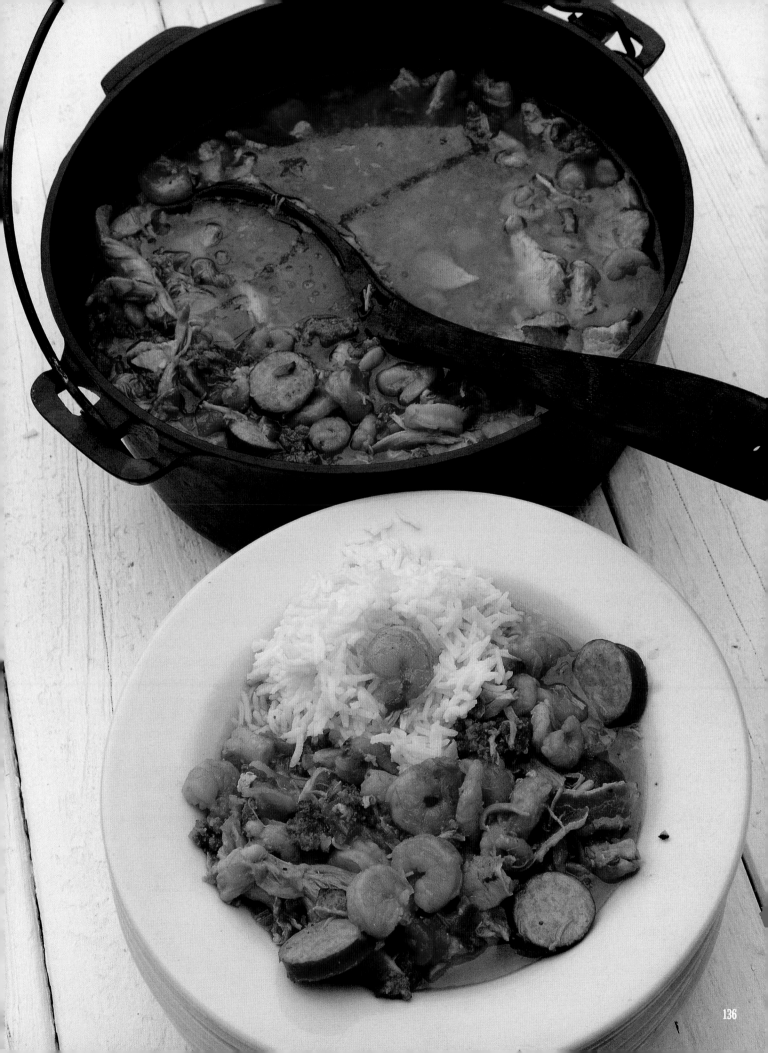

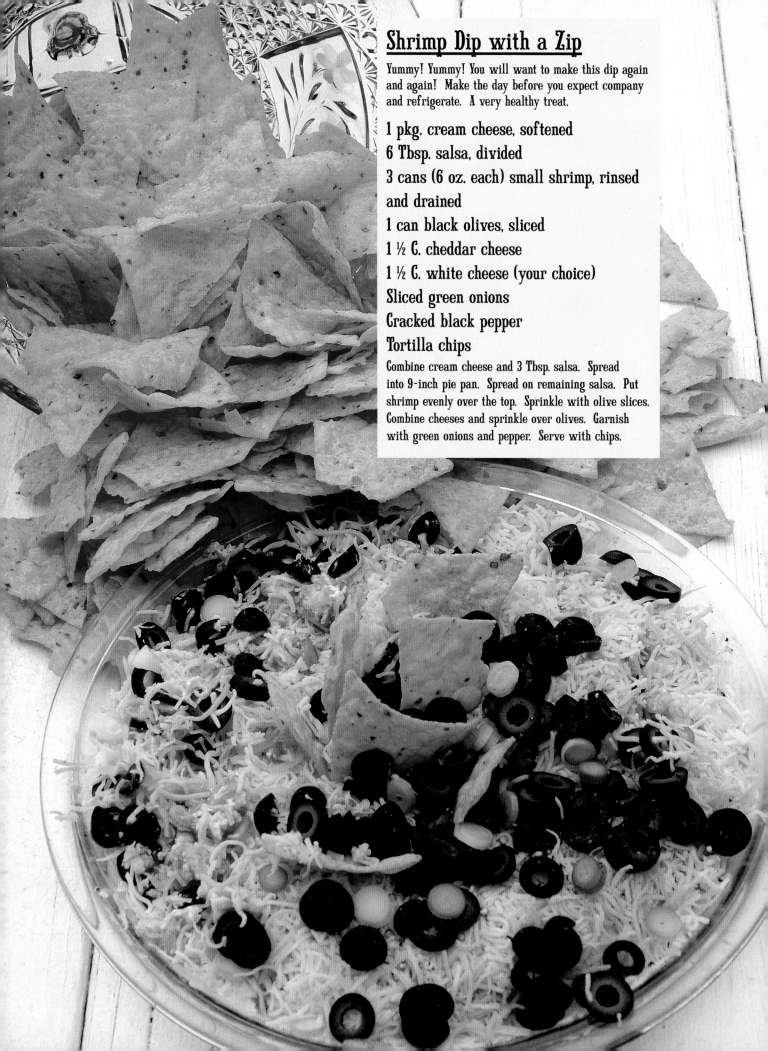

Shrimp Dip with a Zip

Yummy! Yummy! You will want to make this dip again and again! Make the day before you expect company and refrigerate. A very healthy treat.

1 pkg. cream cheese, softened
6 Tbsp. salsa, divided
3 cans (6 oz. each) small shrimp, rinsed and drained
1 can black olives, sliced
1 ½ C. cheddar cheese
1 ½ C. white cheese (your choice)
Sliced green onions
Cracked black pepper
Tortilla chips

Combine cream cheese and 3 Tbsp. salsa. Spread into 9-inch pie pan. Spread on remaining salsa. Put shrimp evenly over the top. Sprinkle with olive slices. Combine cheeses and sprinkle over olives. Garnish with green onions and pepper. Serve with chips.

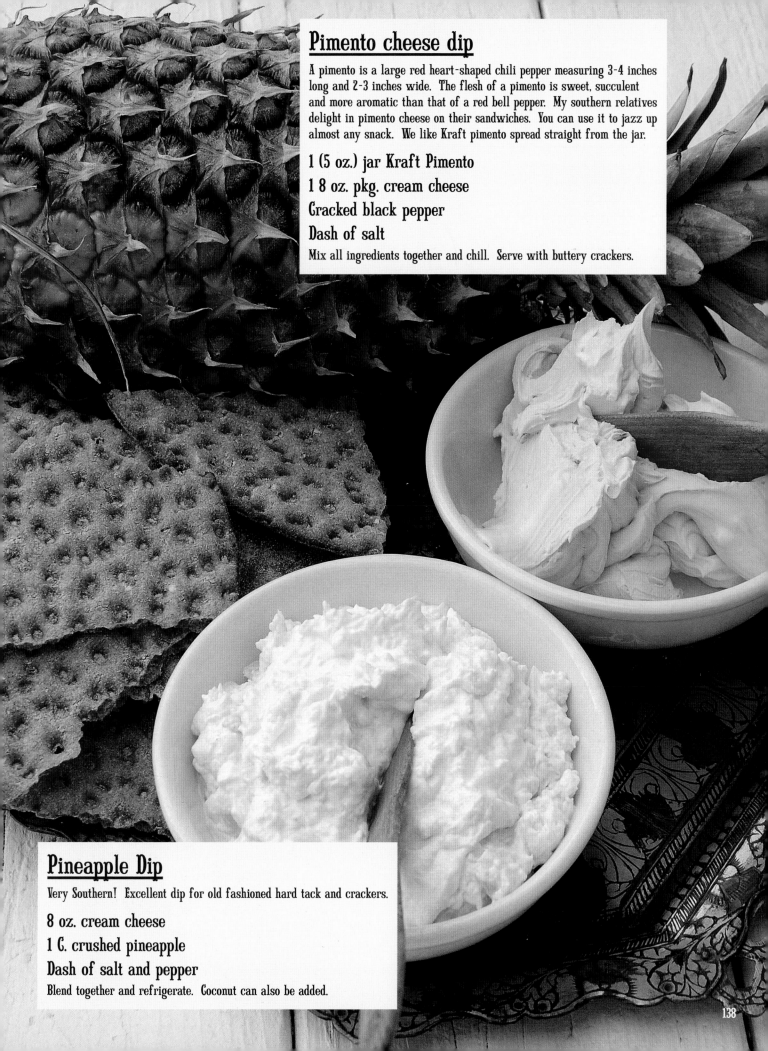

Pimento cheese dip

A pimento is a large red heart-shaped chili pepper measuring 3-4 inches long and 2-3 inches wide. The flesh of a pimento is sweet, succulent and more aromatic than that of a red bell pepper. My southern relatives delight in pimento cheese on their sandwiches. You can use it to jazz up almost any snack. We like Kraft pimento spread straight from the jar.

1 (5 oz.) jar Kraft Pimento

1 8 oz. pkg. cream cheese

Cracked black pepper

Dash of salt

Mix all ingredients together and chill. Serve with buttery crackers.

Pineapple Dip

Very Southern! Excellent dip for old fashioned hard tack and crackers.

8 oz. cream cheese

1 C. crushed pineapple

Dash of salt and pepper

Blend together and refrigerate. Coconut can also be added.

138

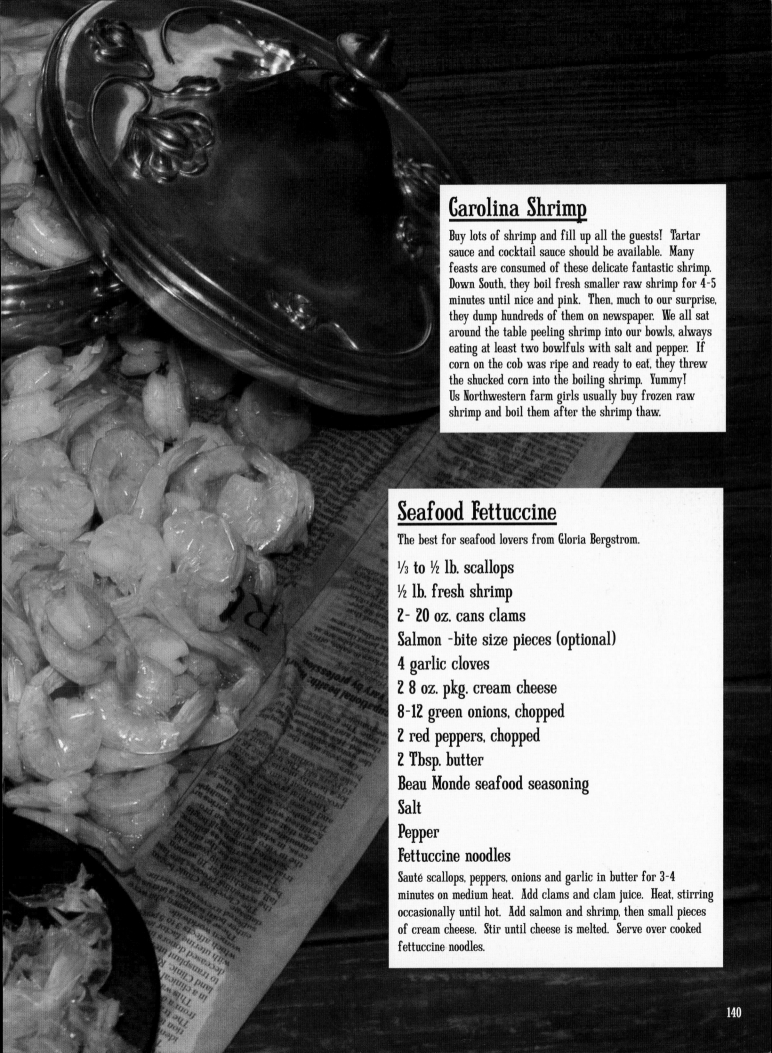

Carolina Shrimp

Buy lots of shrimp and fill up all the guests! Tartar sauce and cocktail sauce should be available. Many feasts are consumed of these delicate fantastic shrimp. Down South, they boil fresh smaller raw shrimp for 4-5 minutes until nice and pink. Then, much to our surprise, they dump hundreds of them on newspaper. We all sat around the table peeling shrimp into our bowls, always eating at least two bowlfuls with salt and pepper. If corn on the cob was ripe and ready to eat, they threw the shucked corn into the boiling shrimp. Yummy! Us Northwestern farm girls usually buy frozen raw shrimp and boil them after the shrimp thaw.

Seafood Fettuccine

The best for seafood lovers from Gloria Bergstrom.

⅓ to ½ lb. scallops

½ lb. fresh shrimp

2- 20 oz. cans clams

Salmon -bite size pieces (optional)

4 garlic cloves

2 8 oz. pkg. cream cheese

8-12 green onions, chopped

2 red peppers, chopped

2 Tbsp. butter

Beau Monde seafood seasoning

Salt

Pepper

Fettuccine noodles

Sauté scallops, peppers, onions and garlic in butter for 3-4 minutes on medium heat. Add clams and clam juice. Heat, stirring occasionally until hot. Add salmon and shrimp, then small pieces of cream cheese. Stir until cheese is melted. Serve over cooked fettuccine noodles.

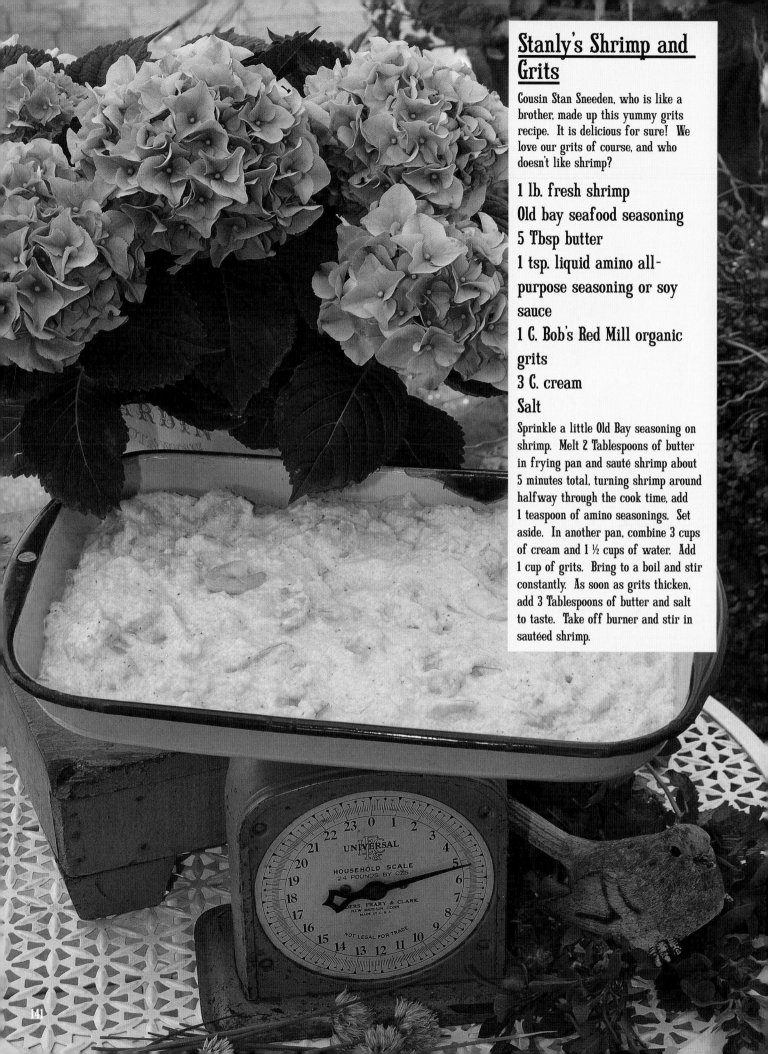

Stanly's Shrimp and Grits

Cousin Stan Sneeden, who is like a brother, made up this yummy grits recipe. It is delicious for sure! We love our grits of course, and who doesn't like shrimp?

1 lb. fresh shrimp
Old bay seafood seasoning
5 Tbsp butter
1 tsp. liquid amino all-purpose seasoning or soy sauce
1 C. Bob's Red Mill organic grits
3 C. cream
Salt

Sprinkle a little Old Bay seasoning on shrimp. Melt 2 Tablespoons of butter in frying pan and sauté shrimp about 5 minutes total, turning shrimp around halfway through the cook time, add 1 teaspoon of amino seasonings. Set aside. In another pan, combine 3 cups of cream and 1 ½ cups of water. Add 1 cup of grits. Bring to a boil and stir constantly. As soon as grits thicken, add 3 Tablespoons of butter and salt to taste. Take off burner and stir in sautéed shrimp.

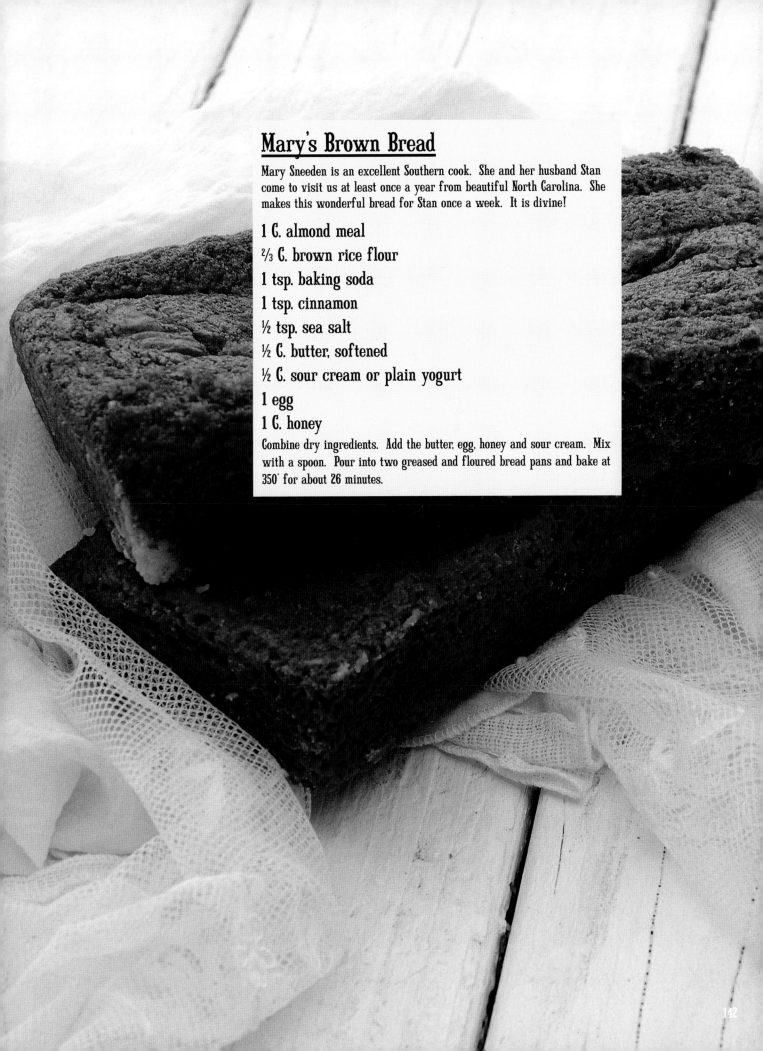

Mary's Brown Bread

Mary Sneeden is an excellent Southern cook. She and her husband Stan come to visit us at least once a year from beautiful North Carolina. She makes this wonderful bread for Stan once a week. It is divine!

1 C. almond meal

⅔ C. brown rice flour

1 tsp. baking soda

1 tsp. cinnamon

½ tsp. sea salt

½ C. butter, softened

½ C. sour cream or plain yogurt

1 egg

1 C. honey

Combine dry ingredients. Add the butter, egg, honey and sour cream. Mix with a spoon. Pour into two greased and floured bread pans and bake at 350° for about 26 minutes.

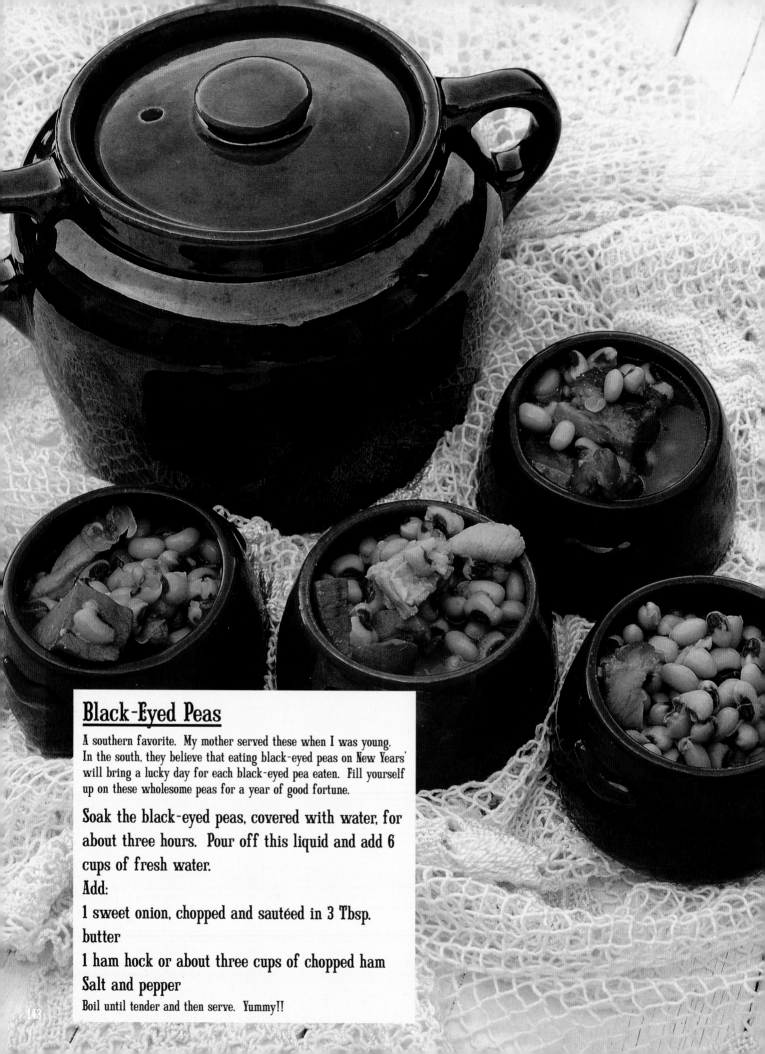

Black-Eyed Peas

A southern favorite. My mother served these when I was young. In the south, they believe that eating black-eyed peas on New Years' will bring a lucky day for each black-eyed pea eaten. Fill yourself up on these wholesome peas for a year of good fortune.

Soak the black-eyed peas, covered with water, for about three hours. Pour off this liquid and add 6 cups of fresh water.

Add:

1 sweet onion, chopped and sautéed in 3 Tbsp. butter

1 ham hock or about three cups of chopped ham

Salt and pepper

Boil until tender and then serve. Yummy!!

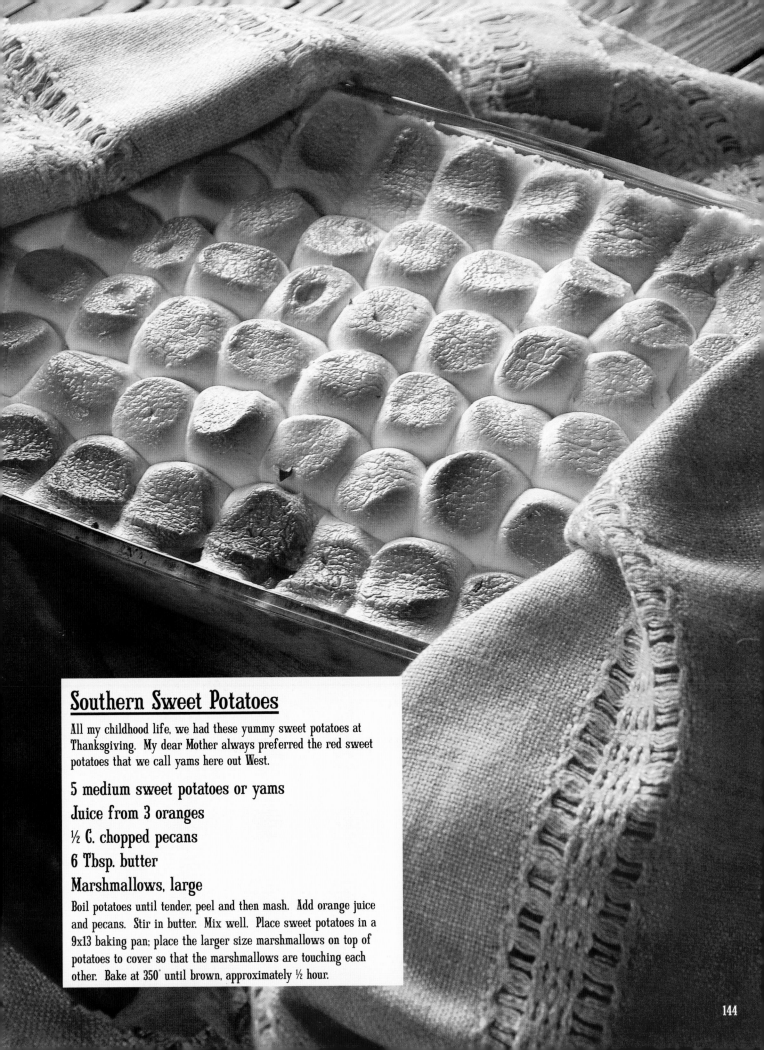

Southern Sweet Potatoes

All my childhood life, we had these yummy sweet potatoes at Thanksgiving. My dear Mother always preferred the red sweet potatoes that we call yams here out West.

5 medium sweet potatoes or yams
Juice from 3 oranges
½ C. chopped pecans
6 Tbsp. butter
Marshmallows, large

Boil potatoes until tender, peel and then mash. Add orange juice and pecans. Stir in butter. Mix well. Place sweet potatoes in a 9x13 baking pan; place the larger size marshmallows on top of potatoes to cover so that the marshmallows are touching each other. Bake at 350˚ until brown, approximately ½ hour.

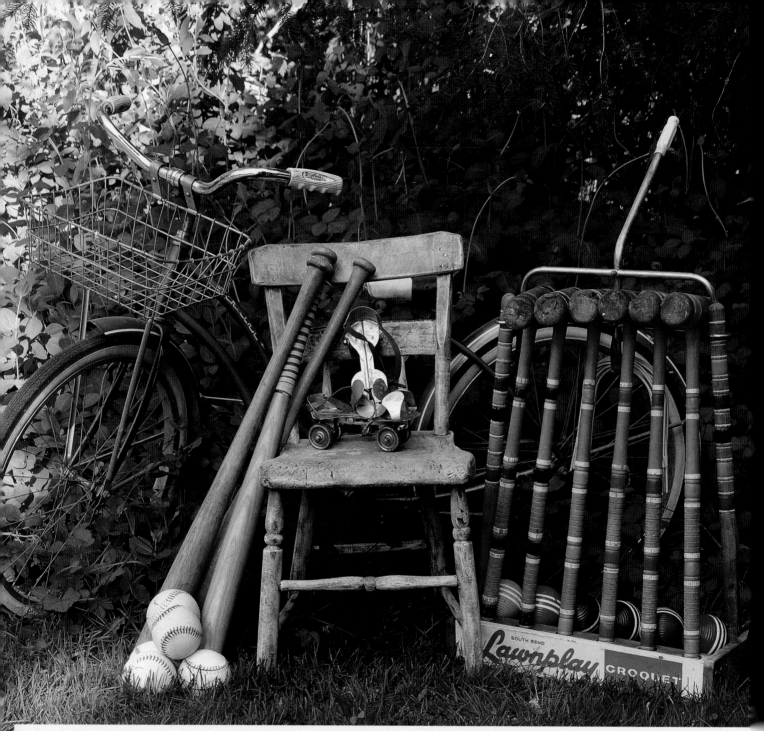

I'm the country farm girl who went to live temporarily in the city and actually roller-skated to school in the third grade. Oh, how different everything was. My grandfather had a large (approximately 7 acres) pecan orchard and grape arbor to play in and a wonderful hired man named Corbet to take care of everything outside. He was so nice to me when I cut my knee; he carried me into the house. What fun it was to roller skate on a real sidewalk with my roller-skates, I even had a key. Out west we didn't have sidewalks, only dirt and wooden paths. There were inside toilets, fireplaces (8 of them), telephones and greenhouses (we only had vegetable gardens at my home). There was so much sun and heat, wow! My wonderful grandmother made menus every day and a sweet servant named Sarah did all the cooking and clean-up. She was so kind and could she ever cook! Life was amazing. Grandfather helped my daddy get all his teeth pulled, fitted with dentures and fixed his sinus infections. He did healing treatments and daddy got all well. My brother Stanly was born in North Carolina. When school was finished and summertime came we rode the big train home. It took a long time; five days I think. Baby Stan had his own baby basket- what a memory!

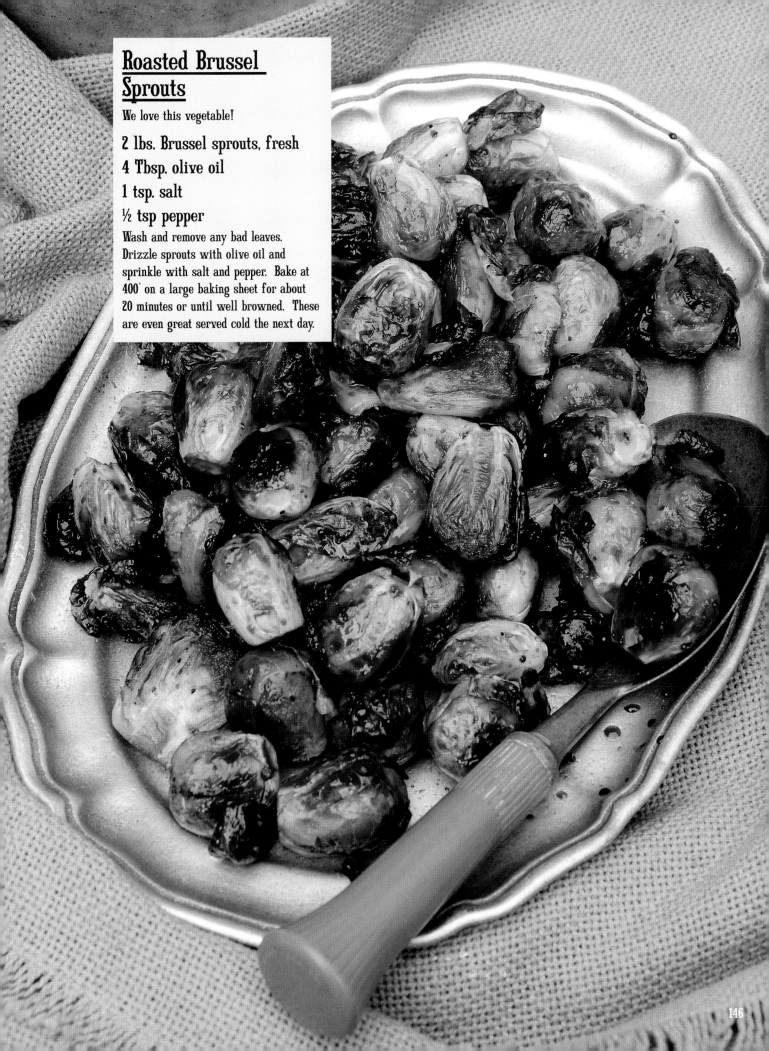

Roasted Brussel Sprouts

We love this vegetable!

2 lbs. Brussel sprouts, fresh
4 Tbsp. olive oil
1 tsp. salt
½ tsp pepper

Wash and remove any bad leaves.
Drizzle sprouts with olive oil and
sprinkle with salt and pepper. Bake at
400˚ on a large baking sheet for about
20 minutes or until well browned. These
are even great served cold the next day.

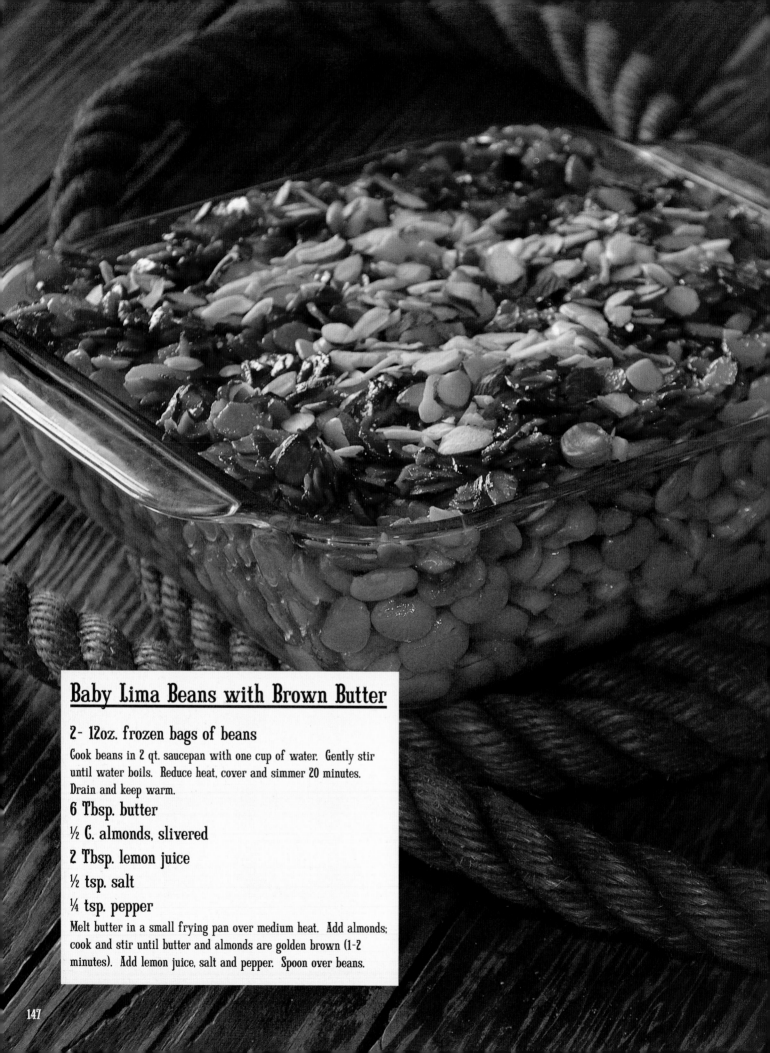

Baby Lima Beans with Brown Butter

2- 12oz. frozen bags of beans
Cook beans in 2 qt. saucepan with one cup of water. Gently stir
until water boils. Reduce heat, cover and simmer 20 minutes.
Drain and keep warm.

6 Tbsp. butter

½ C. almonds, slivered

2 Tbsp. lemon juice

½ tsp. salt

¼ tsp. pepper

Melt butter in a small frying pan over medium heat. Add almonds;
cook and stir until butter and almonds are golden brown (1-2
minutes). Add lemon juice, salt and pepper. Spoon over beans.

APPETIZERS CONDIMENTS & SNACKS

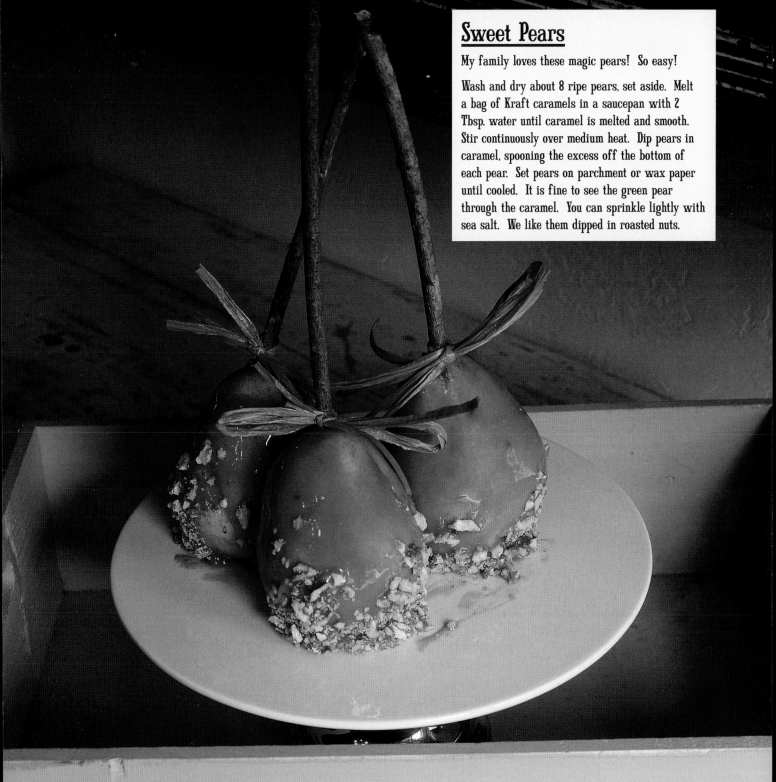

Sweet Pears

My family loves these magic pears! So easy!

Wash and dry about 8 ripe pears, set aside. Melt a bag of Kraft caramels in a saucepan with 2 Tbsp. water until caramel is melted and smooth. Stir continuously over medium heat. Dip pears in caramel, spooning the excess off the bottom of each pear. Set pears on parchment or wax paper until cooled. It is fine to see the green pear through the caramel. You can sprinkle lightly with sea salt. We like them dipped in roasted nuts.

ORCHARD FARM

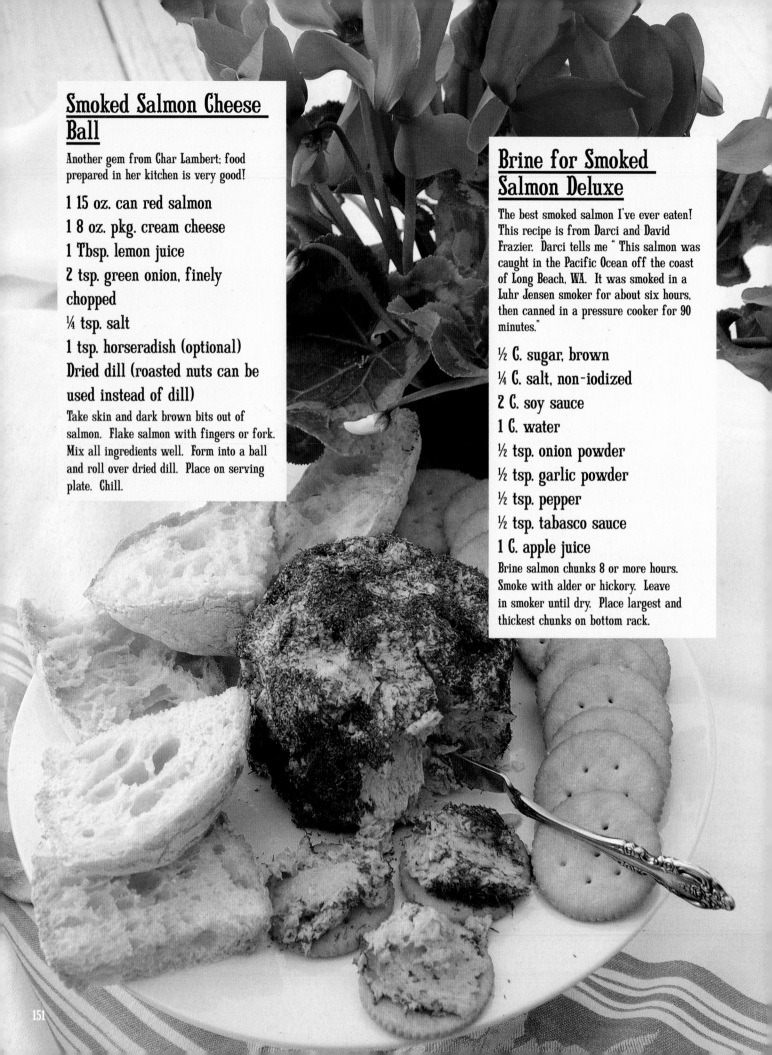

Smoked Salmon Cheese Ball

Another gem from Char Lambert; food prepared in her kitchen is very good!

1 15 oz. can red salmon
1 8 oz. pkg. cream cheese
1 Tbsp. lemon juice
2 tsp. green onion, finely chopped
¼ tsp. salt
1 tsp. horseradish (optional)
Dried dill (roasted nuts can be used instead of dill)

Take skin and dark brown bits out of salmon. Flake salmon with fingers or fork. Mix all ingredients well. Form into a ball and roll over dried dill. Place on serving plate. Chill.

Brine for Smoked Salmon Deluxe

The best smoked salmon I've ever eaten! This recipe is from Darci and David Frazier. Darci tells me " This salmon was caught in the Pacific Ocean off the coast of Long Beach, WA. It was smoked in a Luhr Jensen smoker for about six hours, then canned in a pressure cooker for 90 minutes."

½ C. sugar, brown
¼ C. salt, non-iodized
2 C. soy sauce
1 C. water
½ tsp. onion powder
½ tsp. garlic powder
½ tsp. pepper
½ tsp. tabasco sauce
1 C. apple juice

Brine salmon chunks 8 or more hours. Smoke with alder or hickory. Leave in smoker until dry. Place largest and thickest chunks on bottom rack.

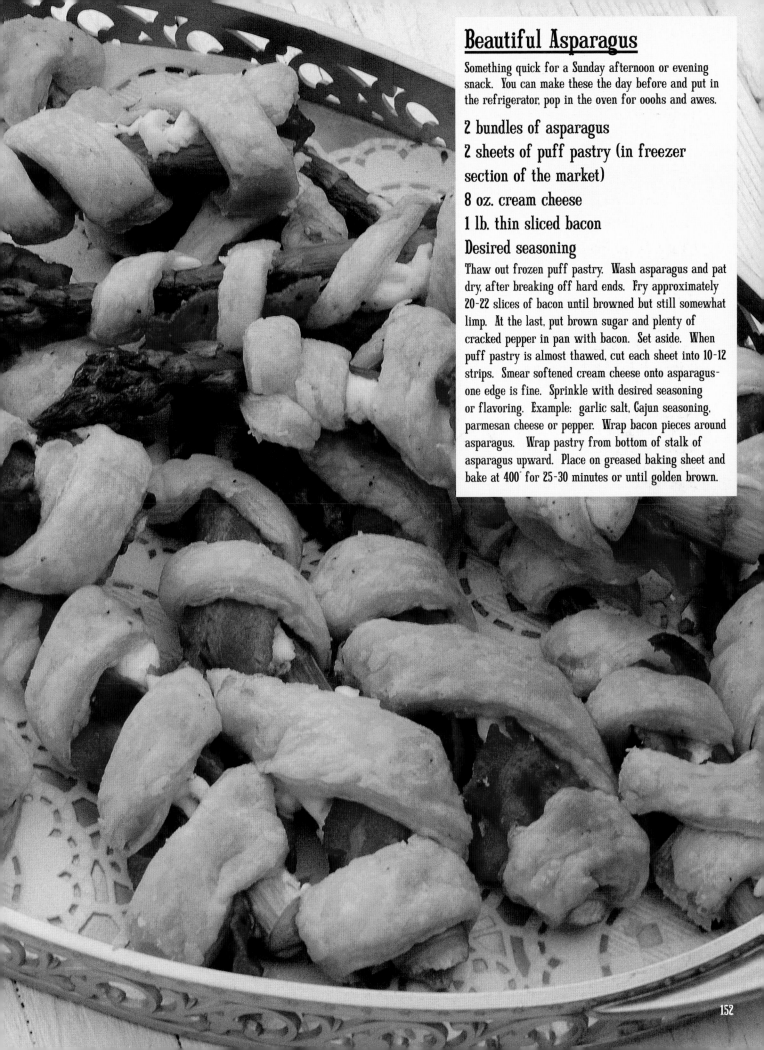

Beautiful Asparagus

Something quick for a Sunday afternoon or evening snack. You can make these the day before and put in the refrigerator, pop in the oven for ooohs and awes.

2 bundles of asparagus

2 sheets of puff pastry (in freezer section of the market)

8 oz. cream cheese

1 lb. thin sliced bacon

Desired seasoning

Thaw out frozen puff pastry. Wash asparagus and pat dry, after breaking off hard ends. Fry approximately 20-22 slices of bacon until browned but still somewhat limp. At the last, put brown sugar and plenty of cracked pepper in pan with bacon. Set aside. When puff pastry is almost thawed, cut each sheet into 10-12 strips. Smear softened cream cheese onto asparagus- one edge is fine. Sprinkle with desired seasoning or flavoring. Example: garlic salt, Cajun seasoning, parmesan cheese or pepper. Wrap bacon pieces around asparagus. Wrap pastry from bottom of stalk of asparagus upward. Place on greased baking sheet and bake at 400˚ for 25-30 minutes or until golden brown.

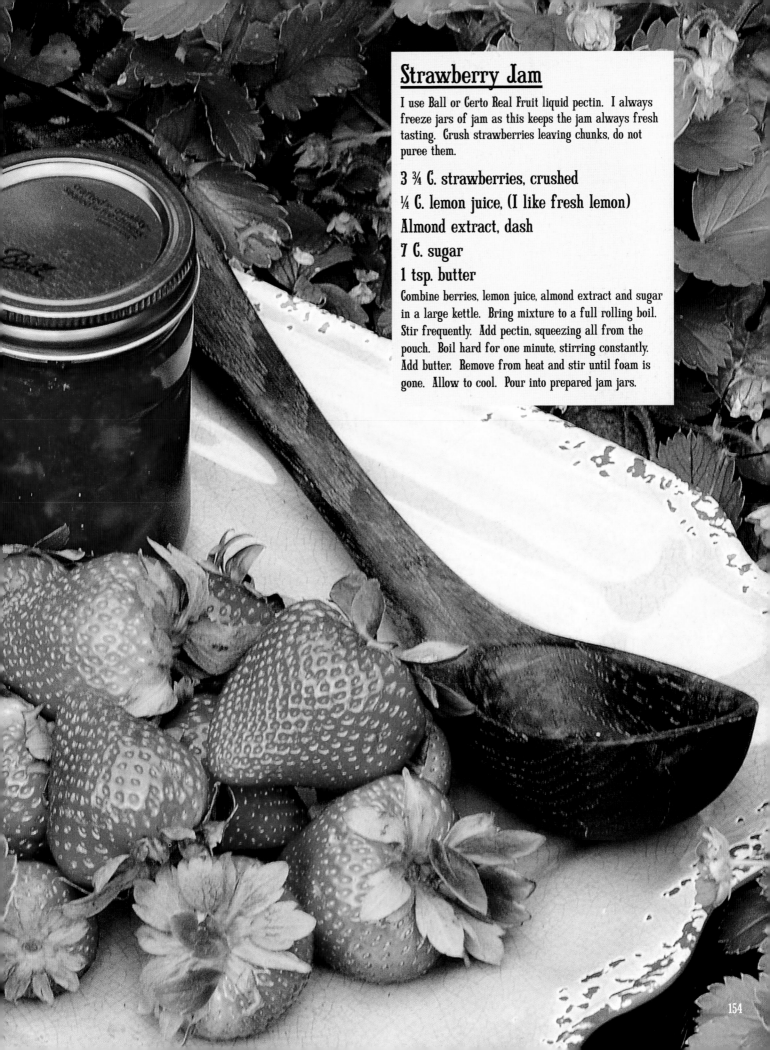

Strawberry Jam

I use Ball or Certo Real Fruit liquid pectin. I always freeze jars of jam as this keeps the jam always fresh tasting. Crush strawberries leaving chunks, do not puree them.

3 ¾ C. strawberries, crushed

¼ C. lemon juice, (I like fresh lemon)

Almond extract, dash

7 C. sugar

1 tsp. butter

Combine berries, lemon juice, almond extract and sugar in a large kettle. Bring mixture to a full rolling boil. Stir frequently. Add pectin, squeezing all from the pouch. Boil hard for one minute, stirring constantly. Add butter. Remove from heat and stir until foam is gone. Allow to cool. Pour into prepared jam jars.

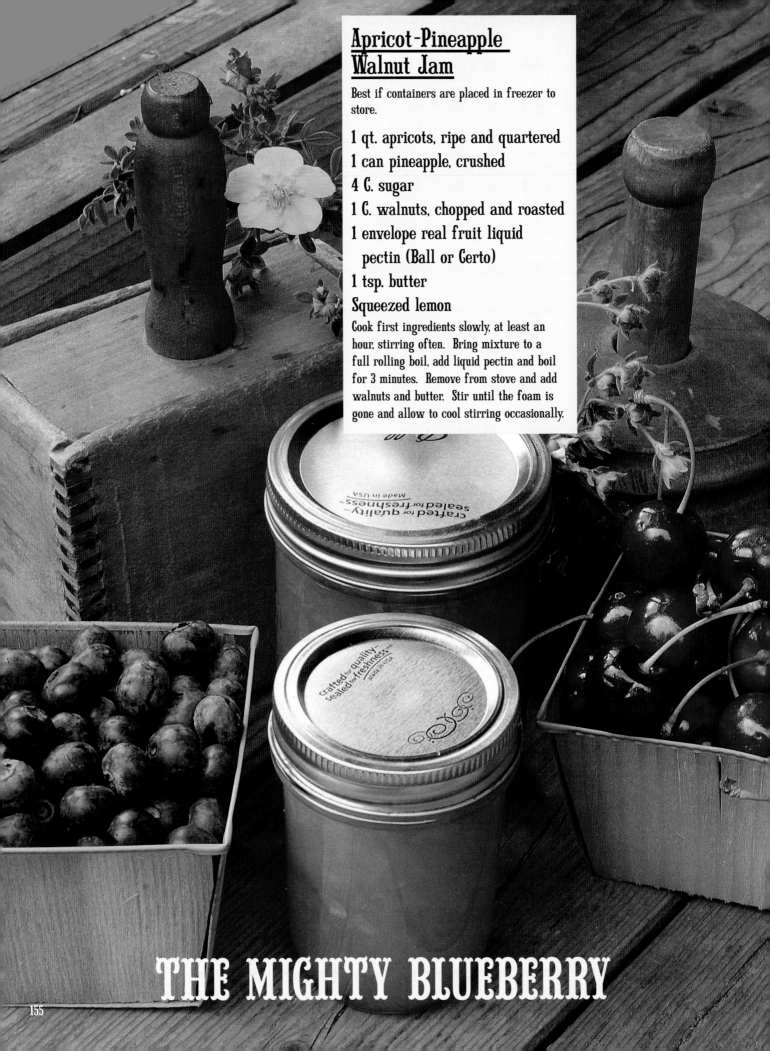

Apricot-Pineapple Walnut Jam

Best if containers are placed in freezer to store.

1 qt. apricots, ripe and quartered

1 can pineapple, crushed

4 C. sugar

1 C. walnuts, chopped and roasted

1 envelope real fruit liquid
 pectin (Ball or Certo)

1 tsp. butter

Squeezed lemon

Cook first ingredients slowly, at least an hour, stirring often. Bring mixture to a full rolling boil, add liquid pectin and boil for 3 minutes. Remove from stove and add walnuts and butter. Stir until the foam is gone and allow to cool stirring occasionally.

THE MIGHTY BLUEBERRY

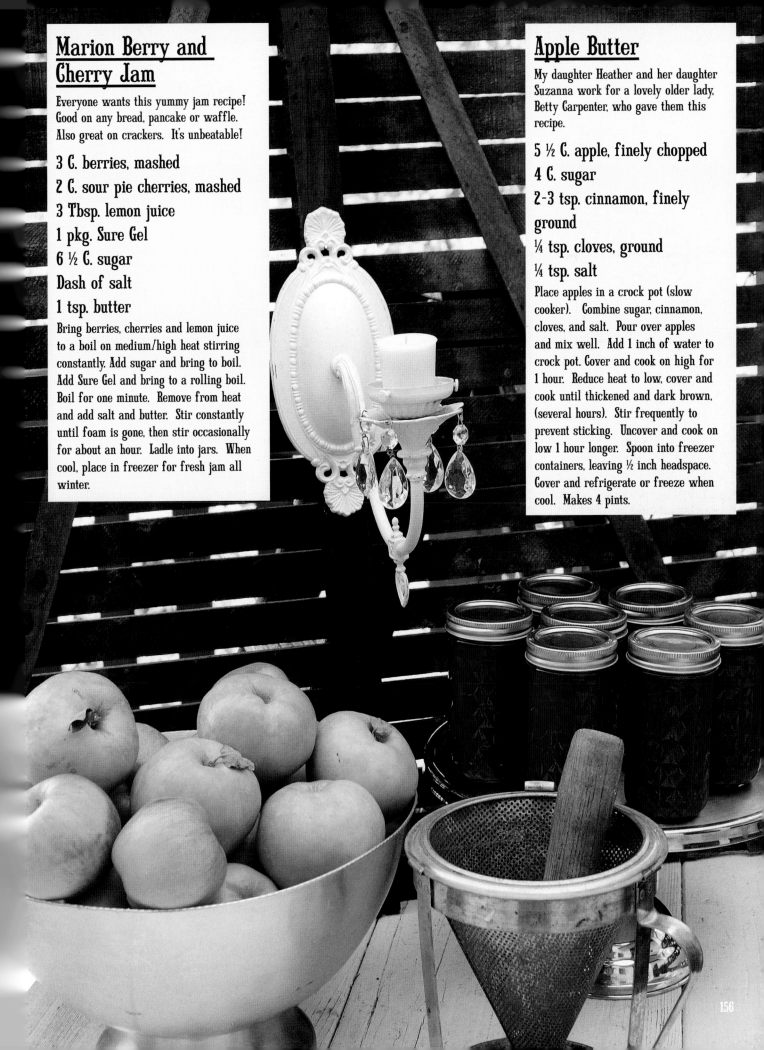

Marion Berry and Cherry Jam

Everyone wants this yummy jam recipe! Good on any bread, pancake or waffle. Also great on crackers. It's unbeatable!

3 C. berries, mashed

2 C. sour pie cherries, mashed

3 Tbsp. lemon juice

1 pkg. Sure Gel

6 ½ C. sugar

Dash of salt

1 tsp. butter

Bring berries, cherries and lemon juice to a boil on medium/high heat stirring constantly. Add sugar and bring to boil. Add Sure Gel and bring to a rolling boil. Boil for one minute. Remove from heat and add salt and butter. Stir constantly until foam is gone, then stir occasionally for about an hour. Ladle into jars. When cool, place in freezer for fresh jam all winter.

Apple Butter

My daughter Heather and her daughter Suzanna work for a lovely older lady, Betty Carpenter, who gave them this recipe.

5 ½ C. apple, finely chopped

4 C. sugar

2-3 tsp. cinnamon, finely ground

¼ tsp. cloves, ground

¼ tsp. salt

Place apples in a crock pot (slow cooker). Combine sugar, cinnamon, cloves, and salt. Pour over apples and mix well. Add 1 inch of water to crock pot. Cover and cook on high for 1 hour. Reduce heat to low, cover and cook until thickened and dark brown, (several hours). Stir frequently to prevent sticking. Uncover and cook on low 1 hour longer. Spoon into freezer containers, leaving ½ inch headspace. Cover and refrigerate or freeze when cool. Makes 4 pints.

156

Sing Me Love's Lullaby

(Love's Lullaby Of Dreams)

Also published for
High Voice in F
Low Voice in C
Violin and Cello obligatos
published in each key

Medium Voice

Lyric by
DOROTHY TERRISS

Music by
THEODORE MORSE

Some of the best years of our lives are when our children are young...we know where they are and we have defenses against the dark side of the world in the warm haven of our homes. Our children learn to voice their views without fear of censure or ridicule where truth and trust is evident! It's where the spirit of loving and giving is practiced every day. Honesty, courage, compassion, self-respect and respect for the rights of others is a value of freedom, justice and brotherly love. It is all taught by word and obedience. Let us all be thankful!

3569 - 3

Sing Me Loves Lullaby

Lyric by
DOROTHY TERRISS
Music by
THEODORE MORSE

C — C to c (E♭)
in E♭ — E♭ to g (b♭)
in F — F to a (c)
Cello Obligatos for Each Key

LEO FEIST INC NEW YORK

Potato Salad

From Lily Frances, my granddaughter. A wonderful, different potato salad handed down from her mother, Cheri' Mattson and Cheri's mother in law, Marilyn Mattson.

2 ½ lbs. russet potatoes, boiled and chopped

6 eggs, boiled, peeled and chopped

2 C. pickles, chopped (I didn't use this many)

Mayonnaise to your liking (approximately 1 ½ cups)

1-2 tsp. Johnny's Salad and Pasta Elegance (green lid)

Season to taste

Mix all together and chill before serving.

Cold Water Brine Dills

To each jar add:

½ C. vinegar

1 Tbsp. salt

1-2 garlic cloves

¼ tsp. powdered alum

1 tsp. pickling spices

1 head of dill

Pack cukes into jar, add cold water clear to the top, heat lids, place the lids and screw on rings. Do not open jar for a good month.

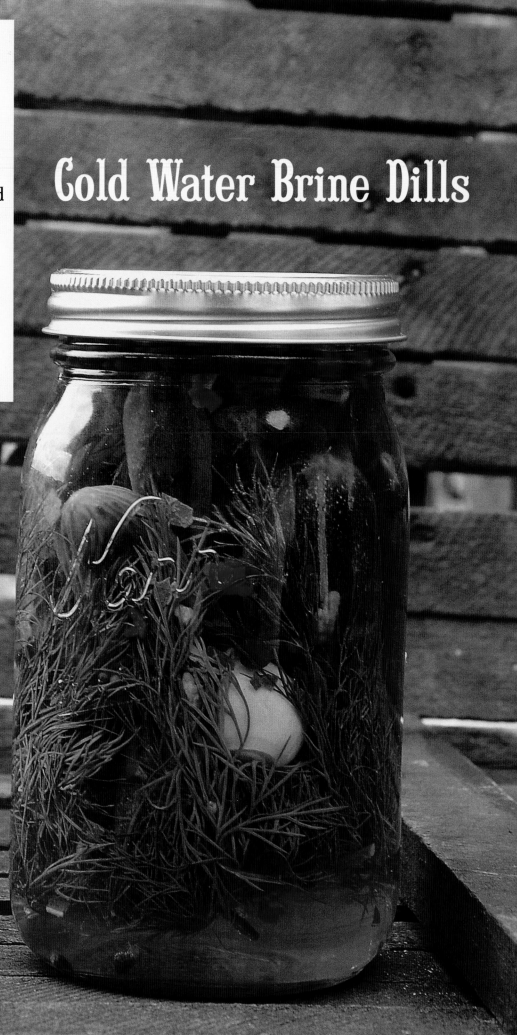

Cold Water Brine Dills

Grandma's Bread and Butter Pickles

Our grandmother from the South made the best pickles. Her recipe for watermelon pickles is in one of my other books. Enjoy these pickles all winter!

1 gallon cucumbers, sliced

6 medium sweet onions, sliced

½ C. salt

4 C. apple cider vinegar

4 C. sugar

1 tsp. turmeric

½ tsp. cloves, whole

2 tsp. mustard seed

Place cucumbers, onions and salt in a large stainless steel kettle with ice for 3 hours. Do not drain. In a separate kettle, mix vinegar, sugar, turmeric, cloves and mustard seed. Bring to a boil. Add cucumber and onions- simmer until they lose their bright color. Seal jars.

Caramel Popcorn

A very good sweet and salty snack. So neat for fall or use red and green M&Ms for the Christmas season.

20 C. popcorn, popped
1 ½ C. firmly packed brown sugar
¾ C. butter
½ C. dark corn syrup (light syrup may be used too)
½ tsp. salt
1 ½ C. peanuts, pecans or filberts (they are all good)
1 bag M&Ms
Parchment or wax paper

Pour popcorn onto large, buttered cookie sheet. Stir brown sugar, butter, corn syrup and salt in a saucepan. Boil for one minute on medium heat. Pour over popcorn. Add nuts and bake at 325° for 25 minutes, stirring often. Place mixture on wax or parchment paper. Cool about 20 minutes. Add M&Ms and break popcorn apart into pieces of choice. When completely cool, store in an airtight container.

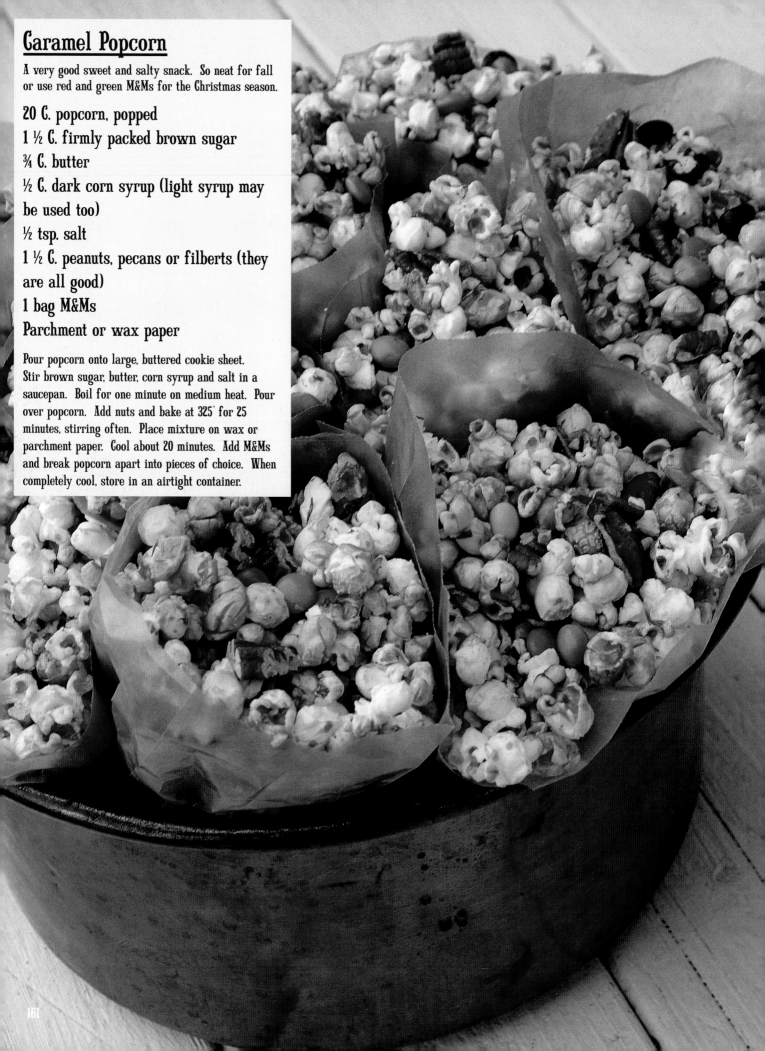

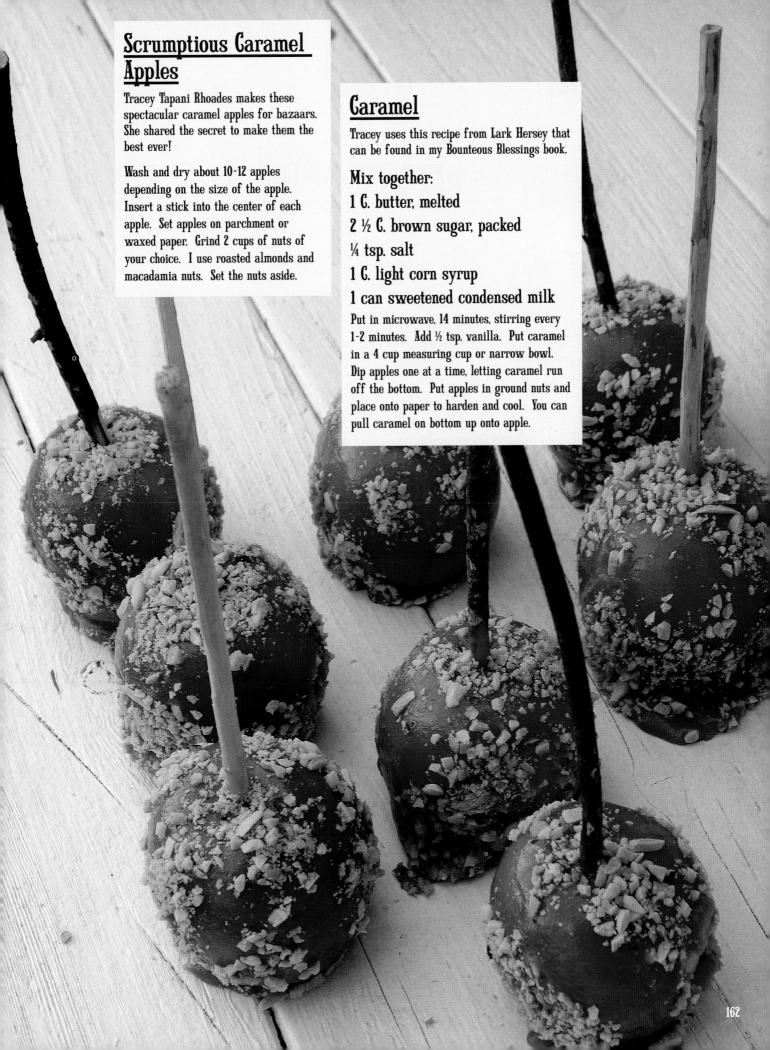

Scrumptious Caramel Apples

Tracey Tapani Rhoades makes these spectacular caramel apples for bazaars. She shared the secret to make them the best ever!

Wash and dry about 10-12 apples depending on the size of the apple. Insert a stick into the center of each apple. Set apples on parchment or waxed paper. Grind 2 cups of nuts of your choice. I use roasted almonds and macadamia nuts. Set the nuts aside.

Caramel

Tracey uses this recipe from Lark Hersey that can be found in my Bounteous Blessings book.

Mix together:

1 C. butter, melted

2 ½ C. brown sugar, packed

¼ tsp. salt

1 C. light corn syrup

1 can sweetened condensed milk

Put in microwave, 14 minutes, stirring every 1-2 minutes. Add ½ tsp. vanilla. Put caramel in a 4 cup measuring cup or narrow bowl. Dip apples one at a time, letting caramel run off the bottom. Put apples in ground nuts and place onto paper to harden and cool. You can pull caramel on bottom up onto apple.

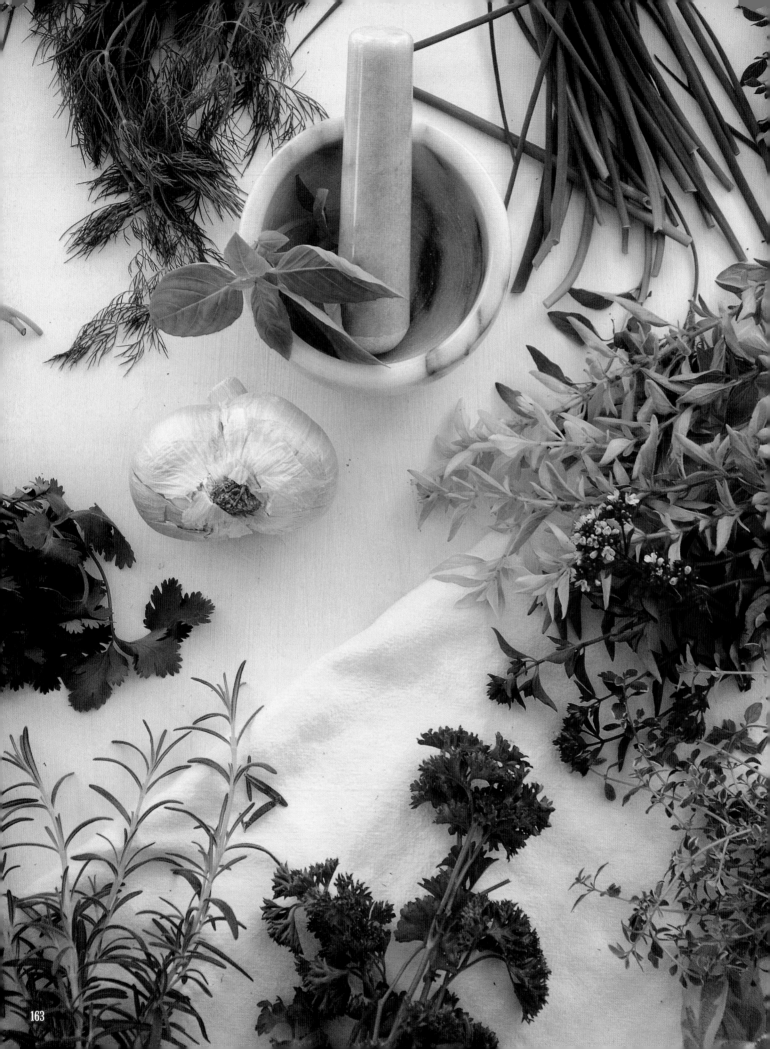

INTRODUCE FRESH HERBS INTO YOUR KITCHEN

Many of our everyday spices are easily available fresh. Grow your own right at home on your window sill. Well worth the effort and far superior to dried herbs.
This wonderful research was compiled by our daughter, Cheri'. Try them all for a great taste.

Chives: Onion's skinny cousin. Good on anything or in anything, period.

Garlic: A matter of opinion: you'll love everything better with elephant garlic.

Oregano: Fresh is best. End of subject.

Dill: A little goes a long way!

Thyme: Just the sound of it creates a tasty nostalgia.

Rosemary: Remember- fresh! And chopped fine. Otherwise it is like eating a pine needle.

Sage: Stuffing is best when it is cooked inside the bird.

Dandelion: Use flowers, leaves and roots. Not too tasty but great in a tea for detox!

Parsley: Try this in your morning smoothie!

Cilantro: Great for all Mexican dishes.

Calendula: This yellow-orange flower is great for digestion. Use on salads or in tea made with it fresh or dried.

Chickweed: The best green in the Northwest! Eat fresh, blend in smoothies or in a tea form.

Peppermint: Well...we all love it, now don't we?

End of Harvest Relish

Recipe from Nancy Uselmann. She tells me "This came
from my mom's friends in Nashville, Illinois (where I
grew up) and I got it in 1975, so you know it's been
around years longer than that. What I love about it
is that it uses up everything left in your garden and
the amounts are not specific. This relish is fantastic
in deviled eggs, potato salad, egg salad, ham salad, or
eaten out of the jar with a spoon (as mother's mother
often did)."

4 C. onion, ground

1 medium head cabbage, ground

10 green tomatoes (4 cups ground)

12 green peppers, ground

6 sweet red peppers, ground

Additional vegetables

½ C. pickling salt (table salt is ok to use
too)

Grind all vegetables using a coarse
blade. Sprinkle with salt and let stand
overnight. Rinse and drain the next day.

Combine:

6 C. sugar

1 Tbsp. celery seed

2 Tbsp. mustard seed

1 ½ tsp. turmeric (optional)

4 C. cider vinegar

2 C. water

Pour over all vegetables and heat to a boil. Simmer for
5 minutes. Seal directly into jars. No canning or water
bath is necessary. This makes approximately 8 pts.

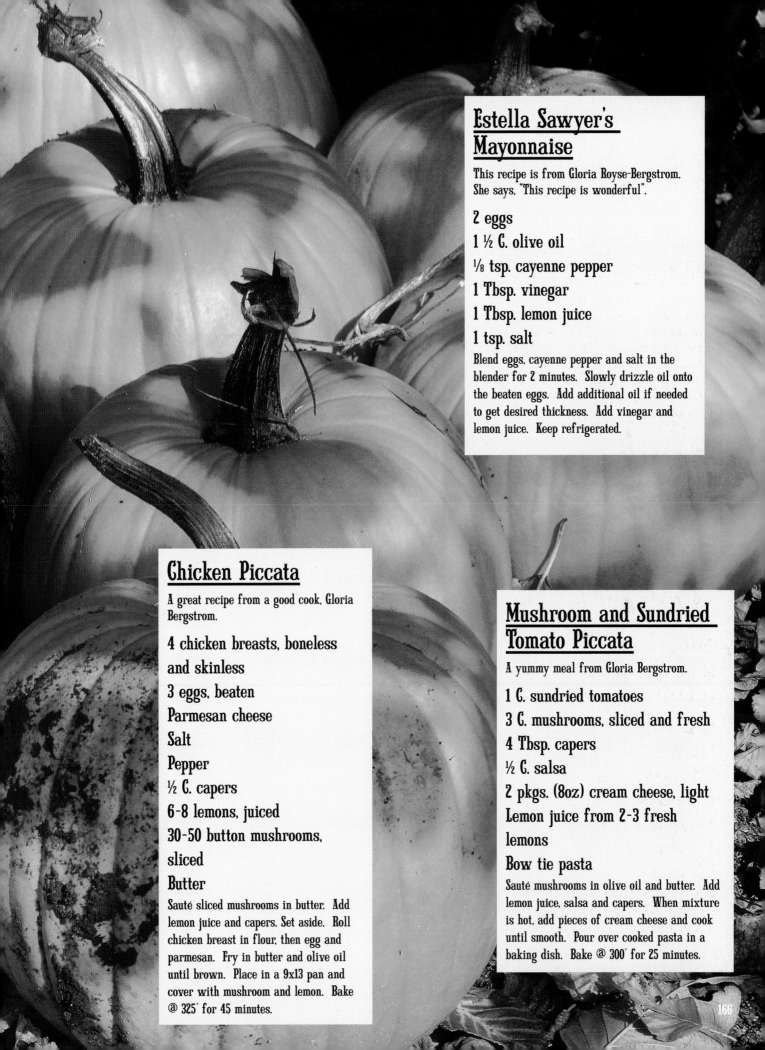

Estella Sawyer's Mayonnaise

This recipe is from Gloria Royse-Bergstrom. She says, "This recipe is wonderful".

2 eggs
1 ½ C. olive oil
⅛ tsp. cayenne pepper
1 Tbsp. vinegar
1 Tbsp. lemon juice
1 tsp. salt

Blend eggs, cayenne pepper and salt in the blender for 2 minutes. Slowly drizzle oil onto the beaten eggs. Add additional oil if needed to get desired thickness. Add vinegar and lemon juice. Keep refrigerated.

Chicken Piccata

A great recipe from a good cook, Gloria Bergstrom.

4 chicken breasts, boneless and skinless
3 eggs, beaten
Parmesan cheese
Salt
Pepper
½ C. capers
6-8 lemons, juiced
30-50 button mushrooms, sliced
Butter

Sauté sliced mushrooms in butter. Add lemon juice and capers. Set aside. Roll chicken breast in flour, then egg and parmesan. Fry in butter and olive oil until brown. Place in a 9x13 pan and cover with mushroom and lemon. Bake @ 325° for 45 minutes.

Mushroom and Sundried Tomato Piccata

A yummy meal from Gloria Bergstrom.

1 C. sundried tomatoes
3 C. mushrooms, sliced and fresh
4 Tbsp. capers
½ C. salsa
2 pkgs. (8oz) cream cheese, light
Lemon juice from 2-3 fresh lemons
Bow tie pasta

Sauté mushrooms in olive oil and butter. Add lemon juice, salsa and capers. When mixture is hot, add pieces of cream cheese and cook until smooth. Pour over cooked pasta in a baking dish. Bake @ 300° for 25 minutes.

166

Animals speak louder than words
If there's gentleness on the inside,
it shows on the outside.

FARM FRESH DRINKS
& CANDY

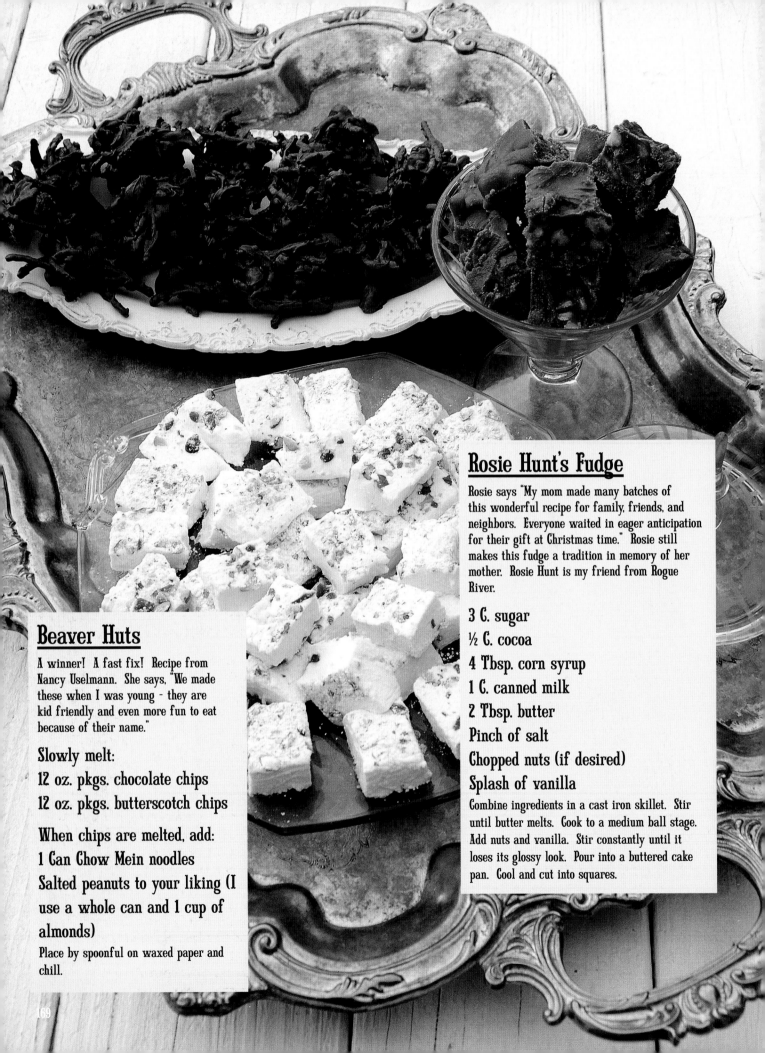

Rosie Hunt's Fudge

Rosie says "My mom made many batches of this wonderful recipe for family, friends, and neighbors. Everyone waited in eager anticipation for their gift at Christmas time." Rosie still makes this fudge a tradition in memory of her mother. Rosie Hunt is my friend from Rogue River.

3 C. sugar

½ C. cocoa

4 Tbsp. corn syrup

1 C. canned milk

2 Tbsp. butter

Pinch of salt

Chopped nuts (if desired)

Splash of vanilla

Combine ingredients in a cast iron skillet. Stir until butter melts. Cook to a medium ball stage. Add nuts and vanilla. Stir constantly until it loses its glossy look. Pour into a buttered cake pan. Cool and cut into squares.

Beaver Huts

A winner! A fast fix! Recipe from Nancy Uselmann. She says, "We made these when I was young - they are kid friendly and even more fun to eat because of their name."

Slowly melt:

12 oz. pkgs. chocolate chips

12 oz. pkgs. butterscotch chips

When chips are melted, add:

1 Can Chow Mein noodles

Salted peanuts to your liking (I use a whole can and 1 cup of almonds)

Place by spoonful on waxed paper and chill.

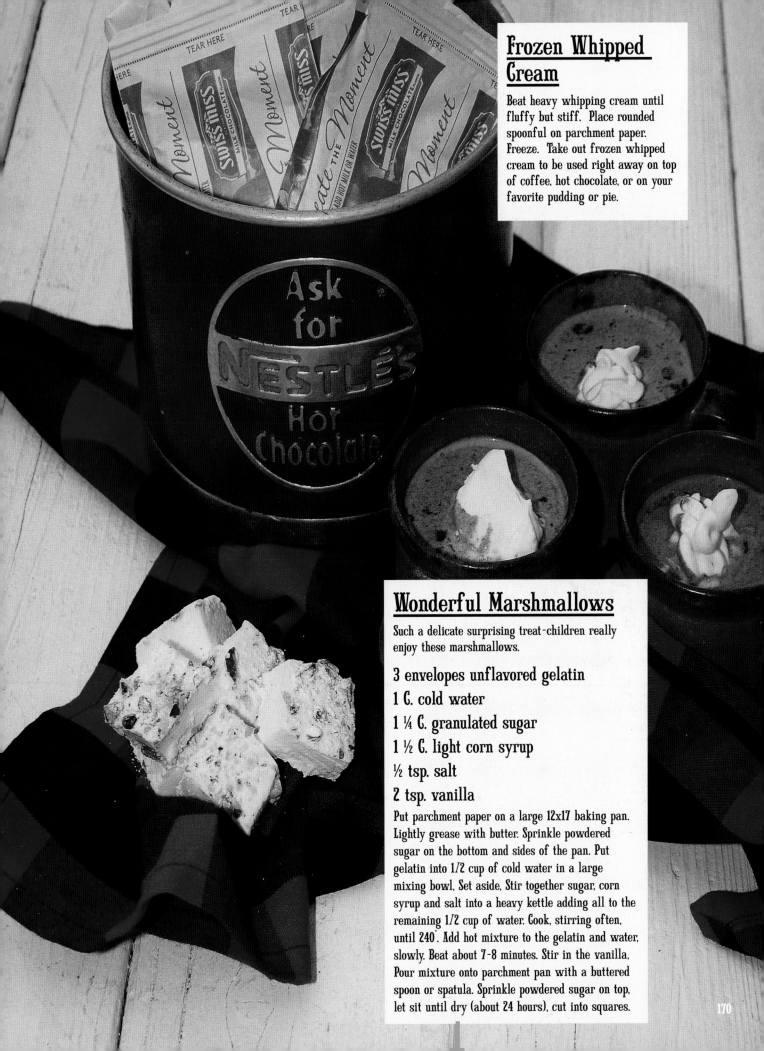

Frozen Whipped Cream

Beat heavy whipping cream until fluffy but stiff. Place rounded spoonful on parchment paper. Freeze. Take out frozen whipped cream to be used right away on top of coffee, hot chocolate, or on your favorite pudding or pie.

Wonderful Marshmallows

Such a delicate surprising treat-children really enjoy these marshmallows.

3 envelopes unflavored gelatin

1 C. cold water

1 ¼ C. granulated sugar

1 ½ C. light corn syrup

½ tsp. salt

2 tsp. vanilla

Put parchment paper on a large 12x17 baking pan. Lightly grease with butter. Sprinkle powdered sugar on the bottom and sides of the pan. Put gelatin into 1/2 cup of cold water in a large mixing bowl, Set aside, Stir together sugar, corn syrup and salt into a heavy kettle adding all to the remaining 1/2 cup of water. Cook, stirring often, until 240˚. Add hot mixture to the gelatin and water, slowly. Beat about 7-8 minutes. Stir in the vanilla, Pour mixture onto parchment pan with a buttered spoon or spatula. Sprinkle powdered sugar on top, let sit until dry (about 24 hours), cut into squares.

170

Sweet and Salty Nuts

Get ready for a divine snack! Our wonderful neighbor, Merle, has given us these tasty pecans for Christmas. Wow! Don't get sick from eating too many!

1 lb. pecans or walnuts (4 ½ Cups)

½ C. granulated sugar

⅓ C. light corn syrup

1 Tbsp. sea salt, coarsely ground

½ tsp. black pepper, freshly ground

Coarse raw sugar

Pre-heat oven to 325˚. Using 2 tablespoons of butter, generously butter a 15x10x1" baking pan, set aside. In a large bowl, stir together nuts, sugar, corn syrup and salt and pepper until well combined. Spread onto prepared pan. Bake 25 minutes until golden brown and bubbly, stirring once or twice. Remove from oven. Sprinkle generously with raw sugar. Toss to coat. Transfer mixture to a large piece of foil. Cool completely, about 30 minutes. Break apart to serve. Store nuts in an airtight container at room temperature.

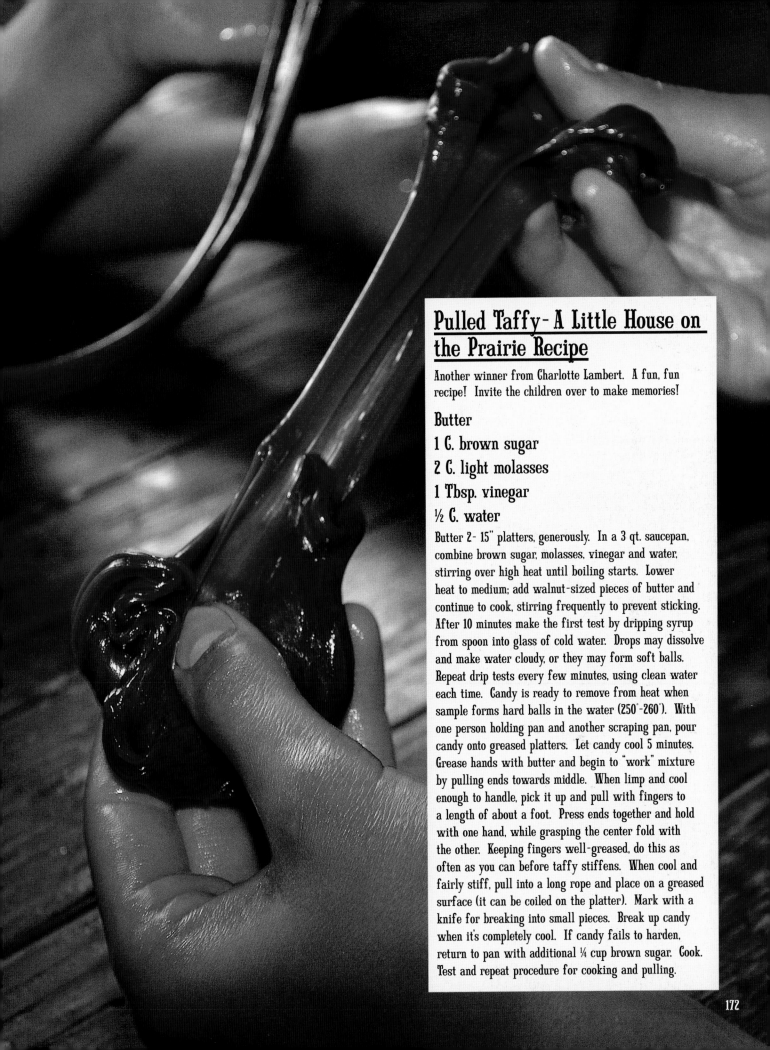

Pulled Taffy - A Little House on the Prairie Recipe

Another winner from Charlotte Lambert. A fun, fun recipe! Invite the children over to make memories!

Butter
1 C. brown sugar
2 C. light molasses
1 Tbsp. vinegar
½ C. water

Butter 2- 15" platters, generously. In a 3 qt. saucepan, combine brown sugar, molasses, vinegar and water, stirring over high heat until boiling starts. Lower heat to medium; add walnut-sized pieces of butter and continue to cook, stirring frequently to prevent sticking. After 10 minutes make the first test by dripping syrup from spoon into glass of cold water. Drops may dissolve and make water cloudy, or they may form soft balls. Repeat drip tests every few minutes, using clean water each time. Candy is ready to remove from heat when sample forms hard balls in the water (250˚-260˚). With one person holding pan and another scraping pan, pour candy onto greased platters. Let candy cool 5 minutes. Grease hands with butter and begin to "work" mixture by pulling ends towards middle. When limp and cool enough to handle, pick it up and pull with fingers to a length of about a foot. Press ends together and hold with one hand, while grasping the center fold with the other. Keeping fingers well-greased, do this as often as you can before taffy stiffens. When cool and fairly stiff, pull into a long rope and place on a greased surface (it can be coiled on the platter). Mark with a knife for breaking into small pieces. Break up candy when it's completely cool. If candy fails to harden, return to pan with additional ¼ cup brown sugar. Cook. Test and repeat procedure for cooking and pulling.

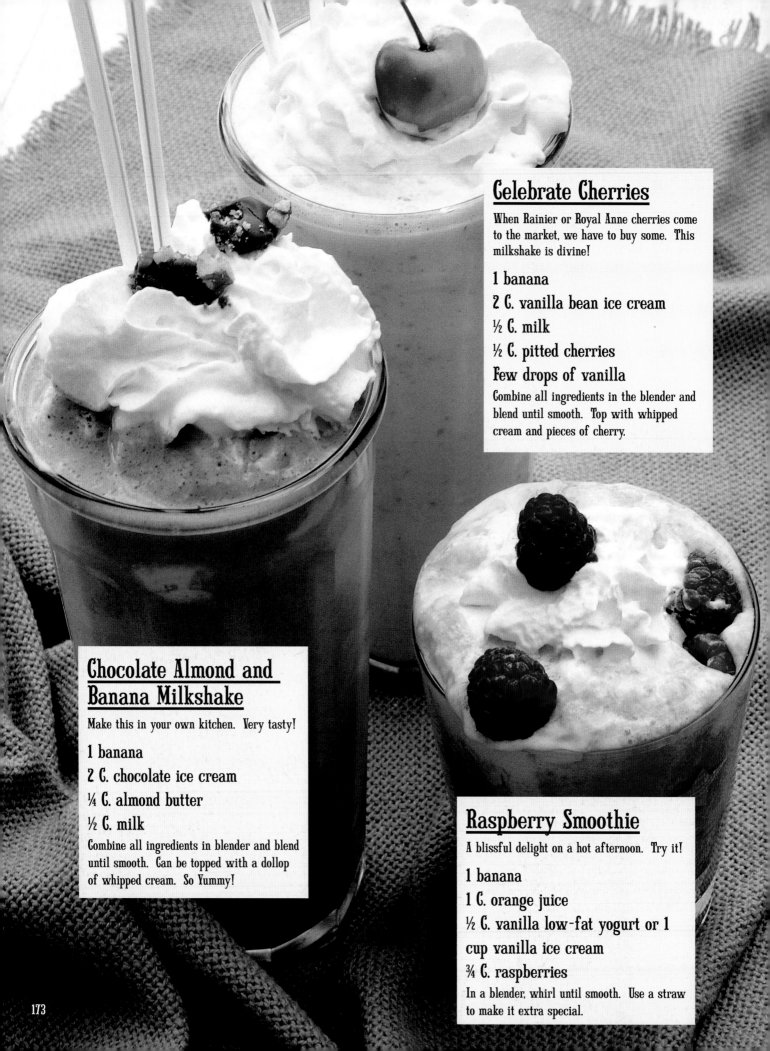

Celebrate Cherries

When Rainier or Royal Anne cherries come to the market, we have to buy some. This milkshake is divine!

1 banana
2 C. vanilla bean ice cream
½ C. milk
½ C. pitted cherries
Few drops of vanilla

Combine all ingredients in the blender and blend until smooth. Top with whipped cream and pieces of cherry.

Chocolate Almond and Banana Milkshake

Make this in your own kitchen. Very tasty!

1 banana
2 C. chocolate ice cream
¼ C. almond butter
½ C. milk

Combine all ingredients in blender and blend until smooth. Can be topped with a dollop of whipped cream. So Yummy!

Raspberry Smoothie

A blissful delight on a hot afternoon. Try it!

1 banana
1 C. orange juice
½ C. vanilla low-fat yogurt or 1 cup vanilla ice cream
¾ C. raspberries

In a blender, whirl until smooth. Use a straw to make it extra special.

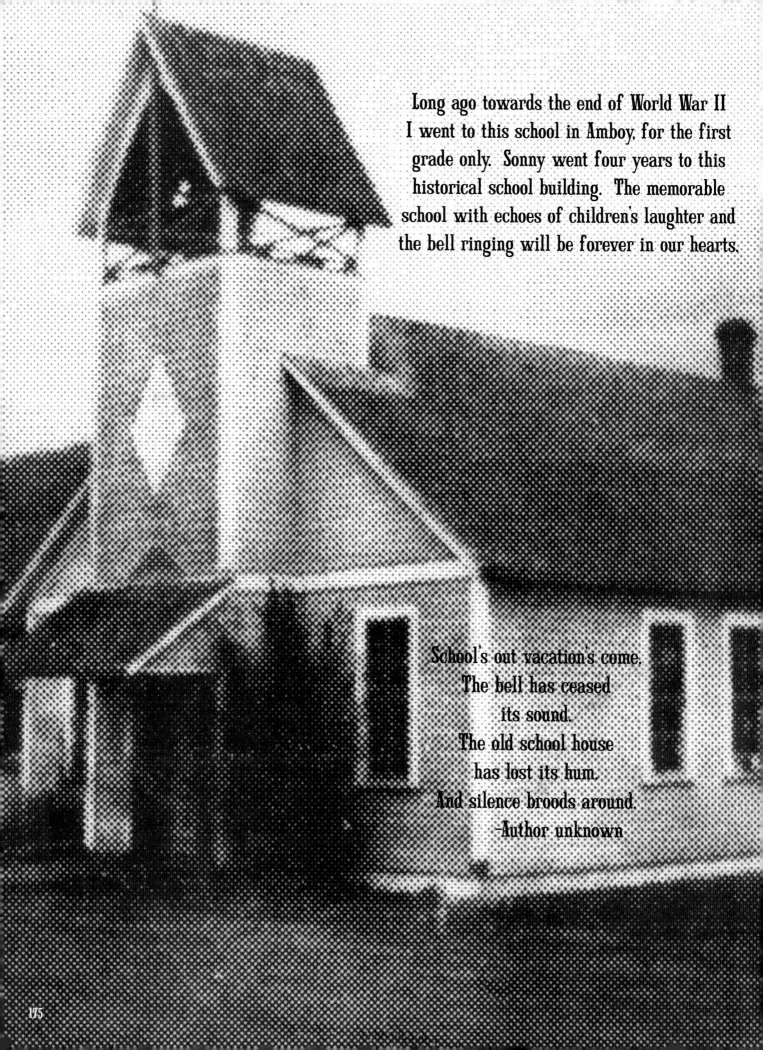

Long ago towards the end of World War II I went to this school in Amboy, for the first grade only. Sonny went four years to this historical school building. The memorable school with echoes of children's laughter and the bell ringing will be forever in our hearts.

School's out vacation's come,
The bell has ceased
its sound.
The old school house
has lost its hum.
And silence broods around.
 -Author unknown

175

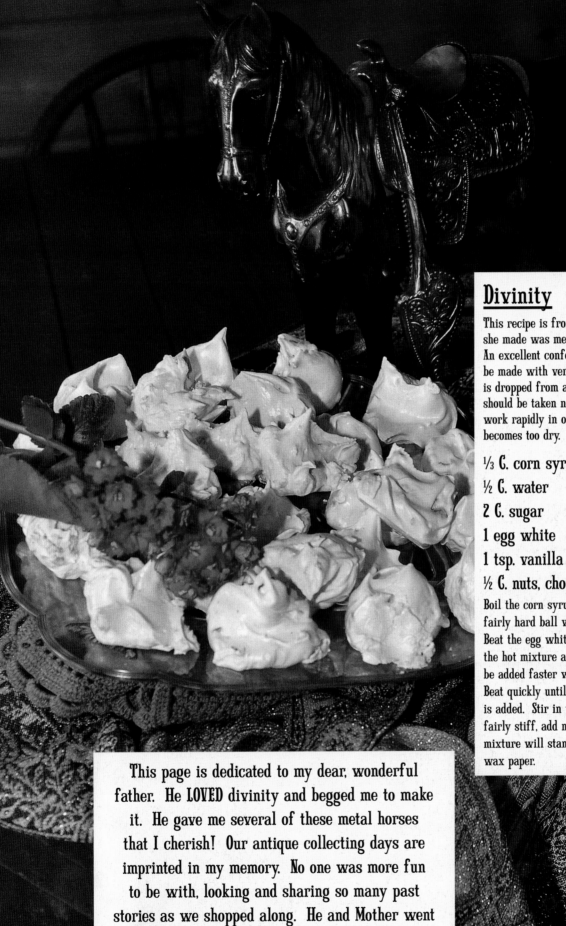

Divinity

This recipe is from Sonny's mother. Everything she made was memorable!

An excellent confection known as divinity can be made with very little difficulty. The divinity is dropped from a spoon onto wax paper. Care should be taken not to boil too long or you must work rapidly in order to drop all of it before it becomes too dry.

⅓ C. corn syrup

½ C. water

2 C. sugar

1 egg white

1 tsp. vanilla

½ C. nuts, chopped

Boil the corn syrup, water and sugar until a fairly hard ball will form in cold water/ 240˚. Beat the egg white until stiff but not dry. Pour the hot mixture a drop at a time until it can be added faster without cooking the egg white. Beat quickly until all the corn syrup mixture is added. Stir in vanilla, and when mixture is fairly stiff, add nuts. Continue beating until mixture will stand alone. Drop by spoonful onto wax paper.

This page is dedicated to my dear, wonderful father. He LOVED divinity and begged me to make it. He gave me several of these metal horses that I cherish! Our antique collecting days are imprinted in my memory. No one was more fun to be with, looking and sharing so many past stories as we shopped along. He and Mother went every year to the big antique sale in Portland. They always begged me to come with them.

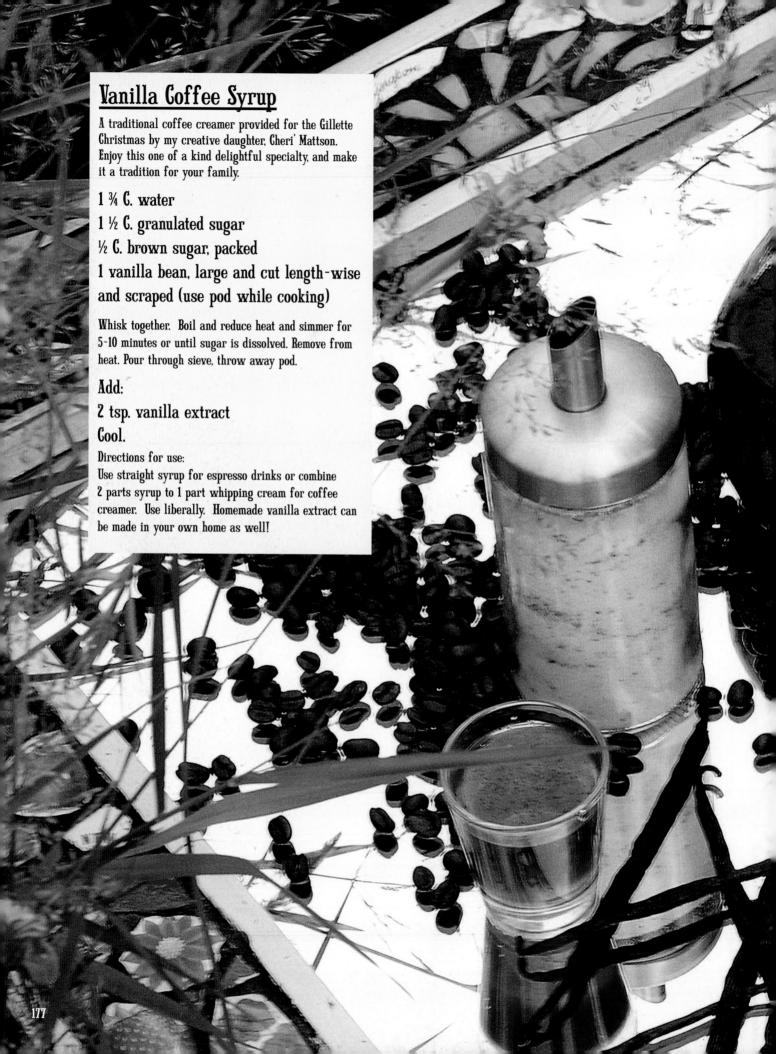

Vanilla Coffee Syrup

A traditional coffee creamer provided for the Gillette Christmas by my creative daughter, Cheri' Mattson. Enjoy this one of a kind delightful specialty, and make it a tradition for your family.

1 ¾ C. water

1 ½ C. granulated sugar

½ C. brown sugar, packed

1 vanilla bean, large and cut length-wise and scraped (use pod while cooking)

Whisk together. Boil and reduce heat and simmer for 5-10 minutes or until sugar is dissolved. Remove from heat. Pour through sieve, throw away pod.

Add:

2 tsp. vanilla extract

Cool.

Directions for use:
Use straight syrup for espresso drinks or combine 2 parts syrup to 1 part whipping cream for coffee creamer. Use liberally. Homemade vanilla extract can be made in your own home as well!

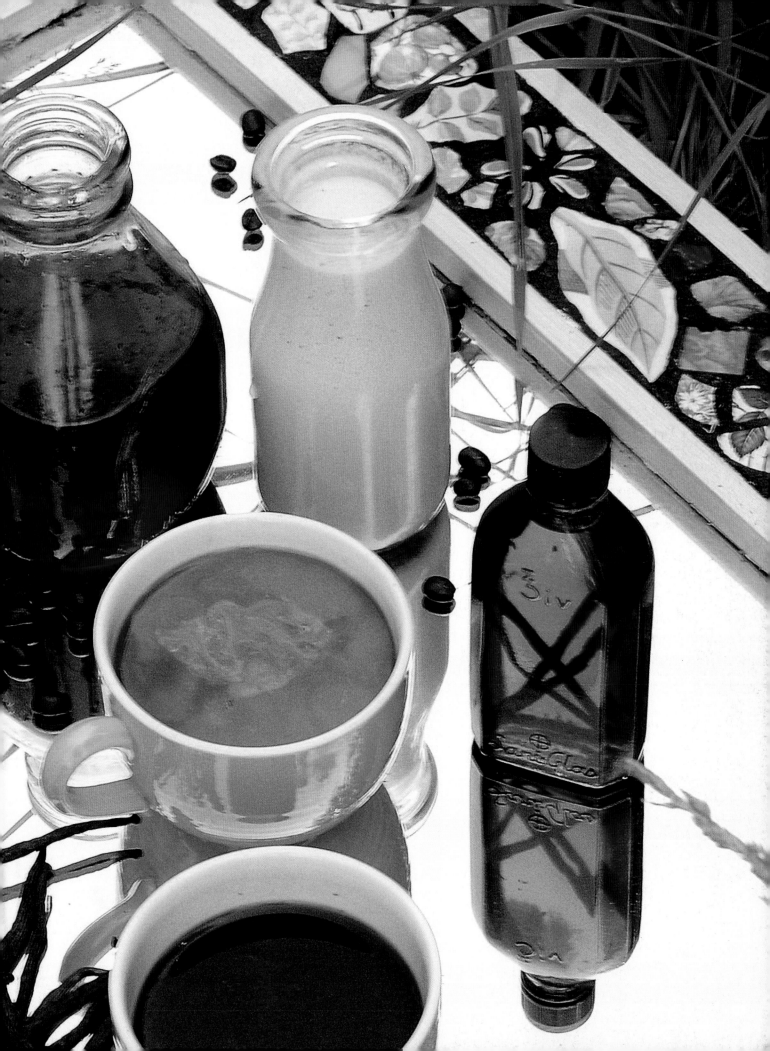

Chester's Addicting Puff Corn

When I ate this yummy delight at my granddaughter Natalie's, I knew this must go in my book! Camilla Tikka brought this and told me her aunt Gillian gave her the recipe. So of course I called Gillian- here it is folks.

2 Bags of Chester's Puff Corn

4 squares of vanilla (white) almond bark

(if you desire more chocolate, add it!)

Melt almond bark in a large bowl. When melted, add the puff corn and mix well. It is ready!

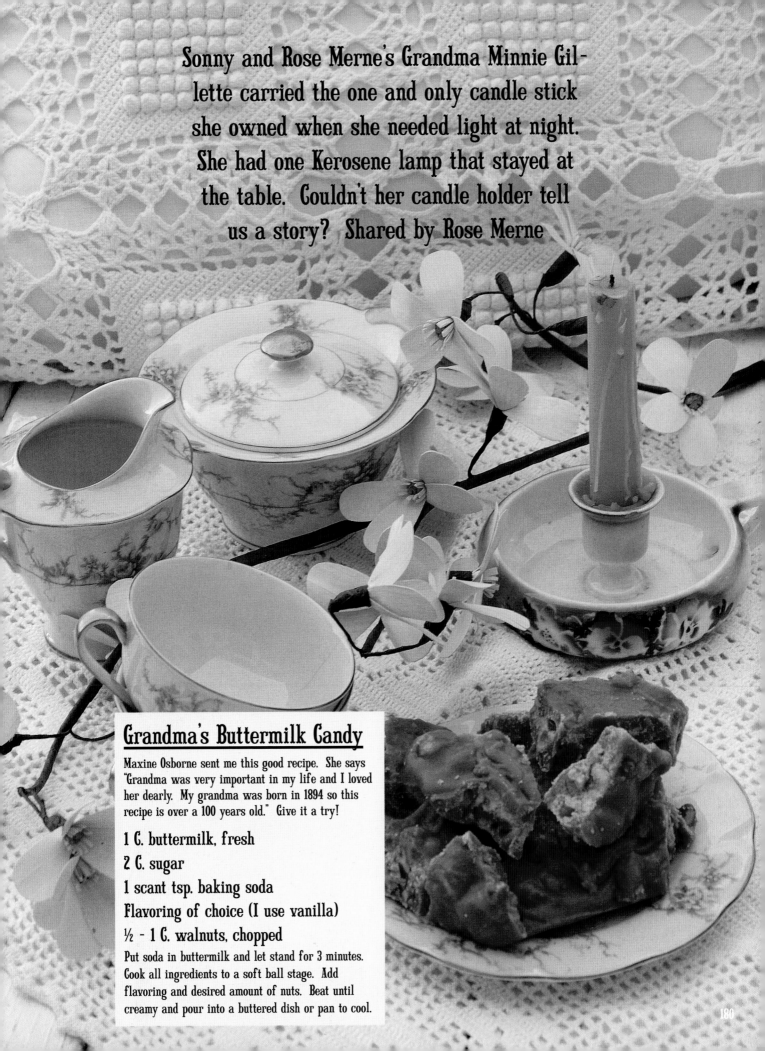

Sonny and Rose Merne's Grandma Minnie Gillette carried the one and only candle stick she owned when she needed light at night. She had one Kerosene lamp that stayed at the table. Couldn't her candle holder tell us a story? Shared by Rose Merne

Grandma's Buttermilk Candy

Maxine Osborne sent me this good recipe. She says "Grandma was very important in my life and I loved her dearly. My grandma was born in 1894 so this recipe is over a 100 years old." Give it a try!

1 C. buttermilk, fresh

2 C. sugar

1 scant tsp. baking soda

Flavoring of choice (I use vanilla)

½ - 1 C. walnuts, chopped

Put soda in buttermilk and let stand for 3 minutes. Cook all ingredients to a soft ball stage. Add flavoring and desired amount of nuts. Beat until creamy and pour into a buttered dish or pan to cool.

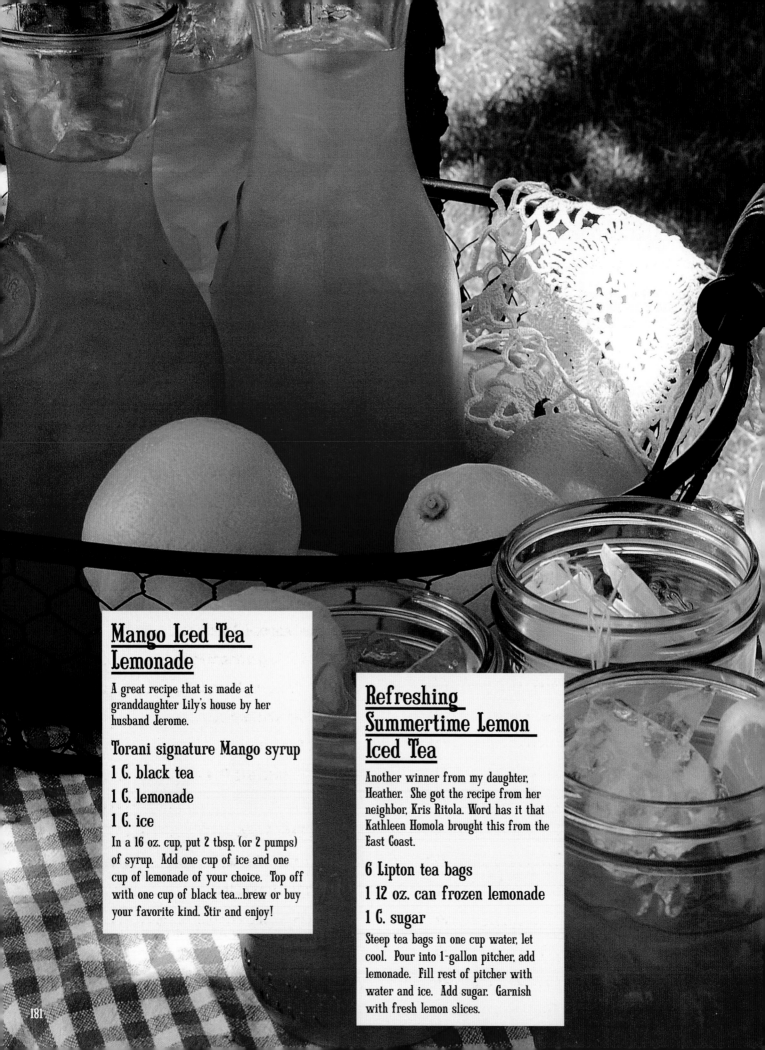

Mango Iced Tea Lemonade

A great recipe that is made at granddaughter Lily's house by her husband Jerome.

Torani signature Mango syrup
1 C. black tea
1 C. lemonade
1 C. ice

In a 16 oz. cup, put 2 tbsp. (or 2 pumps) of syrup. Add one cup of ice and one cup of lemonade of your choice. Top off with one cup of black tea...brew or buy your favorite kind. Stir and enjoy!

Refreshing Summertime Lemon Iced Tea

Another winner from my daughter, Heather. She got the recipe from her neighbor, Kris Ritola. Word has it that Kathleen Homola brought this from the East Coast.

6 Lipton tea bags
1 12 oz. can frozen lemonade
1 C. sugar

Steep tea bags in one cup water, let cool. Pour into 1-gallon pitcher, add lemonade. Fill rest of pitcher with water and ice. Add sugar. Garnish with fresh lemon slices.

BREAKFAST AND BREADS

MAIN DISHES

SOUPS & SALADS

COOKIES AND BARS

CAKES

PIES PASTRIES & DESSERTS

WILMINGTON, NORTH CAROLINA

APPETIZERS CONDIMENTS & SNACKS

FARM FRESH DRINKS & CANDY

The sun is setting upon my days of creating cookbooks. This is my final endeavor to share past culinary skills and creations with future generations to come. In my opinion, a labor of love is not work. It's a passion that comes from some deep part of ourselves, making us who we are. I like the thought of you sharing this passion with me. I believe the core of family values begins around the table. The smell of food is a swirling memory of it all. Again, I want to thank all the good cooks who have shared their treasured recipes. Some of the recipes in this book will not have pictures; please try them anyway, remembering everything within these pages is tried and true.

May our dinner bell always ring with resounding thankfulness to God, for the bountiful blessings He continues to provide.
Thank you, Fran Gillette